The Illustrator's Guide to

PEN AND PENCIL DRAWING Techniques

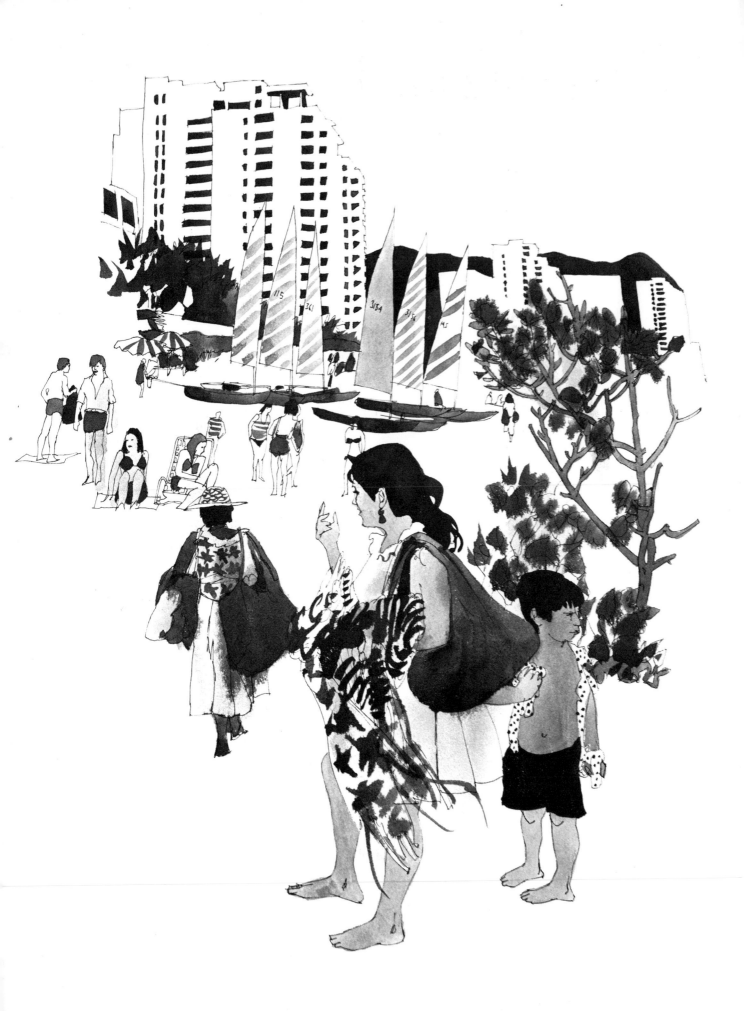

The Illustrator's Guide to

PEN AND PENCIL DRAWING Techniques

HARRY BORGMAN

WATSON-GUPTILL PUBLICATIONS/NEW YORK

The Illustrator's Guide to Pen and Pencil Drawing Techniques is a
new and comprehensive work, incorporating and revising the
following books by Harry Borgman, previously published by Watson-
Guptill: *Drawing in Ink* © 1977 by Harry Borgman, *Drawing in
Pencil* © 1981 by Watson-Guptill Publications, and *The Pen and
Pencil Technique Book* © 1984 by Billboard Ltd.

Edited by Grace McVeigh
Designed by Bob Fillie
Graphic production by Hector Campbell

Copyright © 1989 by Watson-Guptill Publications

First published in 1989 by Watson-Guptill Publications,
a division of Billboard Publications, Inc.,
1515 Broadway, New York, N.Y. 10036

Library of Congress Cataloging in Publication Data
Borgman, Harry.
 The illustrator's guide to pen and pencil drawing techniques / by
Harry Borgman.
 p. cm.
Includes index.
 1. Pen drawing—Technique. 2. Pencil drawing—Technique.
I. Title.
NC905.B674 1989 89-34002
741.2—dc20
ISBN 0-8230-2538-1

Distributed in the United Kingdom by Phaidon Press Ltd.,
Musterlin House, Jordan Hill Road, Oxford OX2 8DP

Manufactured in U.S.A.

1 2 3 4 5 6 7 8 9 10 / 93 92 91 90 89

CONTENTS

PREFACE 7

INTRODUCTION 9

PART 1. PENCIL DRAWING 11

1. MATERIALS AND TOOLS 12
2. STROKE TECHNIQUES 24
3. BUILDING TONE 40
4. SIMPLIFYING TONES 48
5. EXPERIMENTING WITH GRAPHITE PENCIL 52
6. EXPLORING CHARCOAL AND PASTEL PENCILS 70
7. USING WAX PENCILS 80
8. ADDITIONAL TECHNIQUES: SCRIBBLING, HATCHING, DISSOLVED TONE, SUBTRACTIVE TECHNIQUES 88
9. USING COLOR 96
10. TECHNICAL TIPS 128

PART 2. INK DRAWING 133

11. MATERIALS AND TOOLS 134
12. STROKE TECHNIQUES 142
13. BASIC TONAL TECHNIQUES 160
14. EXPLORING DIFFERENT LINE TECHNIQUES 178
15. EXPERIMENTING WITH BRUSH LINE TECHNIQUES 190
16. COMBINING PEN AND BRUSH 198
17. USING UNUSUAL PAPERS, BOARDS, AND A VARIETY OF PENCILS, MARKING PENS, AND CRAYONS 208
18. CORRECTING INK DRAWINGS 240
19. TECHNICAL TIPS 250

CONCLUSION 254

INDEX 255

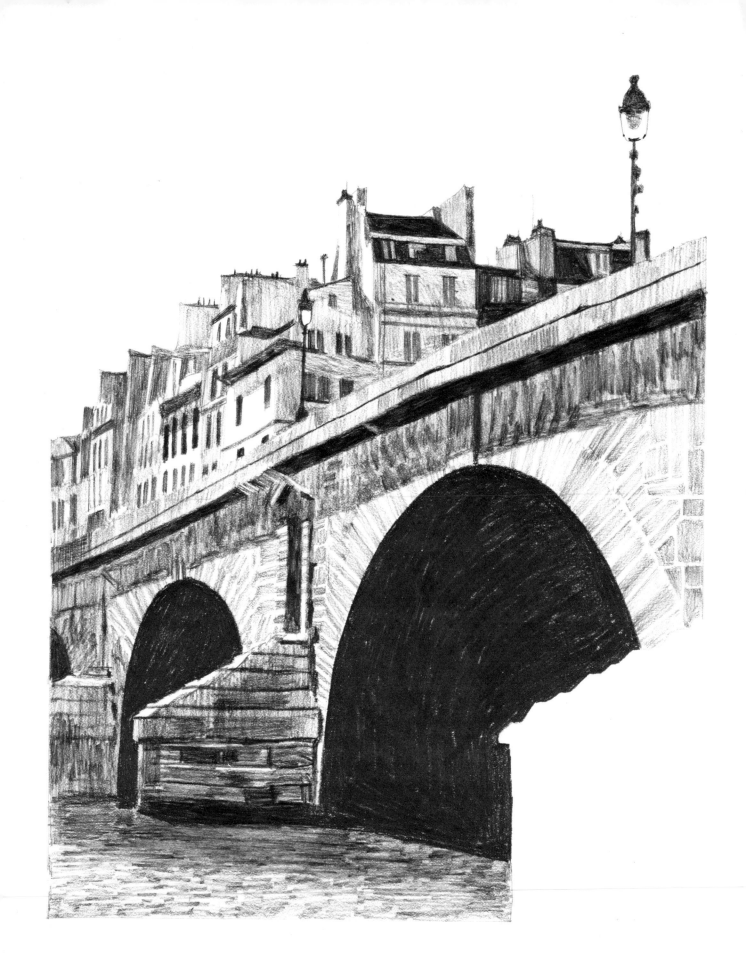

PREFACE

IT SEEMS TO ME that there is always a demand among artists for sound technical instruction in drawing. Aware of this ever-present need, the editors of this book and I felt that it would be worthwhile to publish one large volume covering, in a compact and comprehensive way, the best information on pencil and ink techniques available. Here then is *The Illustrator's Guide to Pen and Pencil Drawing Techniques,* which consists of what we deem to be the most useful information from my previous books *Drawing in Pencil, Drawing in Ink,* and *The Pen and Pencil Technique Book.* The material that we have taken from these three books has been completely redesigned, reedited, revised, and updated.

My advice is to practice each exercise in the book until you have it down pat. Then you can further improve your drawing skills by working through each subsequent step-by-step demonstration, trying your hand at both pencil and ink techniques. Finally, you will want to practice the exercises that show you how to combine pencil and ink with other mediums. Good luck.

HARRY BORGMAN
New York, 1989

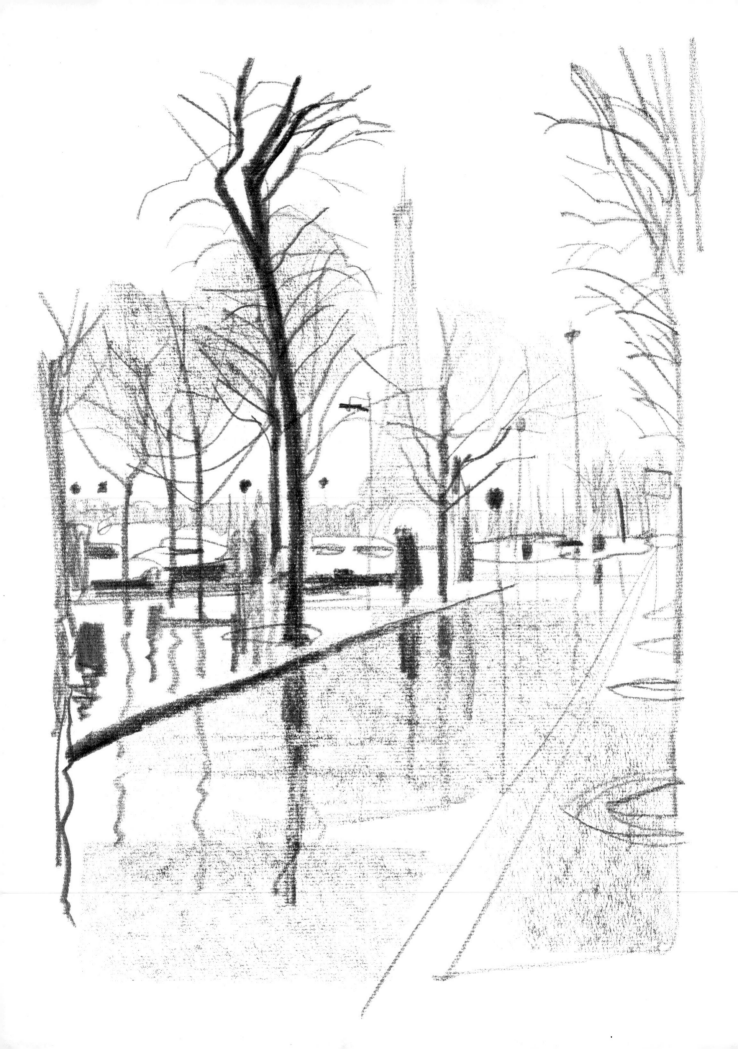

INTRODUCTION

THE BEST WAY to work with this book is to think of it as a complete guide to pen and pencil techniques, which details how you can develop your drawing skills using these tools in particular. As you work with this book, you will find yourself beginning to build on your basic drawing skills. Examples throughout offer you a comprehensive collection of techniques that you should study carefully and often. You can learn a great deal through observation and imitation.

The exercises in this book are planned to help you learn about the tools you will be using—what they are capable of and what their limitations are. When you consider the many kinds of pens and pencils available, as well as the great variety of paper surfaces on which to use them, the full scope of illustration techniques becomes apparent. With the added dimension of color, which has rarely been covered in other drawing books, this exploration becomes even more exciting.

Do not skip the exercises; they are an important part of the instruction in this book. In fact, I would suggest that you do all the exercises several times, using various paper surfaces and kinds of pens and pencils. Above all, study the step-by-step demonstrations so that you really understand how the drawings are done. This is an important means of familiarizing yourself with all the drawing tools—by actually working with them on many different paper surfaces.

The subject matter is diverse and includes outdoor scenes, figures, vehicles, portraits, animals, buildings, and still life subjects. To explore various techniques and effects, I have included drawings done with a variety of drawing tools. These encompass a wide range of drawings from very rough sketches to highly finished works. Keep in mind that an art instruction book can only help to make you aware of the various tools, techniques, and some of the possibilities for experimentation. You must go on from there. In this book I hope to encourage you to experiment and explore the endless possibilities of pen and pencil, and perhaps to help you develop a personal drawing style. This will of course happen only if you consistently practice drawing.

Developing your ability to draw is important, for it can be the basis for all your future artwork. As you develop your drawing skills, you will be able to move into more difficult areas of art, such as painting. Used properly, this book can provide you with the necessary background for your development as an artist. Keep in mind that an art instruction book should be *used*, not left sitting on a library shelf.

It is also important to remember that being an artist requires self-discipline. This can often be more important than talent. Without discipline, it is doubtful whether you can even develop as an artist. Remember that no one will tell you when to do a drawing or force you to work; you must be self-motivated. One of the most important things you can learn from this book is that you can grow and develop as an artist only by working at it consistently.

PLACE DE L'AMA *(left), 11" × 15" (27.9 × 38.1 cm). This very quick, bold study was drawn with a grade 4B graphite stick on MBM Ingres d'Arches paper. Notice the interesting surface texture of the paper.*

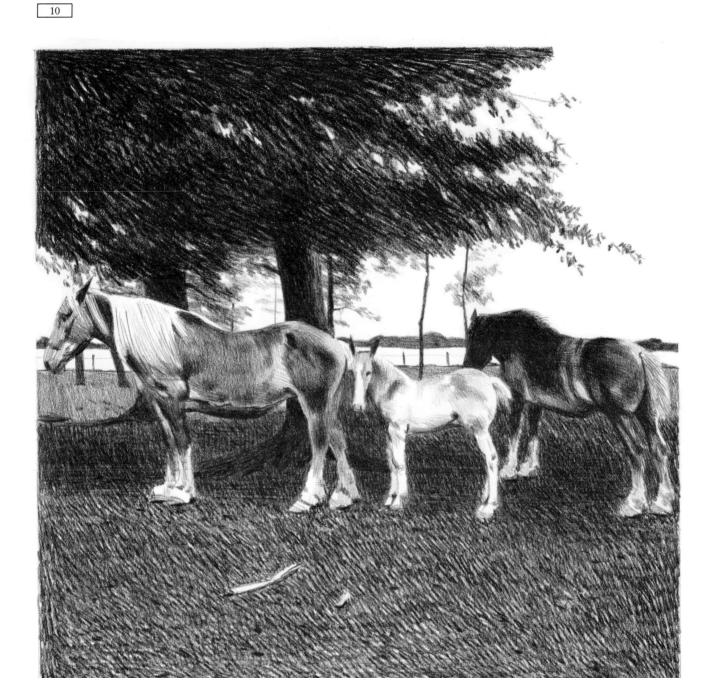

MEADOWBROOK FARMS, *11⁹/₁₆" × 11¼" (29.4 × 28.6 cm).*

PENCIL DRAWING

THE PENCIL SKETCH is fundamental to art. Most work—whether painting, drawing, illustrations, prints, engravings, or even sculpture—invariably begins as a pencil sketch. But the pencil also offers other possibilities to the artist. It can effect highly finished drawings that can stand on their own. Unfortunately, most artists use pencil for preliminary drawings and never develop pencil techniques to the degree they might. In Part One of this book, Pencil Drawing, you will have a chance to explore a variety of pencil techniques with the aim of developing and expanding your drawing skills.

For the beginning art student, the pencil is already a familiar tool, used for writing if not drawing. As a natural drawing instrument, it is simplicity itself. With a pencil and a sheet of paper, you are ready to start drawing.

Not only is there a variety of drawing pencils available to artists, but pencils can be used in so many ways. Just by sharpening the lead point differently, you can create distinctively drawn lines. And the various grades of lead, from very hard to very soft, produce even more variety, in both line and tone. You can create drawings by using only lines, by using tones devoid of lines, or by using any number of techniques in between.

Pencil is also compatible with a wide variety of paper surfaces, whose textures can add a great deal of interest to a drawing. These different papers broaden the drawing possibilities, since each surface responds differently to the pencil.

And, most important, the artist's own imagination brings further possibilities to this truly marvelous medium.

1

MATERIALS AND TOOLS

IF YOU ARE SERIOUS about drawing, you will need to know about the many possibilities available in this medium. One way to gain more skill in your drawing, so that you can move from the simple to the complex, is to learn about your drawing tools and how to handle them. This chapter will tell you what the best materials are and how to use them. Just knowing your tools can give you a measure of confidence, which will reflect itself in your work.

PENCILS

Fortunately for artists and art students, there are a great variety of drawing pencils available, as well as many excellent paper surfaces to work on.

Graphite Pencils. The traditional basic drawing tool—the graphite pencil—is made of compressed graphite that is encased in cedarwood. It is available in many different grades, ranging from very hard to very soft. The order of grading is 9H, 8H, 7H, 6H, 5H, 4H, 3H, 2H, H, HB, B, 2B, 3B, 4B, 5B, and 6B. The 9H lead is the hardest grade, and the 6B is the softest. Personally I prefer using the HB grade for general work and often use the H and 2H grades as well. Experiment with a few of the different grades to see which you prefer. Generally speaking, the harder grades work better on smooth, hard-surface paper, and the softer grades work better on textured paper.

With regard to lead grades, the harder the lead, the lighter the line; the softer the lead, the darker the line. The harder grades—those above 2H are usually used for drafting or for mechanical drawing; the softer grades are used for general drawing. For sketching, the very soft grades—2B through 6B—are best; the hard 2H to B grades are better for meticulous renderings.

Many fine brands of graphite pencils are available, and you will have to try a few of them to see which you prefer. Some brands I have found to be excellent are Berol Eagle turquoise, Koh-I-Noor, Mars Lumograph, and Venus. Some graphite pencils especially suited for sketching have very broad, flat leads for drawing thick lines. These sketching pencils usually come in grades of 2B, 4B, and 6B. The Ebony pencil, which has a large diameter and a very black lead, is also quite good.

Charcoal and Carbon Pencils. There are many types of charcoal and carbon pencils on the market. A good brand is General Charcoal. It is a deep black and comes in grades of HB, 2B, 4B, 6B, and in white. Wolff carbon pencils are also quite good, and they come in grades of HH, H, HB, B, BB, and BBB, which is the softest.

Wax-Type Pencils. One of my favorite drawing pencils is the Koh-I-Noor Hardtmuth Negro pencil. It

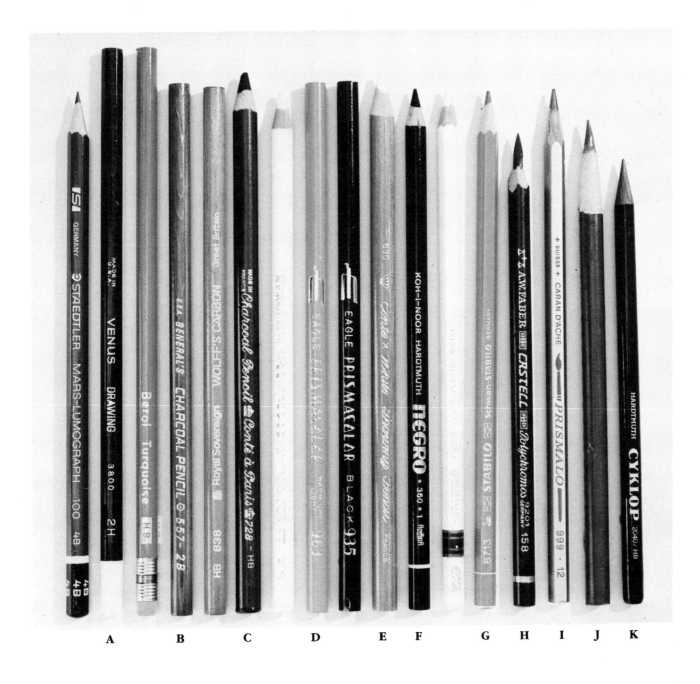

A. *Graphite*
B. *Charcoal and carbon*
C. *Carb-Othello pastel*
D. *Berol Eagle turquoise Prismacolor*
E. *Conté white*
F. *Koh-I-Noor Hardtmuth Negro*
G. *Stabilo*
H. *Faber Castel Polychromos*
I. *Caran D'Ache Prismalo water-soluble*
J. *China marking pencils and litho crayons*
K. *Hardtmuth Cyklop*

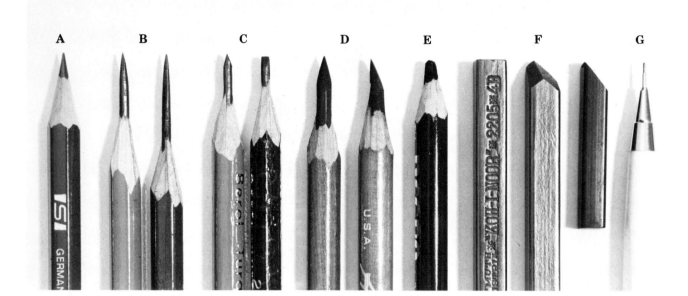

A. *Pencil pointed with a sharpener*
B. *Sharpened with an X-Acto knife and a sanding block*
C. *Chisel-pointed with a sandpaper block*
D. *Two ways to sharpen charcoal pencils*
E. *Blunt point for heavier lines.*
F. *Graphite sticks with different drawing edges*
G. *Mechanical pencil for thin, even lines*

has a wax-type lead that is jet black, and it is available in five degrees of hardness. Many other wax-type pencils are on the market; some have very fine leads, whereas others have very soft, thick leads.

I have used Berol Prismacolor pencils for many years and have found them to be uniform in color and lead consistency. Their leads are smooth, thick, and strong enough to sharpen to a fine point. Their color range is wide, comprising sixty colors. Prismacolor pencils can be purchased singly or in sets of 12, 24, 36, 48, or 60 colors. These pencils can also be used in conjunction with other mediums, such as markers, dyes, watercolors, and other painting mediums. They can be blended or smudged with a paper stump dampened with Bestine, a rubber-cement solvent.

China Marking Pencils. These pencils are available in several colors, including white, black, brown, red, blue, green, yellow, and orange. Stabilo, another wax-type pencil, is also available in eight colors.

Water-Soluble Pencils. Another interesting pencil is the Caran D'Ache water-soluble pencil. You can wash clear water over the drawn lines with a brush and dissolve the tones to create a pencil painting. You can also use Caran D'Ache pencils without dissolving the tones. This brand offers forty brilliant colors, whose strong leads can be sharpened to a fine point. Other types of water-soluble pencils are also available.

Pastels. These come in pencil form and are a very interesting medium to work with. They can be blended easily with your fingers or a paper stump and are especially suitable for soft effects. The brand I use is Carb-Othello, which is available in sixty colors, with matching pastel chalks that can be used for covering large areas. These pencils sharpen well for detailed work and have a large-diameter lead that can be used to draw broad strokes.

Conté Crayon. Conté crayons, which are very good for sketching, come in black, white, sepia, and sanguin. A pencil form of the crayons is also available in three grades of hardness.

Miscellaneous. Another good sketching tool is the graphite stick, which is available in many grades and in a round or square shape. There are all kinds of lead holders and mechanical-type pencils you may want to try. If you prefer an even line when drawing, try using a mechanical pencil with a fine lead. Many grades of replacement lead for holders are available in most art supply stores. Another great sketching tool is the charcoal stick, which also comes in several grades of hardness.

DRAWING ACCESSORIES
Masking Tape. You can use masking tape to stick your drawing paper to a drawing surface.

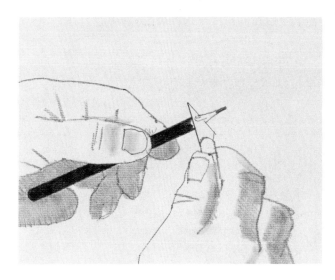

Sharpening Pencil with Knife. *The razor knife is the handiest way to sharpen a pencil. The wood can be carefully cut away from the lead with the sharp edge of the blade. I prefer a long lead when drawing so I don't have to resharpen so frequently; this is the best method for obtaining one. I must caution you again: These knives are very sharp and you must be careful when using them. A pencil sharpener is not advisable because the resulting exposed lead is too short.*

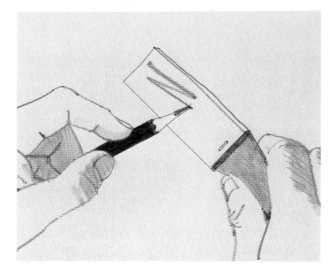

Sharpening Pencil with Sanding Block. *After the wood has been carefully cut away with a blade, the lead can be pointed by using a sanding block or pad. The lead can be shaped to a fine point, a chisel point, a blunt point, a rounded point, or in any number of other ways, depending on which type of line you wish to produce when drawing. Experiment with different-shaped leads to see the various kinds of lines that can be produced.*

X-Acto Knife. Mechanical or hand-held pencil sharpeners are not the best tools to use for sharpening pencils. The leads of pencils sharpened this way are usually too short and too dull. The X-Acto knife method works best: You cut away the wood surrounding the lead and then shape the lead with a sandpaper block. The harder grades of pencils can be sharpened to a long point because the lead is stronger, but be careful with the softer grades, which break rather easily. By using this method of sharpening pencils, you have the advantage of being able to shape the point any way you wish, depending on the effects you want to achieve when drawing. Be careful, however, not to sharpen the wrong end of the pencil, or you'll cut away the number identifying the lead grade.

Charcoal pencils can easily be sharpened with an X-Acto knife, then shaped with a sanding block. Because charcoal and carbon leads are thicker than graphite, they can take on more shapes. The same holds true for pastel pencils—but be very careful when shaping these points because they are soft and tend to break easily. Graphite sticks and Conté crayons can be sharpened to a variety of forms with the sanding block. You can draw with the different edges of these sticks and achieve very distinctive results.

Erasers. There are many types of erasers available, but the most useful is the kneaded rubber type. This is a soft, pliable eraser that can be shaped to a point for picking out highlights or erasing in tight spots. Artgum erasers are safe and efficient for cleaning drawings. Of the several vinyl-type erasers that are quite useful, Magic Rub, Edding R-20, and Mars-Plastic are three good brands. Pink Pearl erasers, which are soft and relatively smudge free, are good for all-around use. Electric erasers are also available, but they are generally used for tougher erasing jobs, which you might encounter when doing India-ink drawings. An erasing shield is a handy item, which can be used to confine the area you're erasing.

Sandpaper Block. This is essential for shaping your pencil leads after you have cut away the wood with an X-Acto knife. The sanding block can be used on all types of pencils and on graphite sticks and Conté crayons; experiment with it. Leads can be shaped to a very sharp point or to a blunt point. An interesting shape is the chisel point, which can make very fine or very thick lines. As the sandpaper becomes saturated with graphite, just tear off the top sheet and expose a fresh one.

Fixatives. You will want to protect your pencil drawings from smearing or smudging. Fixatives are available in spray cans or in bottles for use with an atomizer. I recommend the spray fixative, which is available in two types—glossy or nonglossy. The nonglossy kind, with its matte finish, is the best to use for pencil drawings.

PAPERS

Many drawing papers and illustration boards can be used for pencil drawings. The following are a few of the basic types most suitable for this medium.

Tracing Paper. This is a general all-purpose paper with a fine transparent surface. Usually tracing papers are used for preliminary sketches and for multiple drawings of sketches the artist wants to improve upon. Available in pads ranging in size from 9″ × 12″ (22.8 × 30.4 cm) to 24″ × 36″ (61 × 91.4 cm), tracing paper also comes in rolls of varying widths and lengths.

Layout and Visualizing Paper. Layout papers are excellent, especially those that are top quality. This type of paper has a velvety smooth surface and is semi-transparent, making it ideal for all pencils. It is available in the same pad sizes as tracing paper.

Newsprint. This paper comes in either a smooth or a textured surface. It is suitable for doing lots of quick sketches in charcoal and is perfect for use in a life-drawing class. It is available in pads ranging in size from 12″ × 18″ (30.5 × 45.7 cm) to 24″ × 36″ (61 × 91.4 cm).

Hot- and Cold-Pressed Bristol Board. Hot-pressed board, which is also called plate-finish or high-finish bristol, has a smooth, hard surface. It is usually used for India-ink drawings but is excellent also for pencil drawings. Cold-pressed board is a versatile paper because its slight surface texture is well suited for many mediums, including pencil. I generally use the Strathmore brand, which is available in both the high finish and the cold-pressed. This fine-quality paper comes in various thicknesses, from 2-ply to 5-ply, which is the heaviest. Both surfaces are also available in heavier illustration board, which you may prefer. Strathmore bristol papers are 23″ × 29″ (58.4 × 73.7 cm).

Another fine brand of bristol board is Schoeller. I prefer this brand for India-ink drawings because its surface seems to be more durable—an important point to remember is you have to make corrections with a fiberglass eraser. Also available is a rough, coarsely textured paper that can be used for certain types of pencil drawings, though it is more suited to watercolor.

Watercolor Papers. Other interesting paper surfaces on which to work are watercolor papers, also available in hot-pressed, cold-pressed, or rough surfaces. Watercolor paper can be purchased in separate sheets or in blocks of twenty-five sheets. The watercolor blocks range in size from 9″ × 12″ (22.8 × 30.5 cm) to 18″ × 24″ (45.7 × 61 cm).

Charcoal Papers. These are available in many different colors in a sheet size of 19″ × 25″ (48.3 × 63.5 cm). They can also be purchased bound in pads of

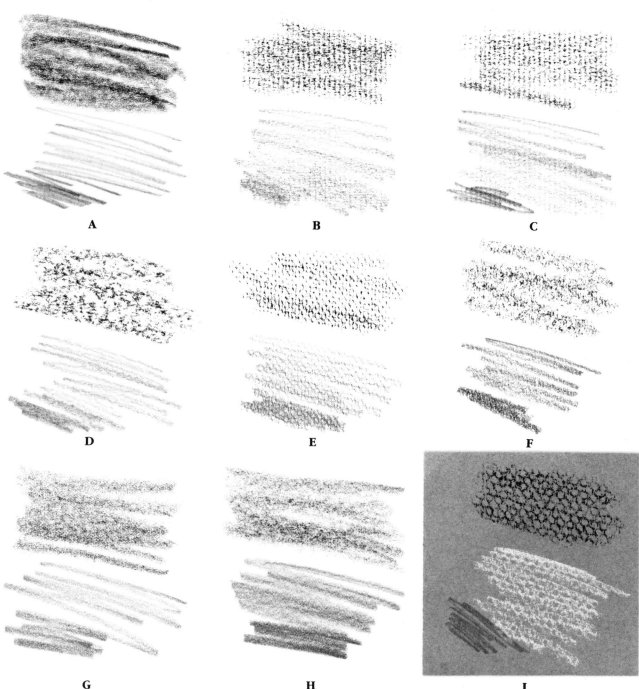

A. *Smooth surface or high-finish bristol (also called plate finish).*
B. *Ingres Canson—a slightly textured surface.*
C. *MGM Ingres D'Arches—a more evenly textured surface.*
D. *Aussedat Annecy—a soft, less machinelike surface.*
E. *Lavis B—a slightly rough-textured surface.*
F. *Regular-surface bristol—a slightly textured surface.*
G. *Layout paper—a fine, smooth surface.*
H. *Tracing paper—a very smooth surface.*
I. *Colored papers—slightly textured.*

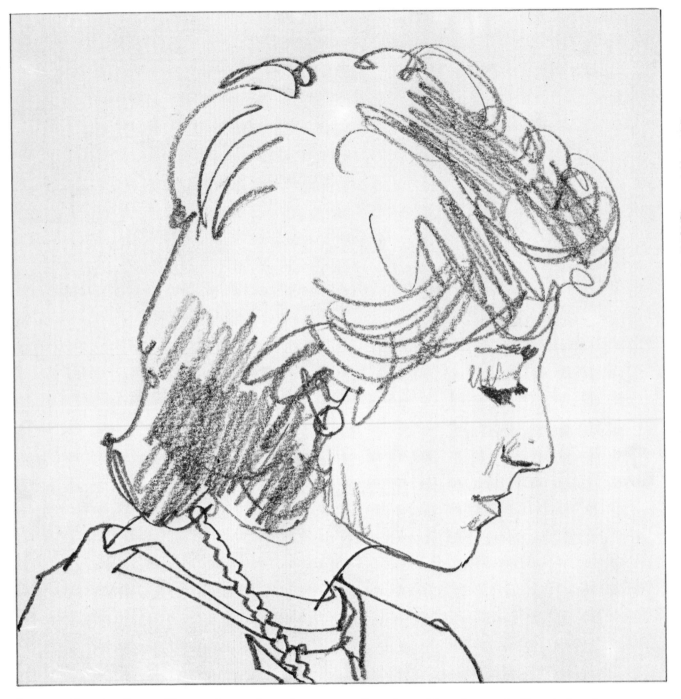

Common Drawing Paper. *The most frequently used paper for drawing is common drawing paper, which has a standard medium surface texture. The British call this cartridge paper. This paper is quite versatile; it can be used with pencil, pen, brush, and even for wash tones. The slight surface texture is excellent for pencil drawings and fine enough for use with pens, since they will not snag the surface. For this illustration, I used a 4B graphite pencil to draw a portrait of a young woman. Notice how well the pencil works on this surface, and although there is no blending on this particular drawing, it certainly is possible on this paper. There is a tonal variation in the lines drawn: The ones on the hair are lighter than those used for the outlining. This was accomplished by using different pressure on the pencil while drawing—the lighter the pressure, the lighter the drawn lines. If you practice drawing lines of various values, you will develop a great deal of control in the use of the pencil.*

Smooth Paper. *One of my favorite surfaces for graphite pencil drawing is smooth paper. The graphite pencil is especially compatible with the smooth surface because a full range of tones—from very black to very light subtle grays—are possible. Wax pencils can also be used successfully on smooth paper. But chalk or charcoal pencils are not suitable; the leads just don't respond to a surface without texture. Notice that the lines in this drawing do not appear to be as rough as those on the previous drawing. This is because of the lack of paper surface texture. This paper cannot be equaled for doing highly detailed drawings with subtly rendered gray tones. When this paper is used, even the quality of the lines is different from those drawn on other papers. When you compare this drawing with the previous one, notice that the lines appear more crisp because of the lack of surface texture. This results from the ease with which the pencil moves across the smooth surface, unobstructed by textures.*

Rough Paper. *The same drawing takes on a completely different character when drawn on a heavily textured surface such as watercolor paper. Notice how the lines themselves take on a texture and that even the darker tones on the hair and the details, such as the eye, are not solid black but are broken up by the roughness of the paper surface. Very interesting drawings can be done on rough-surfaced papers, but creating solid black tones or lines requires that the artist bear down quite heavily on the pencil while drawing. Pencil leads tend to wear down rapidly on this type of surface, but the softer grades, such as the 4B used here, are more compatible for use on rough papers than the harder grades. Rough papers have a more delicate surface, and harder leads may dig into the paper. The finer lines, drawn with a sharpened pencil, are quite dark, whereas those drawn with a duller, broad point are heavily textured, which adds interest to the drawing.*

Charcoal Paper. *Standard charcoal paper is a very popular paper surface; it has a ribbed texture and is known as Ingres in Europe. This paper, which has a mechanical, even surface texture, is a very fine paper for drawing with graphite, charcoal, chalk, or even wax pencils. A drawing done on this paper will tend to have a texture throughout that does not detract but rather enhances the drawing. Most pencils respond very well to this surface; charcoal sticks can also be used with excellent results. Charcoal paper is a delight to draw on and is a favorite of many artists the world over. On this drawing you can clearly see the overall textural effect that occurs when working on this surface.*

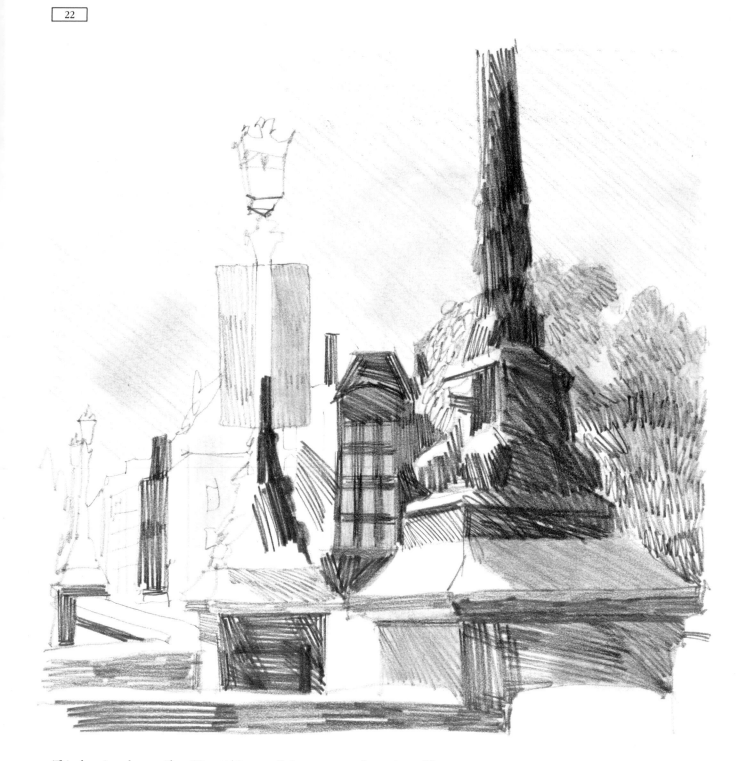

This drawing done with a 2B graphite pencil demonstrates the variety of linear and tonal qualities possible with a graphite pencil. In the sky portion, a series of lines creates a gray tone that was smoothed out with a rolled paper stump. The zigzag lines used in the trees to simulate foliage were also rubbed with a paper stump to create a tone. You can experiment with different grades of pencils to see the various effects possible by rubbing the lines with a paper stump. You can also dampen the stump with Bestine, a rubber cement solvent that dissolves graphite to create interesting tonal effects.

assorted colors as well as in white. These pads range in size from 9″ × 12″ (22.8 × 30.5 cm) to 18″ × 24″ (45.7 × 61 cm).

Printing Papers. Many printing papers have interesting surface textures that are quite good for use for charcoal, carbon, or pastel pencil drawings. Check your local art supply dealer or paper distributor to see what is available. Pantone makes a good paper in a range of five hundred colors. It is printed on a matte surface that works well for pencil drawings. The sheet size is 20″ × 26″ (55.8 × 66 cm).

Many unusual papers can also be found at printing-paper supply houses. I especially enjoy working on Kromkote, a paper with a very glossy surface that is perfect for wax-type pencils.

Other Papers. I have experimented successfully with Japanese rice papers and lithograph printing papers. Vellum, a paper much like tracing paper, is also very good to draw on. And there are many illustration boards available. One I particularly enjoy has a linen-like texture that is excellent for pencil drawing.

DRAWING SURFACES AND LIGHTING

Drawing Board. Although you can use an ordinary table or even a desk to work on, I recommend using a portable wooden drawing board. These boards are quite handy and come in a variety of sizes, ranging from 16″ × 20″ (40.7 × 50.7 cm) to 31″ × 42″ (78.7 × 106.7 cm). You can tape your paper to it and be ready to work. And they are portable.

Drawing Table. Many artists prefer working at a regular artist's drawing board or a drafting table. A drawing board can be tilted and locked at any comfortable working angle. Some drawing tables can even be raised or lowered in height. They can also be tilted to a horizontal position for use as cutting tables. Many of them can be folded for easy storage. A variety of drawing tables are available in every price range; you will have to be the judge of which type suits your needs best.

Taboret. This type of table is handy for storage of your tools and doubles as a convenient table on which to set things while you are working. Again, many types are available at various prices. Of course you may prefer using a wooden box or an old table rather than buying a piece of furniture. As for seating, any comfortable chair will do. I personally prefer one with armrests and casters, for easy movement.

Lighting. If you are going to be working under artificial light, you should invest in a fluorescent lamp, an excellent type of light for artists. Some fluorescent lamps are designed to be clamped onto your drawing table, but I prefer the model that rests on a floor stand. It enables me to easily change the angle of my drawing table without first removing the lamp. Many types of lamps are available, but you can choose the one that suits you.

Reminder. Your local art supply store may not stock all the items I have mentioned, but you should be able to find equivalent ones. You can order supplies from an art supply catalogue if necessary. But think carefully about what you'll need before you buy, and then purchase only what you will use. Limit yourself to the basics, especially if you are a beginner, and purchase the highest quality you can afford. Inexpensive art materials are not worth using, especially poor-quality brushes or paper.

Stumps. *Paper stumps, which are made from tightly rolled paper, are very handy tools. They are usually pointed at the ends and can be used to blend or shade charcoal, chalk, graphite, or even wax pencil drawings. Because of their pointed ends, very delicate blending can be accomplished using these tools. They can be repointed or sharpened with a razor knife and a sanding pad. The long tapered side can be used for blending broad areas, and the tip is ideal for blending smaller hard-to-get-at areas. Wax pencils can be blended by first dampening the stump with a solvent, such as the kind used for diluting rubber cement.*

2
STROKE TECHNIQUES

ARTISTS GENERALLY HOLD a pencil in the same position for drawing as they do for writing. This is especially true when they are seated at a drawing table. But when an artist draws standing at an easel, the position of the pencil is different. This is because the normal writing position is then uncomfortable. For quick sketching still another position may be more suitable.

Positioning the hand and pencil is a very personal thing, and only by experimenting will you find the position that is best for you. Therefore the following exercises should first be done using the normal writing position and then done using other hand positions. The exercises are planned to help you learn how to use your tools and to familiarize you with the pencil's capabilities and limitations. These exercises should be practiced until you become very confident and facile with the pencil. They should also be done using various grades of graphite pencil

as well as other pencils, such as charcoal, carbon, pastel, and wax-type pencils.

Practice drawing different types of lines. Remember to do these exercises with different pencils on various paper surfaces. Try the exercise given on page 26. You will learn how to create line textures, which is another way of building tones. Don't move through your practices too quickly—practice until you do the strokes successfully.

The three step-by-step demonstrations will allow you to practice using thin strokes, broad strokes, and varied strokes. It is most important that you practice drawing with the pencil every day, carefully doing all the exercises until you are proficient at them. They are designed for you to learn about your drawing tools. If you practice the exercises, you will also become proficient at using all the pencils mentioned in the book. The more time you spend practicing, the more you'll learn about drawing.

Working with Thin Strokes. *A common technique for general drawing is to build up tones using thin strokes rather than blending or shading. Here I used an HB grade graphite pencil on drawing paper. The outlines were drawn first, then the tones were added.*

Working with Broad Strokes. *For this sketch I used a soft, 4B grade graphite pencil with a wide, flat lead on drawing paper. The flat shape of the lead allowed me to vary the weight of the lines. The thinner edge of the lead was used for finer lines and the wider portion for shadow areas.*

Working with Varied Strokes. *An outline drawing with an HB grade graphite pencil was done first, then lighter tones were sketched in. Darker tones and black accents were drawn with the 2B grade graphite pencil. Zigzag and crosshatch strokes were used. I worked on common drawing paper.*

Working with Parallel Strokes. *The tones used here are created through the use of lines drawn in the same direction, parallel to one another. This technique requires that the lines be spaced relatively even to ensure a flat tone. I used an HB grade graphite pencil.*

Exercise 1. _Textures with Lines_

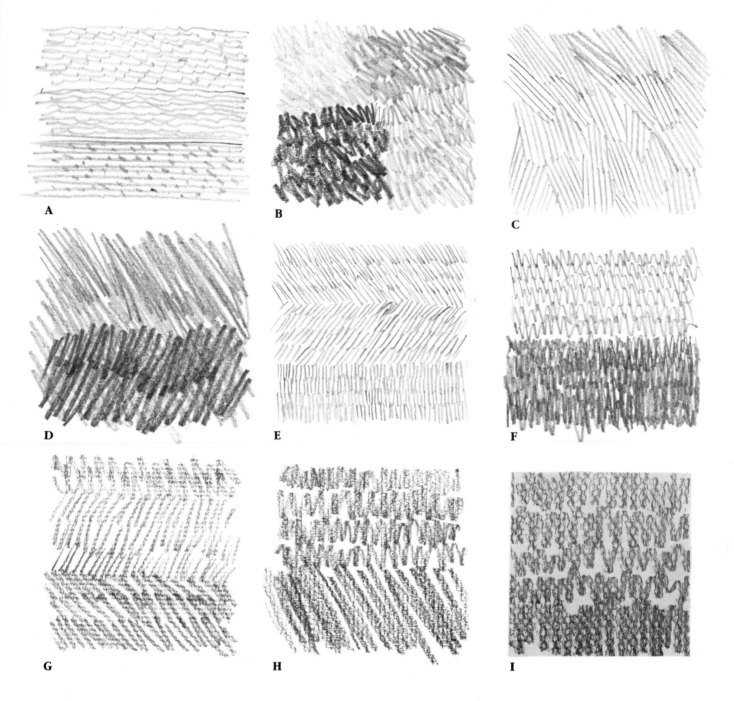

A.

B.

C.

D.

E.

F.

G.

H.

I.

A. _For all these exercises, use an HB pencil on a smooth bristol board. A series of half-loop lines can create an interesting texture and a series of wavy lines drawn closely together can create a fairly even tone. Now draw a series of even horizontal lines with short strokes or dots._

B. _Zigzag strokes drawn with varying pressure can also be used to create tones of different textures. Practice this using other pencil grades._

C. _Draw one series of strokes followed by an adjacent series at a slightly different angle. Continue over a large area, constantly changing the angle of stroke. A very interesting textural tone will result._

D. _Practice drawing textured, even tones using random zigzag strokes. Over this tone draw another zigzag tone, at another angle, using a darker-grade pencil._

E. _Create a tone by drawing short strokes at an angle. The overlapping lines will create a slight texture. Try this by drawing strokes from the opposite direction also._

F. _Practice drawing a textured tone using a variety of strokes over an area. Then do the same thing with a softer-grade pencil, such as a 4B or 6B, keeping your strokes close together to achieve a darker tone._

G. _Do the above exercises on textured paper and compare the results with those done on smooth bristol._

H. _Using pencils other than graphite, try the same exercises on a textured paper._

I. _Do all the exercises on a heavily textured colored paper using first a black charcoal pencil, then a white charcoal pencil, and then black and white pastel pencils._

WOODED AREA NEAR LE MANS, *10⅛″ × 18⅛″ (25.7
× 33.3 cm). This is another drawing done with the Koh-I-
Noor Hardtmuth Negro pencil. The paper surface is smooth
bristol and lends itself well to use with this particular
pencil, which enables you to achieve jet-black tones.*

Step 1. *For this drawing I used HB and 2B grade graphite pencils on a smooth-surfaced paper. The smooth paper is an excellent choice since it makes it possible to achieve crisp, clean lines as well as a wide range of gray tones. This technique uses lines and strokes to produce tones rather than blending or shading. I began by carefully doing my basic drawing in outline form, starting with the leaves growing on the tree, then the large tree, and finally the trees in the background and underbrush.*

Step 2. *Next I added a light tone to the leaves on the central tree, indicating the shadow areas. Notice that I used only linear strokes to create these gray tones. The slight variation in this tone— lighter tones in the upper leaves and darker tones in the central and lower leaves—was accomplished by varying the pressure on the pencil while drawing. I next drew short random strokes on the ground area, indicating the grass and the weeds. This is not a realistic rendition. It merely simulates the texture of the grass. The pattern created by the lines adds some interest to the drawing.*

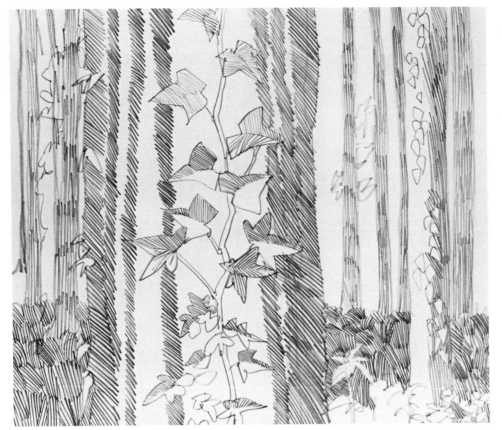

Step 3. *I added a medium gray tone to the foreground tree by drawing in strokes at the same angle. Here I was not interested in creating a surface texture, as I did with the grass in the last step, but just a tone. I drew vertical lines on the other tree trunks to add tones to these areas. The direction of the strokes used here was changed to help clarify the different elements in the drawing. Notice that the different parts of the picture separate quite well, even though the drawing is only partially completed.*

Step 4. *I decided to add the dark tone in the background, since this would help me determine the other tonal values in the drawing. I drew in the tone using pencil strokes drawn very close together, keeping the tone quite solid in the lower area. For variation, I drew in the tone at the far right using the dark at the top and the lighter tone in the lower section. The lines were randomly drawn to add to the textural effect I was after.*

Step 5. *I rendered the darkest tone on the tree trunk on the right side, carefully drawing around the leaves growing on the tree. The lines were drawn closely together, but some paper was allowed to show through to create a texture. I added the black areas on the central tree trunk, drawing in the long vertical shapes that define the bark surface. Notice that I carefully drew around the leaf shapes, keeping these light against the darker background. The pencil strokes used here are short and drawn in different directions. The area at the top has been left unfinished so that you can see how these strokes are drawn.*

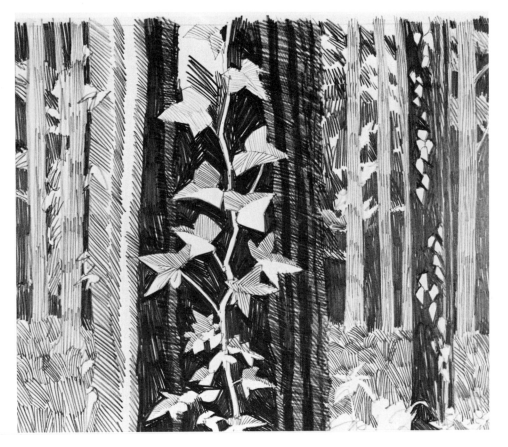

Step 6. *After finishing the central tree trunk, I indicated the shadows cast from the leaves on the vine with pencil strokes drawn over these areas. The whole background was toned down by going over the whole area with boldly drawn pencil strokes. This helped greatly to clarify the drawing and to accent the light leaves. Notice that I have been building up the tones in the drawing quite gradually, working in definite stages. I also worked over the whole drawing rather than concentrate on any one area or object. This ensured a uniform look to the finished drawing.*

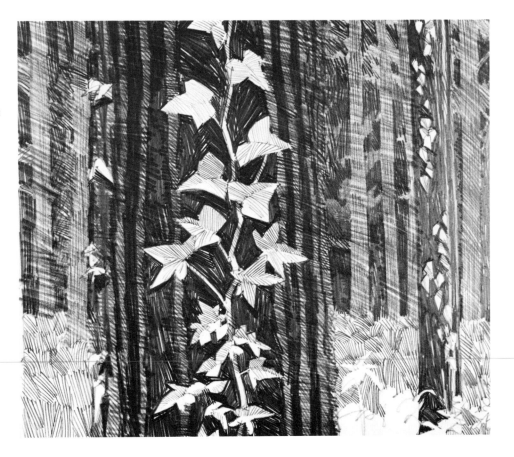

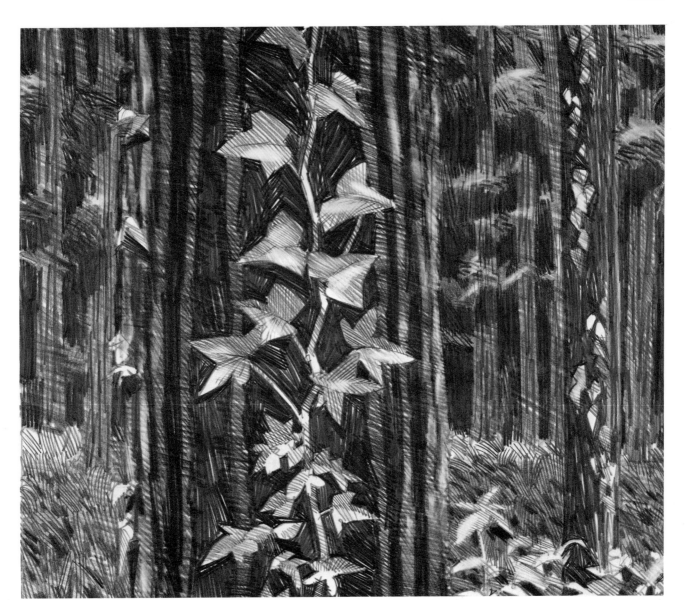

Step 7. *Now tones were drawn in the foliage in the foreground, using simple strokes of the pencil without any blending. The grassy area was darkened by using horizontally drawn lines, then a few shadows were drawn in with solid black. The leaves growing on the tree trunks were toned down a bit with pencil lines, with some of the strokes overlapping to create a crosshatch effect. The background area was darkened further and the foliage shadows were drawn on the trees. A bark texture was also drawn on the trees in the background, using vertical strokes. This darkened the tree trunks so much that the background had to be drawn using solid black. A kneaded rubber eraser was used to erase lighter areas on the tree foliage in the background and also on some of the foreground leaves. This created a smudged, soft effect, which contrasted nicely with the pencil strokes used in most of the drawing. This technique works very well for a wide range of subjects, especially those with great detail and textures. The graphite pencil is an excellent choice when using smooth-surfaced papers for drawing because a wide range of tones and textures are possible, and drawn textures become more important when no paper texture will show.*

Step 1. *Using a 2B grade graphite pencil, the type with a broad lead, I drew a diagrammatic sketch of the scene. This was done on common drawing paper, a good choice when drawing with a graphite pencil. Notice that in this diagram I drew in only the most basic shapes and lines that divide the picture plane. The foliage shapes were drawn first, then the various ground levels and hills.*

Step 2. *Here I began to draw in some of the details in the upper portion of the scene. The trees were sketched in and the building shapes were defined by carefully drawing in the roof shapes and some of the shadow areas. The shadows were added to the trees as well and a tree with branches was drawn in the middle-ground area. Leaf textures were loosely indicated on some of the trees using boldly drawn pencil strokes. Notice that this drawing is not labored but is done in a rather free, sketchy manner.*

Step 3. *Now, working on the lower section of the scene, I used strokes drawn to simulate the foliage texture. Notice that most of these tones were composed of quickly drawn, zigzag strokes, and the direction of the strokes was changed to add variety to these particular areas. A few dark shadow accents were added with bold horizontal pencil strokes.*

Step 4. *Next, I added a very light pencil tone to the sky by lightly stroking the paper with the pencil. This was done over the background trees also. Using short up-and-down strokes, I drew in the textured grassy area in the background. This same texture, which simulates grass, was used over the foreground areas, but these strokes were drawn larger, helping to create the illusion of perspective. Notice that the addition of a few well placed grays helped to define the scene and separate the various planes.*

Step 5. *I drew in the middle gray tones using the flat edge of the wide pencil lead and drawing with an even pressure. You can see that I used different types of strokes while drawing. In the bushes and trees on the upper left, short up-and-down strokes were used to create the tones. The strokes used to depict the bushes in the foreground were composed of thinner vertically drawn lines. In the center of the picture, where there appears to be a river or gully, the strokes used were drawn with the wide edge of the pencil lead. I changed the pressure while drawing to achieve variation in tone.*

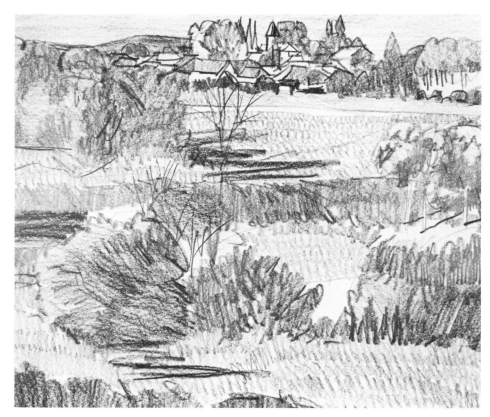

Step 6. *At this stage I added the darkest gray tones by bearing down more on the pencil while drawing. I was still using the same 2B grade lead, so you can see that a wide range of tones was possible with only one pencil. I darkened a few of the background trees and houses, then drew in the strong shadow in front of the first row of buildings. More darks were added to the gully area and to the foreground trees, with tones drawn in short up-and-down strokes with the pencil held at different angles. The black shadow was drawn under the foreground tree and the bushes at the foreground edge were darkened considerably to create a silhouette effect.*

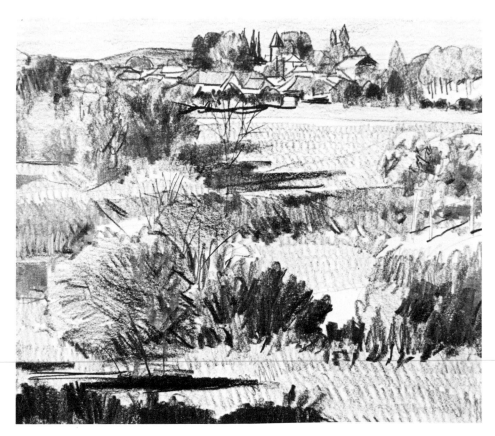

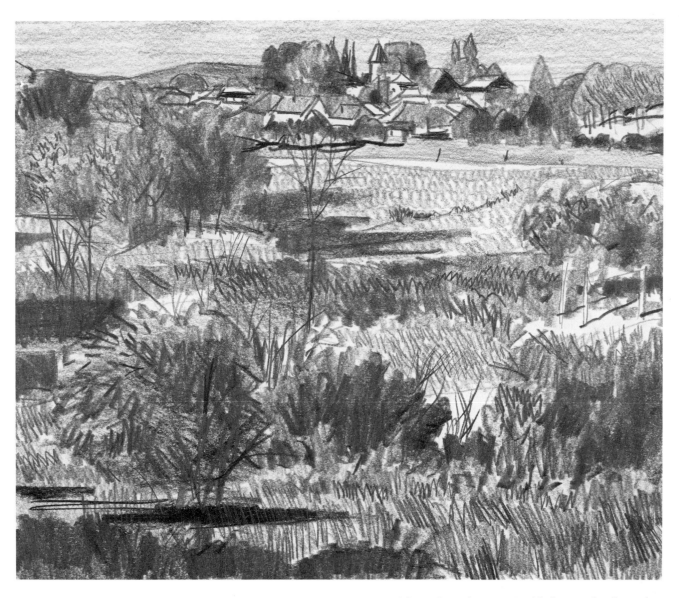

Step 7. *Throughout the scene I added more details, such as the fence posts in the background, the tree trunks, and the branches of bushes. More darker foliage was drawn in the gully area with short zigzag strokes. Just below this area I drew in shorter, lightly drawn pencil strokes, indicating another type of grass texture. On the tree in the left foreground, I boldly drew the foliage texture using zigzag strokes. I rendered the grassy area in the foreground with longer, thinner pencil strokes, changing the direction frequently while drawing to create a variation in this tone. The details in the buildings were drawn in as well as more shadows in this area. The gully on the left was darkened—as were the trees in the central area—by strengthening the tones in these areas. Every part of this scene has been rendered in a loose, sketchy manner and the overall drawing retains the same quality throughout. Nothing looks out of place by being overworked. This is an important point to keep in mind when doing drawings in any style. Whether your drawing is rendered in great detail or is a simple, loose sketch, it should appear uniform, without any variation in the technique.*

Step 1. *I began by doing a very basic, diagrammatic sketch of the head—a loose but proportionally accurate drawing. First, draw the large circular shape of the skull, then the other features. The chin, nose, ear, and eyes can be indicated with quickly drawn strokes. This drawing was done with a 2B grade graphite pencil on common drawing paper. I've drawn it very lightly because it is only a guide for doing the finished drawing.*

Step 2. *Next, I began to define the features and other details, such as the hair. I worked very carefully so that the drawing would be accurate. The facial features, such as the nose, mouth, and chin were drawn in, then the eyes and eyebrows were carefully indicated. The mouth line and the lips were added next, then the neckline. The hair was loosely sketched in, using pencil strokes that follow the general shape. The ear was drawn in outline form.*

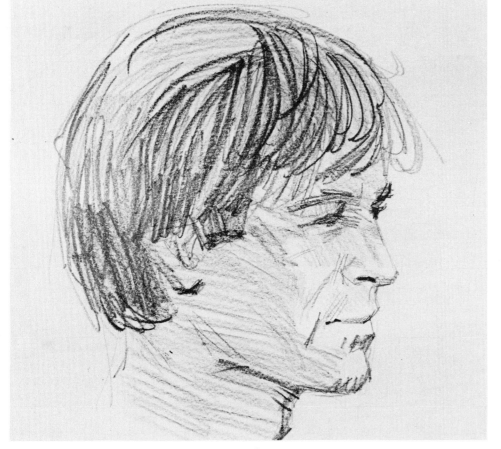

Step 3. *Using a 4B grade pencil with a broad lead, I drew in the dark accents on the eyes, nose, mouth, lips, and neck. The hair was sketched in using roughly drawn pencil strokes that followed the shape of the head. I drew in some of the various planes on the face and suggested some of the bone structure. The drawing was shaping up nicely because the proportions and sizes of the various elements were correct.*

Step 4. *Working with the 2B grade pencil, I carefully added the lightest gray tones to the face and hair, using boldly drawn strokes. In some areas I followed the form while drawing, as you can see on the cheek below the eye and on areas around the nose and the mouth.*

Step 5. *I added the medium gray tones by boldly drawing with the 4B grade pencil, varying the direction of the lines while working. Some of the strokes were drawn over one another, creating a type of crosshatch effect. This technique helped me to build up the tones and yet retain a sketchy effect. Next I darkened the hair a bit, using the flat edge of the pencil lead to render a solid tone rather than one consisting of lines.*

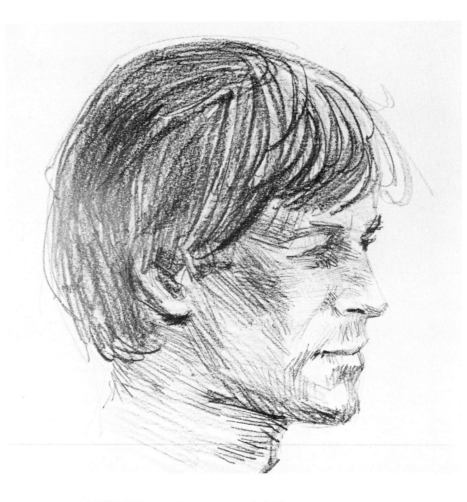

Step 6. *Here, the darkest tones were drawn in with a much softer graphite pencil, a 6B grade. Notice the dark accents on the eyes, nose, and mouth. These have been clearly indicated and add contrast to the overall drawing. The darks were strengthened around the ear and under the chin. Take care when you add accents such as these—if incorrectly placed, they can ruin your drawing.*

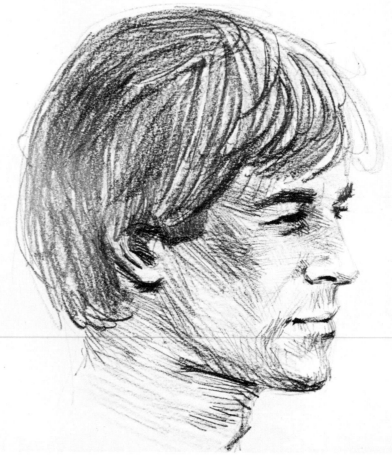

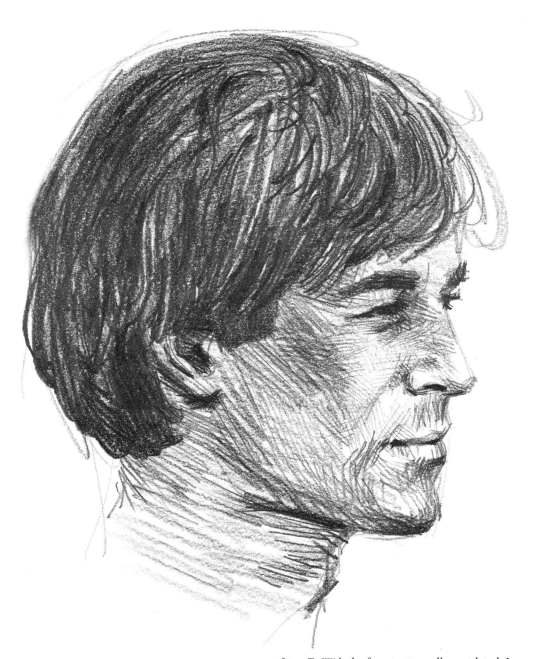

Step 7. *With the face pretty well completed, I now worked more on the hair. Working with a 6B grade graphite pencil, I drew in more strokes, following the direction of the hair. I slowly built up these tones and added shadow areas throughout, with the deepest tones last. This is an excellent sketch technique and can be used on various subject matter. Notice that all the blending I've done here has been accomplished through drawn pencil strokes rather than rubbing or blending with a stump. The most important stage of this drawing was the diagrammatic sketch done at the beginning, when the proportions and sizes were determined. If they were not correct then, it would have been reflected in the finished drawing. These simple diagrams are essential; they are the basis for line or tone drawings and even paintings.*

3

BUILDING TONE

BUILDING TONE is accomplished by applying pencil strokes so closely together that they appear to merge. This technique does not involve rubbing or smudging the lines; it simply requires that the lines be very compactly drawn together. There are different ways to work with these tones. Pencil strokes are not usually visible when tonal gradations are used. Variations in results can be achieved by using different grades of charcoal pencils, or by working with chalk or graphite pencils. The texture of the paper can also alter the effects. See the two examples given below.

On the following pages are a few exercises to help you practice working with tone and one step-by-step demonstration showing you the entire process in creating a drawing by using blended tones.

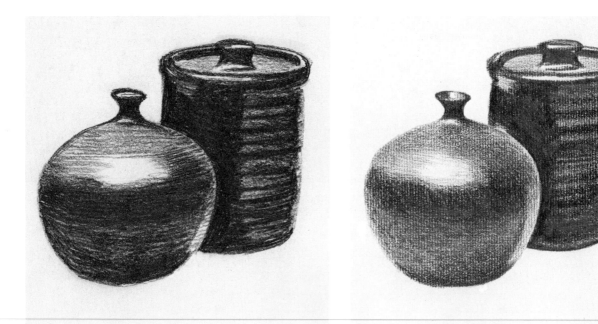

Blended Tone. *This drawing, done with a chalk pencil, used only blended pencil strokes without an outline. The pencil strokes were done on common drawing paper. The strokes were blended by drawing them close together, as you can see. The edges of the jar and bowl are not outlined but are formed by the gray tones.*

Built-up Tone on Charcoal Paper. *HB, 2B, and 4B grade graphite pencils were used for this drawing, which consists of tones without visible strokes. The tones were built up smoothly, taking full advantage of the paper texture. Light pencil pressure deposited graphite only on the raised portion of the paper. Heavier pressure filled in the valleys, creating solid black tones.*

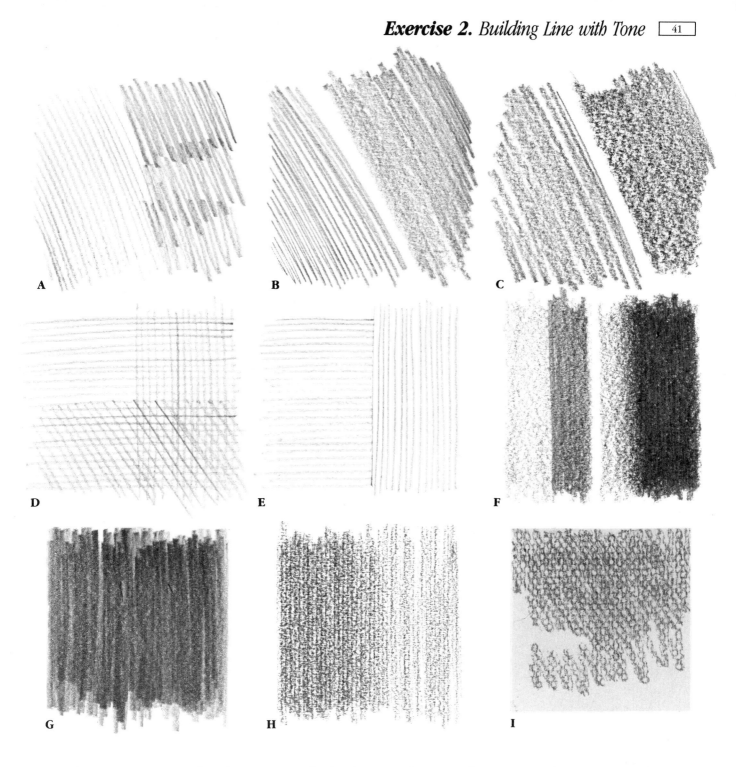

A. *To create a gray tone, draw lines next to each other. Try this using lines of different weights with varying distances between them.*

B. *With an HB and then a 2B pencil, quickly draw lines close together without hesitation. Then create an even tone by moving the pencil slightly as you stroke across the paper so that no single pencil line shows.*

C. *Quickly draw close strokes with a 4B pencil, attempting to achieve an even gray tone. Try this also with a 6B grade pencil and notice how much darker the tone is than when drawing with the harder grades.*

D. *Crosshatching is an interesting technique in which lines are drawn over each other to create tones. This technique is generally used for ink drawing.*

E. *It's very good practice to try drawing very evenly spaced lines. These should be drawn freehand without the aid of a ruler.*

F. *With a 2B pencil, first draw a very light, even tone and then a much darker one. Do the same with a 4B and a 6B, blending the tone into a very dense black.*

G. *Using strokes, try to create an even, gray tone. Draw dark ones as well as light ones.*

H. *Try blending pencil tones from dark to light with different types and grades of pencils on papers of varying textures.*

I. *Practice all of the previous exercises on a textured colored paper. Then do them all again, using a white pencil.*

Exercise 3. *Creating Tones*

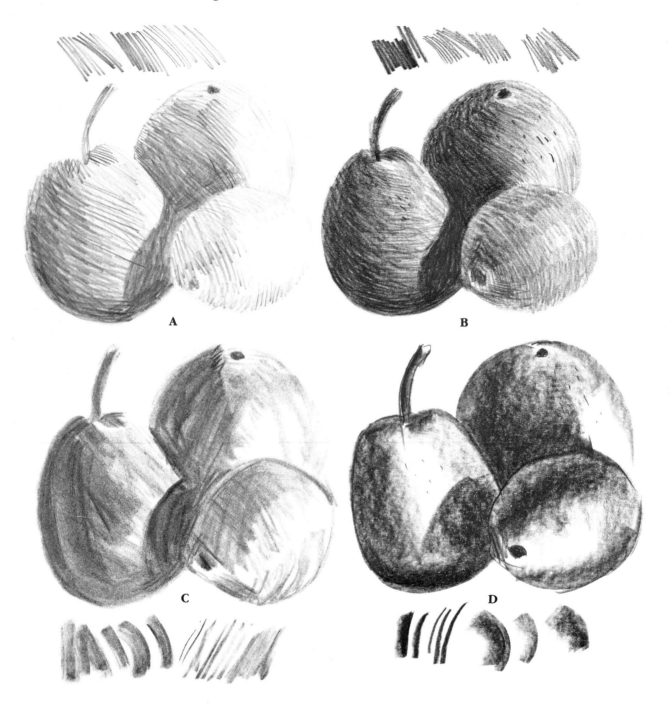

A

B

C

D

A. *Practice drawing a simple object or objects such as this still life, creating all your tones with only lines. Don't attempt to blend any of the lines. Use an HB graphite pencil on smooth bristol paper. Small diagrams of various types of strokes accompany each sketch.*

B. *On smooth bristol, draw the same object with a 2B charcoal pencil. This time try to keep your tones fairly smooth and blended.*

C. *Now draw the same object using a soft charcoal stick. This can also be done on smooth bristol, but a textured surface will work better.*

D. *Draw the same object again, using a Conté crayon. You can use an edge at the top of the stick for very fine lines. For broader strokes, break off a piece of the crayon and draw with the flat side. With just a little practice, you can create interesting effects with the Conté crayon.*

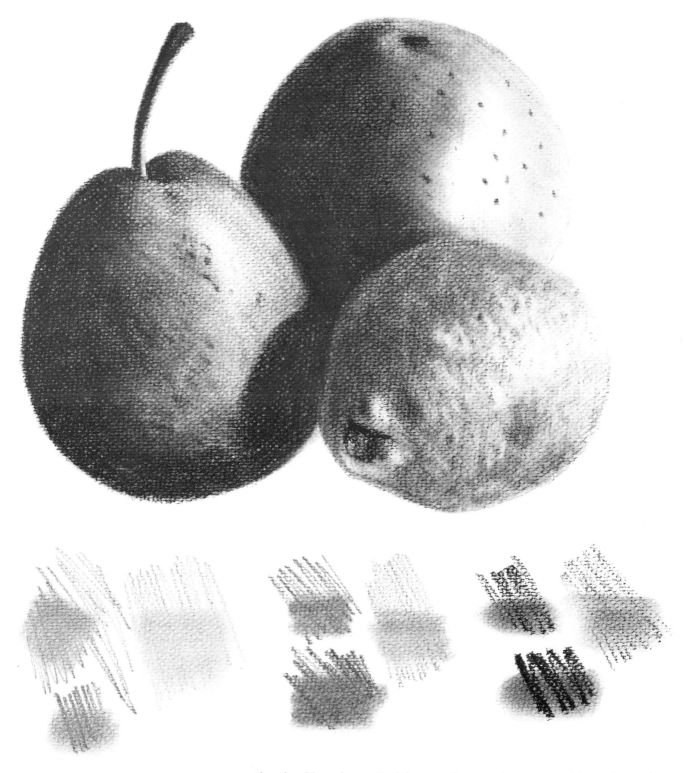

If you've diligently practiced the preceding exercises, you should now be ready to attempt a more detailed finished drawing of the same subject. This drawing was done on a textured paper surface with a General charcoal 4B and a Wolff BB carbon pencil. Tones were blended with a paper stump. Beneath the drawing I've demonstrated how various pencils can be smudged or blended with the paper stump. The first group includes different grades of graphite pencils; the middle group illustrates various grades of charcoal pencils; and the last group shows different wax pencils.

Demonstration 4. *Drawing with Blended Tones*

Step 1. *Charcoal paper with its ribbed texture is a unique surface. For this demonstration HB, 2B, and 4B grades of charcoal pencils were used on charcoal paper. I began my basic drawing with the HB grade pencil, which was sharpened with a razor knife, then pointed on a sanding pad. Notice how simple lines have been used to define the various elements in the scene. Even though this drawing was done with a minimum of lines, the proportions are correct and the nature of the subject is quite clear.*

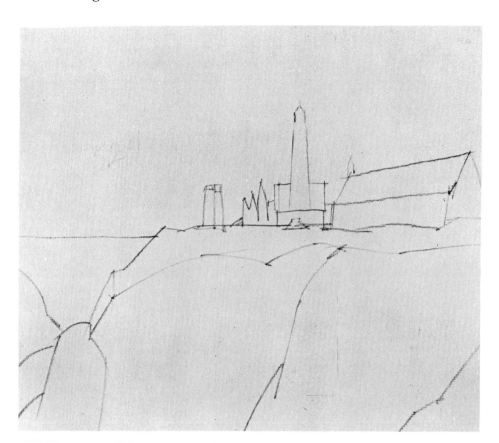

Step 2. *Details were added to the buildings and the lighthouse with the HB grade pencil. The rest of the scene was refined and clarified by drawing in the cloud shapes and filling in the details on the rocky cliff with the softer 4B grade charcoal pencil. The shadow areas on the clouds were drawn in and a few tones were added to the cliff. Notice that the drawn lines have an interesting quality owing to the texture of the paper surface.*

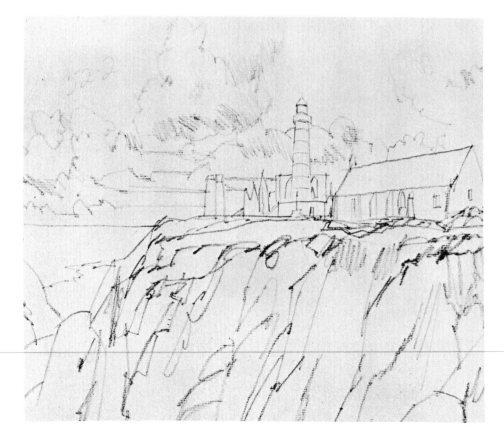

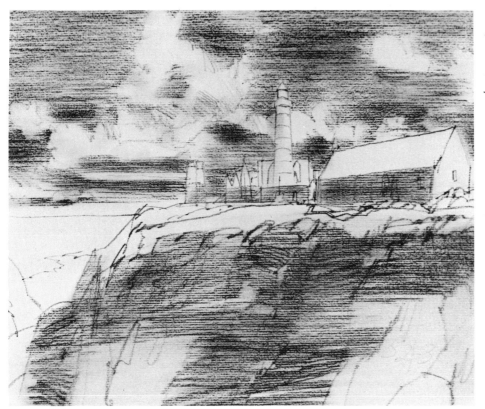

Step 3. *Using a medium 2B grade charcoal pencil, I drew the lighter tones in the sky area. This was done with horizontal strokes that followed the ribbed texture of the paper because the tone could be drawn more uniformly that way. When lines are drawn in the other direction, the paper texture becomes more pronounced. I now added a tone to the buildings, letting the pencil strokes again follow the ribbed texture of the paper. When I drew the tone on the rocky cliff, I used random strokes to achieve a more mottled effect. I used a small rag here over these tones to blend and rub them smooth, but you could use a stump.*

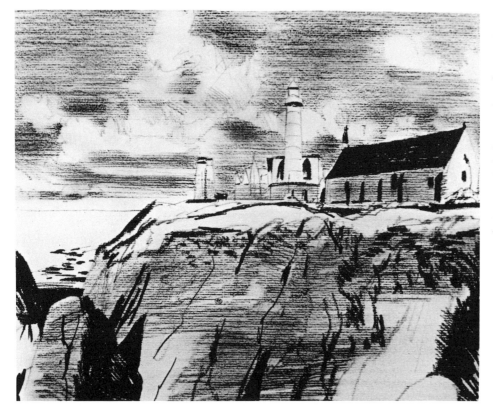

Step 4. *To draw in the darkest tones, I used a soft 4B grade charcoal pencil. This tone was drawn on the shadow areas and also was used to indicate the crevices and other details on the rocky cliff. I drew the roof on the larger building and added the windows. Smaller details and accents were drawn on the lighthouse and other buildings. On the beach in the distance I indicated rocks by using dark pencil strokes.*

Step 5. *I added a tone to the sea in the background using a soft 4B grade charcoal pencil. More dark tones were drawn in the cliff to build up the form. All these tones were blended smooth with a rag. Blending charcoal tones can also be accomplished by using soft facial tissue or even your finger. I rendered the grassy area on top of the cliff, using the same 4B grade pencil, but with more pressure, to produce a near-black tone.*

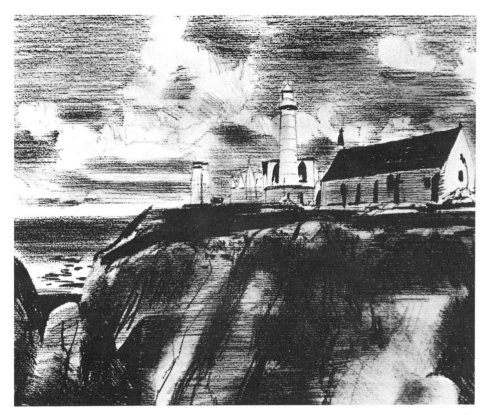

Step 6. *I sharpened the 4B grade pencil, then shaped the point finely with a sanding pad and carefully drew in the darker areas on the clouds. I blended these strokes together as I drew, so they are quite smooth. When a kneaded eraser is properly shaped, it can be used to lift out areas in the gray tones. With a kneaded eraser, I carefully erased the pure white areas you see in the clouds and details such as rocks and highlighted areas from the side of the cliff.*

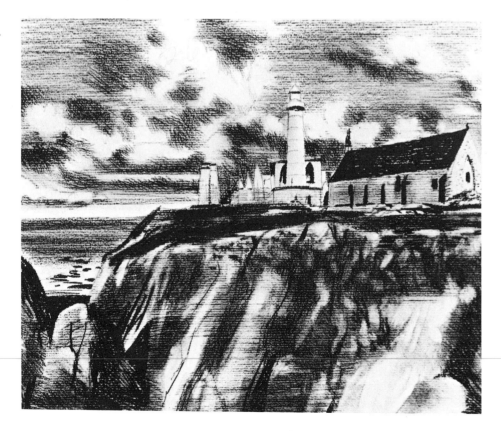

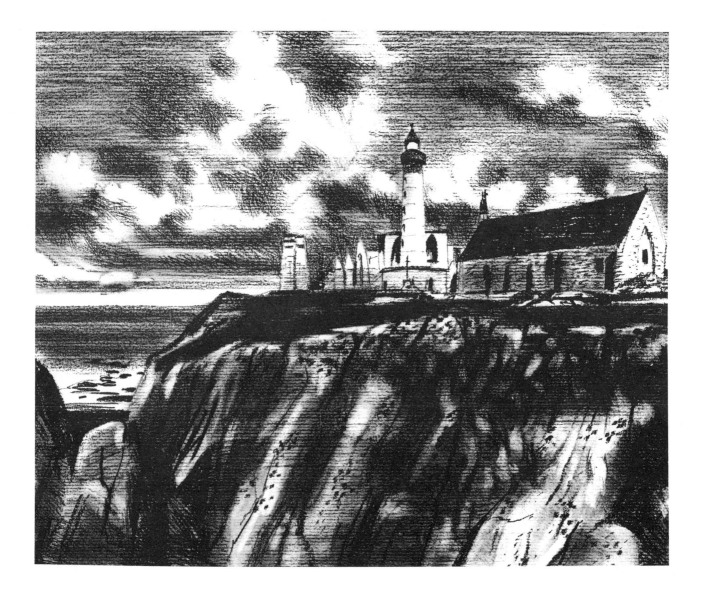

Step 7. *The buildings were finished by drawing in details such as the brick textures and the windows. Working next on the cliff surface, I added more crevices and cracks with finely drawn strokes. Over this, I indicated small bushes using spots of black. Notice how the ribbed surface texture of this paper shows throughout the drawing, creating a very distinctive look. This is another basic pencil drawing technique that can be used for almost any type of subject. The paper is especially compatible for use with charcoal pencils, but chalk, wax, and graphite pencils will also work well on this surface. When you use charcoal or chalk pencils, you can easily remove tones or lighten them with the kneaded rubber eraser. As already mentioned, tones can be lifted out by using the pointed end of a kneaded rubber eraser. Also, keep in mind that charcoal and chalk lines smudge easily. You can avoid smudging by placing a piece of tracing paper under your hand while drawing. On this drawing, I carefully removed the charcoal dust that had accumulated before spraying it with fixative. This dust was removed from the white areas of the drawing with a kneaded rubber eraser. Although it is almost invisible, the dust becomes quite noticeable when sprayed with fixative.*

4
SIMPLIFYING TONES

A GREAT DEAL can be learned about drawing and seeing by separating a scene into two or three values. This procedure can also help make you aware of what not to draw, since this type of simplified rendering requires that you omit many details. Practice this kind of exercise on scenes, still life objects, portraits, and figure studies. When breaking a picture down into simplified tones, remember that the white paper is as important a part of the drawing as the gray tones. You can take a relatively complex scene and greatly simplify it through a careful analysis.

I don't necessarily do a tone breakdown for every drawing, but I do mentally try to view the object or scene in exactly this manner, often making an actual diagram of the breakdown of tones, which helps to make the transition from the actual subject to the finished drawing. You can train yourself to visualize in this way through practice.

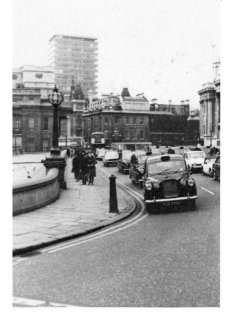

Frequently I use photographs as reference material, since it is not always practical to draw from life. I carry a camera with me in case I see good subjects for picture ideas. Here is a photograph taken in London.

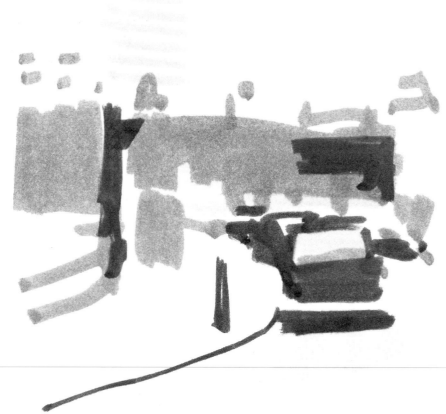

To do a drawing from the photograph at left, I first tried to break down the scene into very simple gray values or tones. Here I used markers to illustrate how this could be done. From this tone breakdown, it is quite easy to do a pencil drawing.

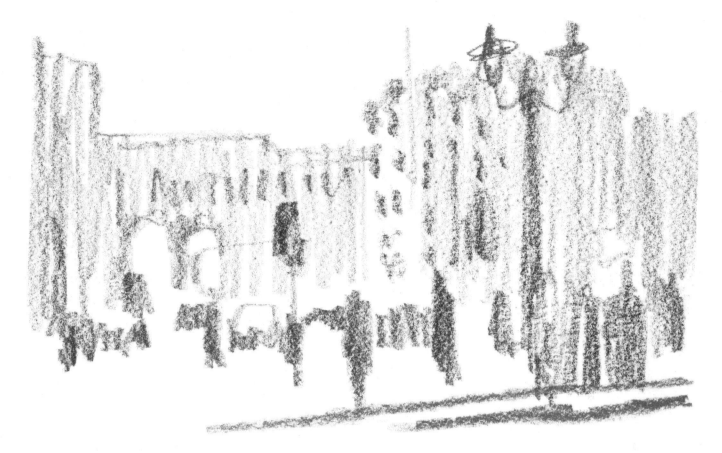

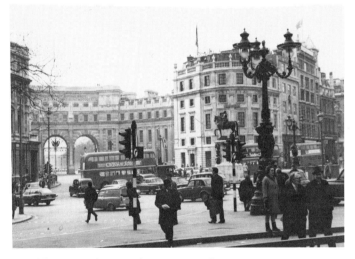

This is another London scene and a good subject for a tone breakdown.

Here is a very simple tone breakdown done on tracing paper with a 4B graphite pencil. This diagram greatly simplifies the subject and is most helpful for the final pencil rendering. These exercises help you not only to translate complicated scenes into simple tones but also to train your eye to see. You can practice drawing these diagrams from photographs in magazines, from your own photographs, or from life. At first, try using only black and two gray tones; then include more tones as you develop. After you get used to doing these sketches with markers, you can start doing them with pencil. Eventually you will be able to look at an object or scene and visualize the tone values without doing a sketch.

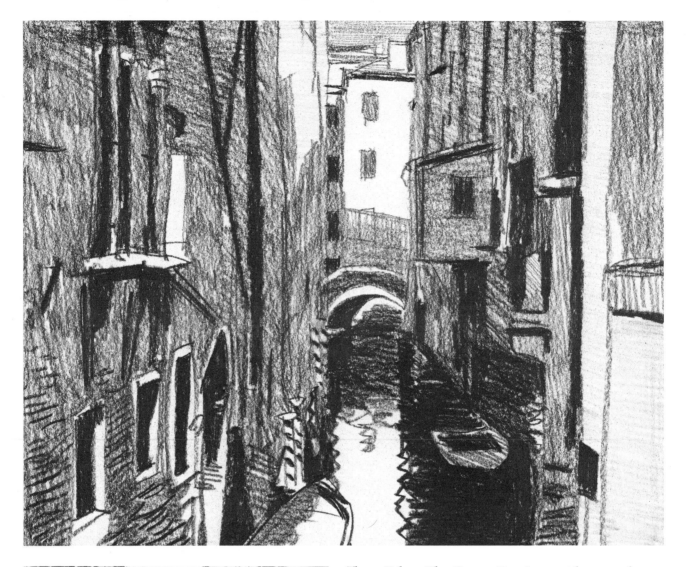

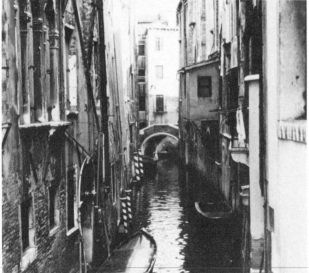

Three Values Plus Paper. *Here is a complex scene that has been broken down into four distinct values: three tones of gray and the white of the paper. I used a 2B grade charcoal pencil for the basic outline drawing, then shaded in all the lightest tones on the buildings. This tone is made up of carefully drawn, even lines. The medium gray, which is the dominant tone in the scene, is added by using strokes drawn randomly, changing direction frequently while drawing. Notice that this method of rendering is different from the technique used for the lighter tone. The darker tone, while still quite uniform, has a different textural quality, which adds interest to the drawing. Next, the black tones are drawn in, as are ripples in the water and various building details. I have determined just where these different tones are drawn by carefully studying the snapshot. You have to do this kind of planning before you render any of the tones on the basic drawing.*

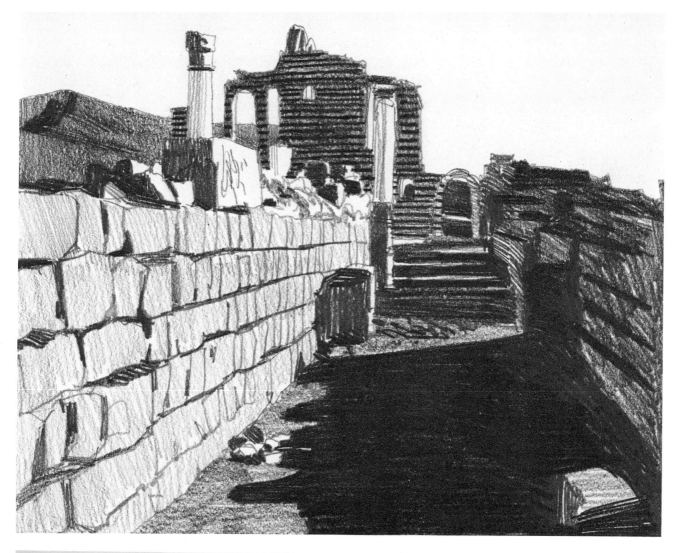

Four Values Plus Paper. *This drawing is more complex than the previous one because there are more gray values to deal with. This means even more planning and careful analysis of the photograph or scene are necessary to achieve a successful drawing. Black-and-white photographs are much easier to translate into simple tones of gray and black, but as you gain experience through practice, you will be able to interpret color scenes into black and gray values. Notice that all the tones in this drawing have been rendered quite simply and that they separate well. The addition of the stone and brick textures makes the drawing appear more complex than it really is. The drawing is done with HB, 2B, and 4B grade graphite pencils on common drawing paper. The lighter tones were put in first with the HB grade pencil; the medium tones, darker tones, and blacks were added next with the 2B and 4B grade pencils. The white sky and other white accents are quite important in this drawing because they provide contrast.*

5
EXPERIMENTING WITH GRAPHITE PENCIL

THE GRAPHITE PENCIL is one of the most commonly used pencils for drawing. Its availability in a wide range of lead grades adds to its usefulness as a fine drawing tool and may account for its popularity with artists.

Graphite pencils can be used in many ways, and numerous examples of possible techniques are illustrated in this section. These techniques can produce varying results, from rough sketches to highly detailed renditions. The drawings have been done on various types of paper with differing textures to demonstrate the variety of work you can do. The various drawing styles range from decorative to hyperrealistic. The techniques cover line, line-tone, line and tone, and dissolved tones. The subject matter includes outdoor scenes, animals, portraits, and figures. Two examples are of the same subject drawn in different techniques for your comparison. One example includes a preliminary sketch, showing how tones in a scene can be translated into simpler tones. Although all the techniques shown may not interest you, it is important for you to be aware of them. Studying the various methods of working and the different rendering techniques will enable you to recognize how a drawing was done.

There are three step-by-step demonstrations included in this section. Each demonstration shows progressive stages in the drawing process. The first demonstration deals with a sketching technique—using a variety of strokes to create and blend tones. The second demonstration shows you how to use flat tones to achieve a decorative effect. The third demonstration covers an interesting technique involving line and line-tone. Using this technique, an artist can create tone with lines.

After studying these demonstrations carefully and reviewing the exercises, you should pick out a simple subject and try one of the techniques. Your drawing can be done from life or from a photograph, if you prefer. If you choose to use a photograph, be sure it is well lit and clear. Otherwise you may have a problem seeing details. I often work from Polaroid photographs, which are rather small. But it is much better to work from larger, 8″ × 10″ (20 × 25 cm) prints when drawing complicated subjects. You can also use good photographs in magazines.

As you try to duplicate the technique here, remember to start with very simple line or sketch techniques and simple subjects. Keep your drawings small. Gradually progress to more complicated techniques and subjects and to larger drawings. If you try to advance too quickly or take on a project beyond your capabilities, you will only become discouraged.

BOULEVARD ST. GERMAIN, PARIS, *9½" × 10" (24.1 × 25.4 cm). This drawing was done on a slightly textured paper surface with a Koh-I-Noor Hardtmuth 350 Negro pencil, grade 2. This pencil is a delight to use, and it became one of my favorites while working on this book. The technique here is quite simple, employing only line with very flat tones. The final effect is rather decorative and lends a certain charm to the drawing.*

Step 1. *Using a medium grade HB graphite pencil, I did my basic outline sketch on common drawing paper. Notice that even though my sketch is loosely done, it is accurate and has correct proportions. As you gain experience and confidence in drawing through practice, you will be able to approach your own work in the same manner. Study the various lines used here to delineate different objects. Notice the smooth, graceful lines I've used for the rocks and hills and the zigzag strokes I've drawn for the foliage.*

Step 2. *Next I indicated the very lightest tones in the scene with an HB grade graphite pencil. The 2B or 4B grades are not the best choice for drawing light tones; their softer leads are more suitable for darker tones. Using the same pressure to ensure an even tone, I carefully drew in the light tones. Lines used to create the tones varied—those used on the bushes were drawn with scribbled strokes, and those on the sky and desert area were done with horizontal lines. Some lines, such as those for the rocks, follow the form, creating the illusion of depth.*

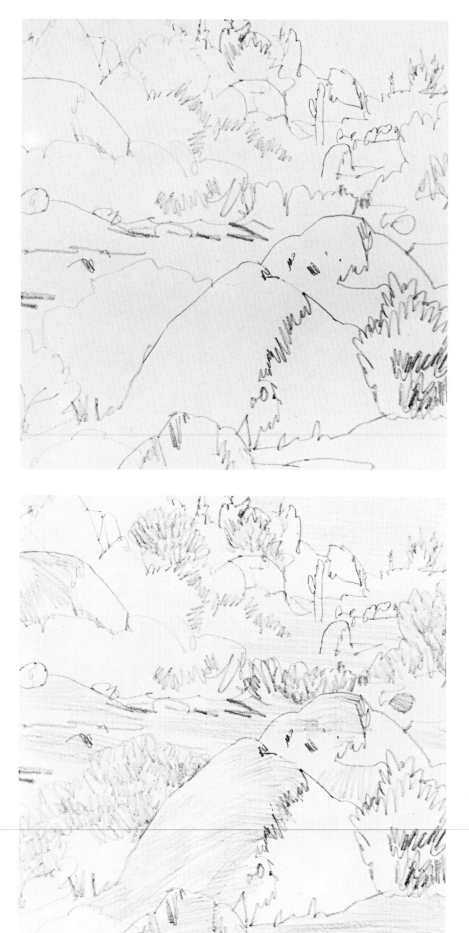

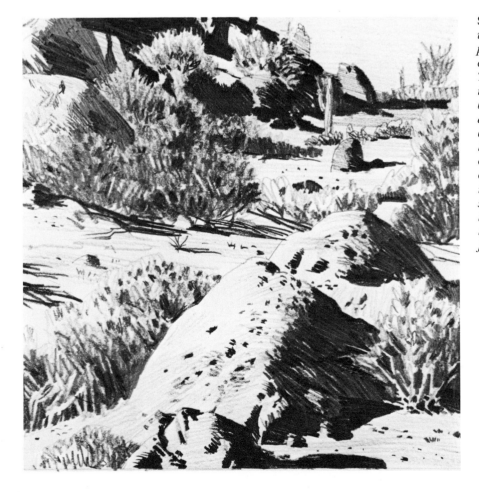

Step 3. *I now drew in the medium tones with the 2B grade graphite pencil, starting with the background rock formations. I used strokes that were evenly drawn and close together, creating a flat tone. While drawing these strokes, I used the same amount of pressure on the pencil. The background hill and trees were drawn using a zigzag line to simulate leaf textures. Notice that on the foreground bushes I was careful to draw around the branch shapes, leaving them as a light silhouette against the darker background.*

Step 4. *At this point, the darkest tones were added with a 4B grade graphite pencil—the best choice because of its capacity to produce very black tones. The background rock area, which is in shadow, was drawn with the solid black, but I was careful to draw around the trees and bushes. I added branches in the trees as well as a lighter tone on the rocks just forward of the background. The darker accents over this area suggested the irregularities inherent in the rocky surface. After placing a few darks in the middle-ground trees, I rendered the shadows of the trees on the desert floor.*

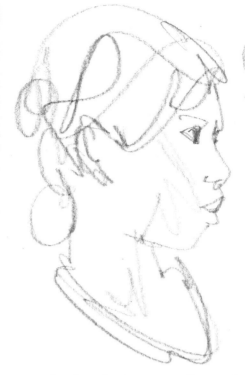 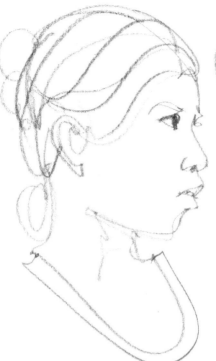 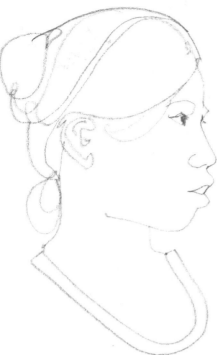

Sketch technique—*usually a quick preliminary, undetailed sketch.*

Loose-line technique—*free drawing but more accurate and detailed than a sketch.*

Contour-line technique—*a more carefully drawn sketch emphasizing contours of subject.*

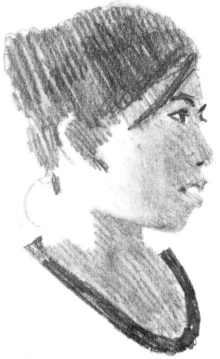 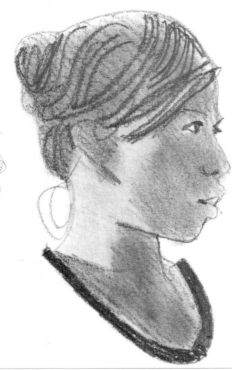

Tone technique—*a drawing done in shades of tone or color rather than line.*

Line-tone technique—*lines drawn closely together to create a tonal value.*

Line and tone technique—*a line drawing combined with tones.*

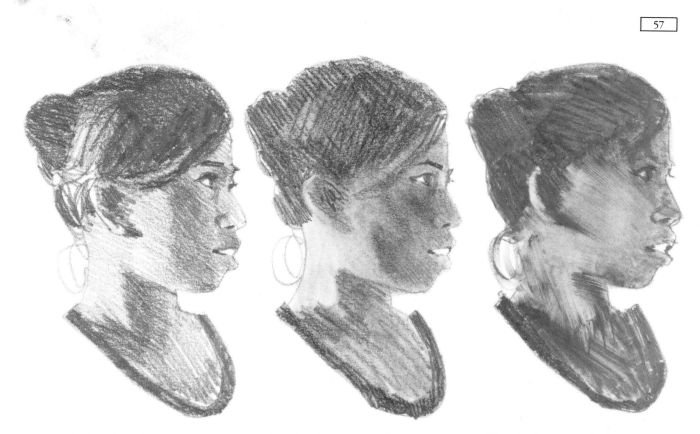

Blended-tone techniques—*two or more gray or color tones blended through rendering.*

Smudged-tone technique—*two or more gray or color tones blended with fingers, a rag, or a rolled paper stump.*

Dissolved-tone technique—*tones or lines dissolved with a solvent.*

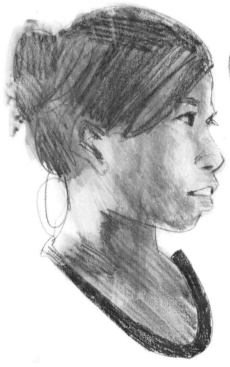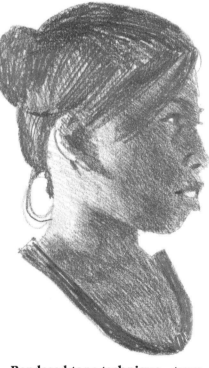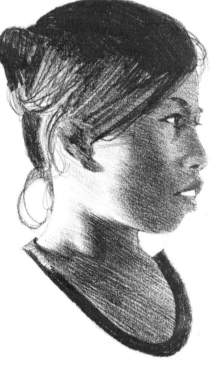

Water-soluble technique—*tones or lines dissolved with water.*

Rendered-tone technique—*tones carefully blended and fused through rendering.*

Tightly rendered tone technique—*a very meticulously rendered drawing that is usually quite photographic.*

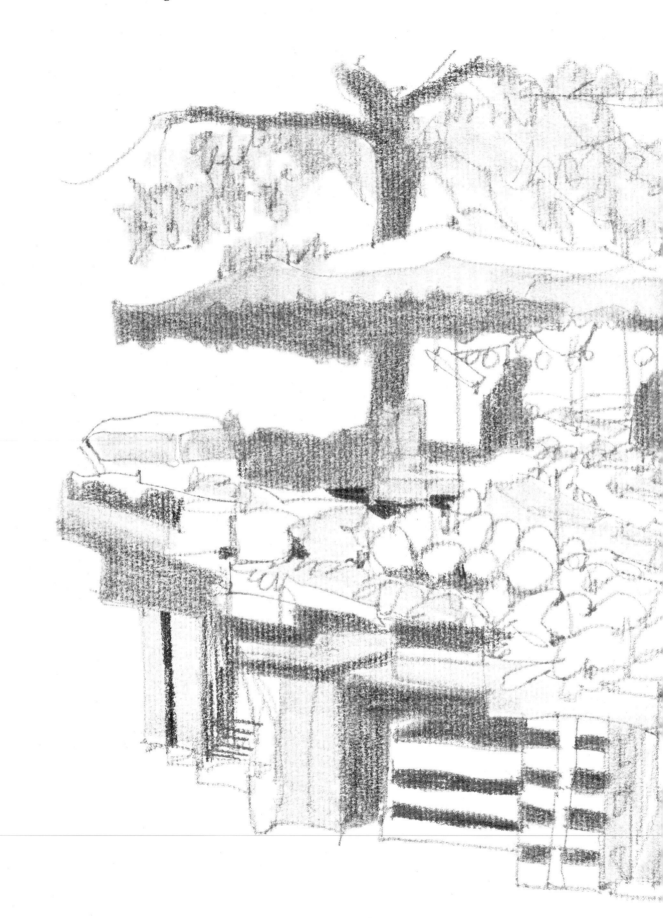

STREET MARKET, RUE MOUFFETARD, *9″ × 13″ (22.8 × 33 cm). This sketch was done with a 2B pencil for the line work and a 4B for the gray tones, which were then rubbed with a paper stump. There are many street markets in Paris, and this is one of my favorites.*

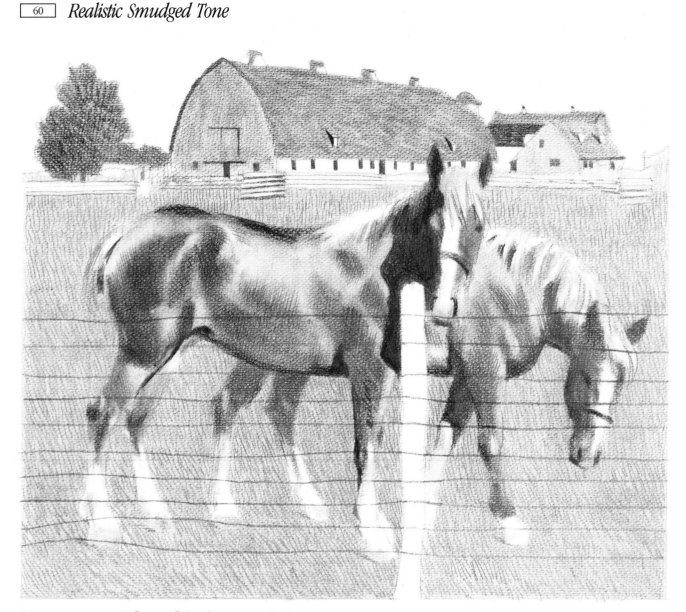

MICHIGAN FARM, *11¼″ × 9¼″ (28.6 × 23.5 cm). This drawing was done on Canson Montigolfier paper using three different grades of pencils—HB, 4B, and 6B. The soft gray tones were created by rubbing the pencil tones with a paper stump.*

QUAI DE BOURBON *(right), 9½″ × 12⅞″ (24.1 × 32.7 cm). An HB pencil was used on a very smooth bristol surface. This illustrates a highly detailed, meticulously rendered drawing technique suitable for many subjects. It is a complex technique that you can master only with a great deal of practice. Many of the lighter values were created by erasing some of the pencil tones with a kneaded rubber eraser. A high-surface bristol paper with a smooth surface is best for this type of work.*

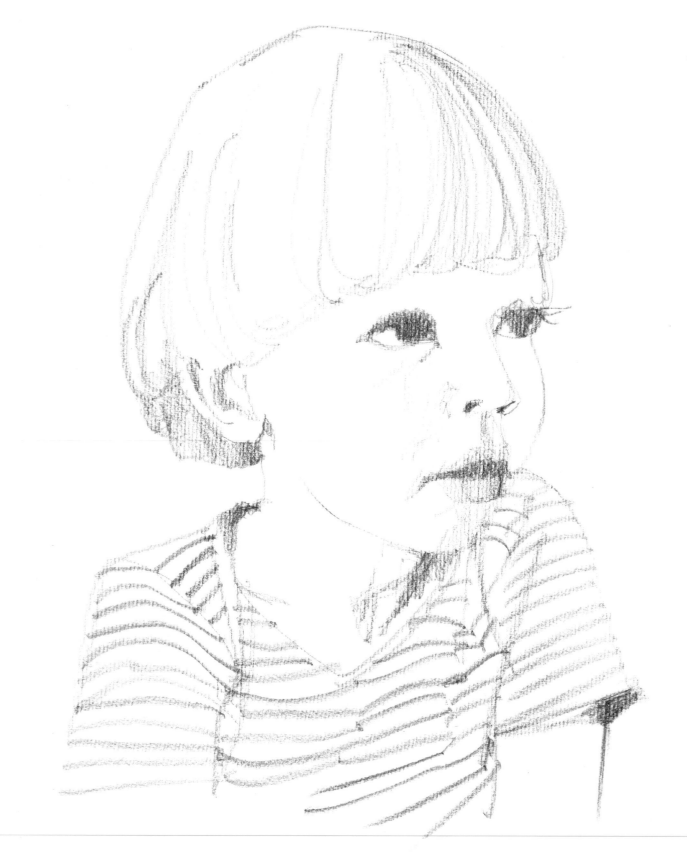

TAVIS, *8⅛" × 11½" (20.6 × 29.2 cm). This study illustrates a nice, free drawing technique that is perfect for sketching portraits. The few tones I used were intended to accent the form of the face. I drew with an HB pencil on Ingres Canson paper.*

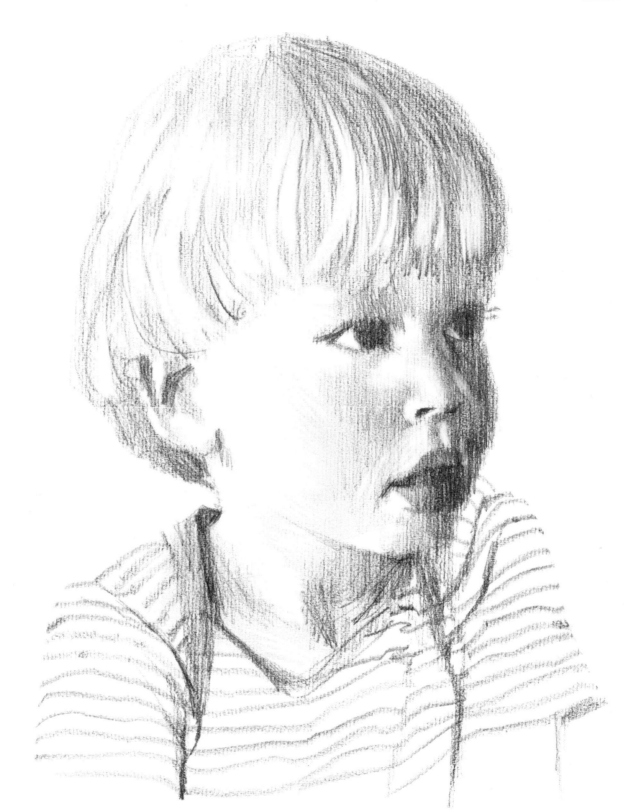

TAVIS, *8⅛″ × 11½″ (20.6 × 29.2 cm). Same model, same pose, but this time drawn in a different technique. This is a much more detailed version, using more tones. I smudged the pencil tones with my fingers and picked out the white highlights with a kneaded rubber eraser—a very effective technique for portraiture. This drawing was done from photographs taken of the model.*

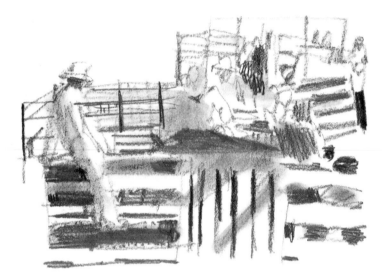

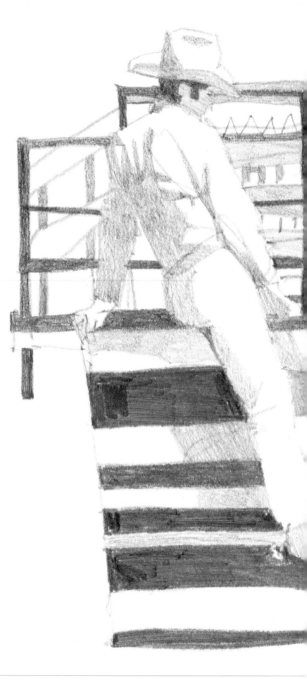

TONAL STUDY FOR A PENCIL DRAWING
*(above), 9⅛" × 6¼" (23.2 × 25.9
cm). Often I make a preliminary study
like this before starting the actual
rendering of a complicated subject.
This helps me to establish not only the
tonal values but the composition as
well. Many problems that can emerge
while you are drawing can easily be
resolved beforehand with this method.
I usually do these rough sketches on
tracing paper with a soft pencil. Here
some of the tones were rubbed with a
rag.*

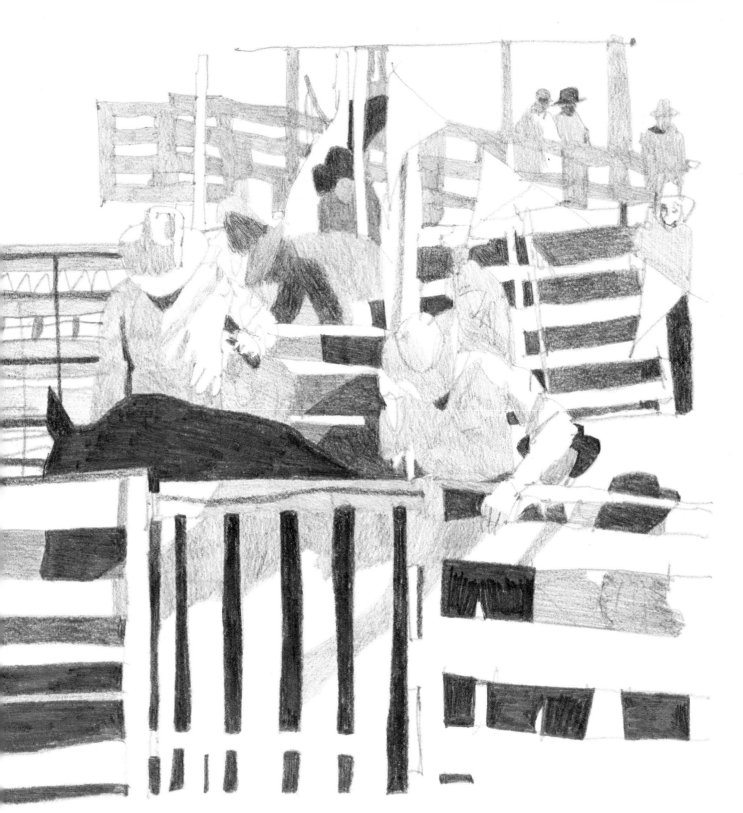

RODEO AT HILLSDALE, MICHIGAN *(right), 14⅞″ × 9½″ (36 × 24.2 cm). Done on Annecy paper with HB, 2B, and 6B grade pencils, this drawing conveys a distinctive design feeling. Notice that I have used only very flat, simple tones, without any blending. This adds to the decorative feeling of the drawing.*

Demonstration 6. *Decorative Line and Smudged Tone*

This demonstration involves an approach that is much more design-oriented than demonstrations. Here, basically flat tones and shapes are used to create a strong visual design.

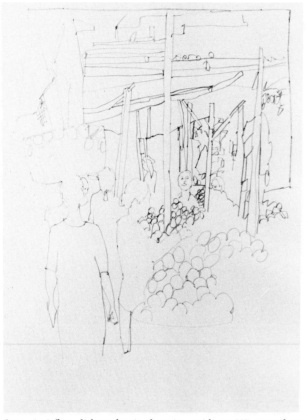

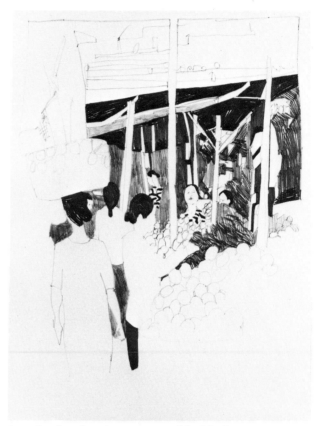

Step 1. *I first did my basic drawing with an HB pencil on a smooth high-finish bristol board.*

Step 2. *After drawing in some of the black areas to establish the middle range of tones, I gradually added more dark tones, using pencil strokes that created interesting textures. I used a 4B pencil for the darker tones and an HB for the lighter values.*

DENPASAR MARKET, *9½" × 11¾" (24.2 × 29.8 cm). To finish the drawing, I used the paper stump to darken skin tones and establish dark tones at the top of the drawing. I also added shadow tones to the foreground fruit and smoothed the background and upper tones. With a 6B pencil, I added some dark shapes to the very top of the drawing for design interest. Local markets make interesting subjects. Keep your eyes open and your camera ready when traveling.*

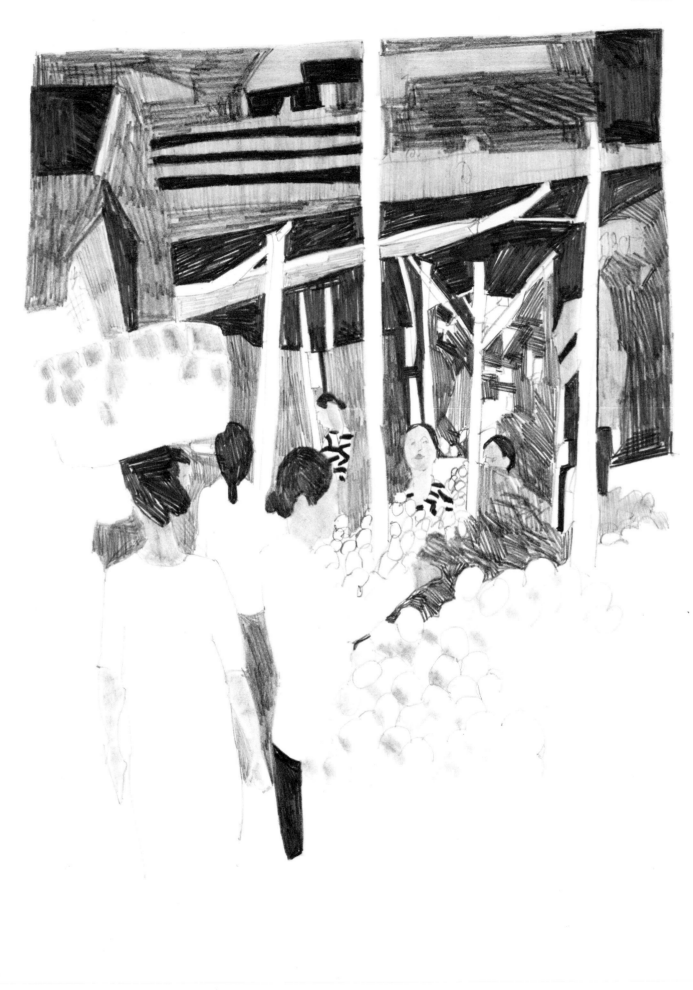

Demonstration 7. *Line-Tone*

As you have seen, line can easily be used to create tones. Individual pencil strokes, when drawn closely together, fuse visually and give the impression of tonal value. Density of tone can be altered by drawing lines closer together or simply by drawing thicker lines. Even pressure can vary the lines, thereby changing the tones. This may seem a little difficult at first, but once you see how it is done, you should have no trouble with this technique.

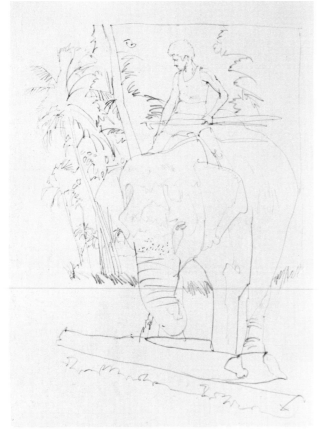

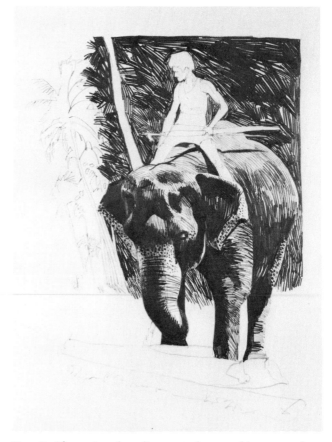

Step 1. *I drew my basic line drawing with an HB pencil on a smooth four-ply Strathmore bristol.*

Step 2. *After using short linear strokes to add tones to the elephant, carefully following its form, and then adding some gray tones with a 4B pencil, I went on to complete the elephant and sharpen up some of the details and shadow areas. I then added dark background strokes, varying their direction to simulate the texture of jungle foliage.*

WORKING ELEPHANT, SRI LANKA, *10¼″ × 14″ (26 × 35.1 cm). My final step was to draw in the palm trees, the Mahout, as the driver is called, and the logs, and to cover some of the jungle background with a light pencil tone. I worked further on the tone in the background area with a paper stump, even drawing lightly over the white. Then I worked a little more on the Mahout, crisping up shadows and muscle shapes, and finishing the drawing.*

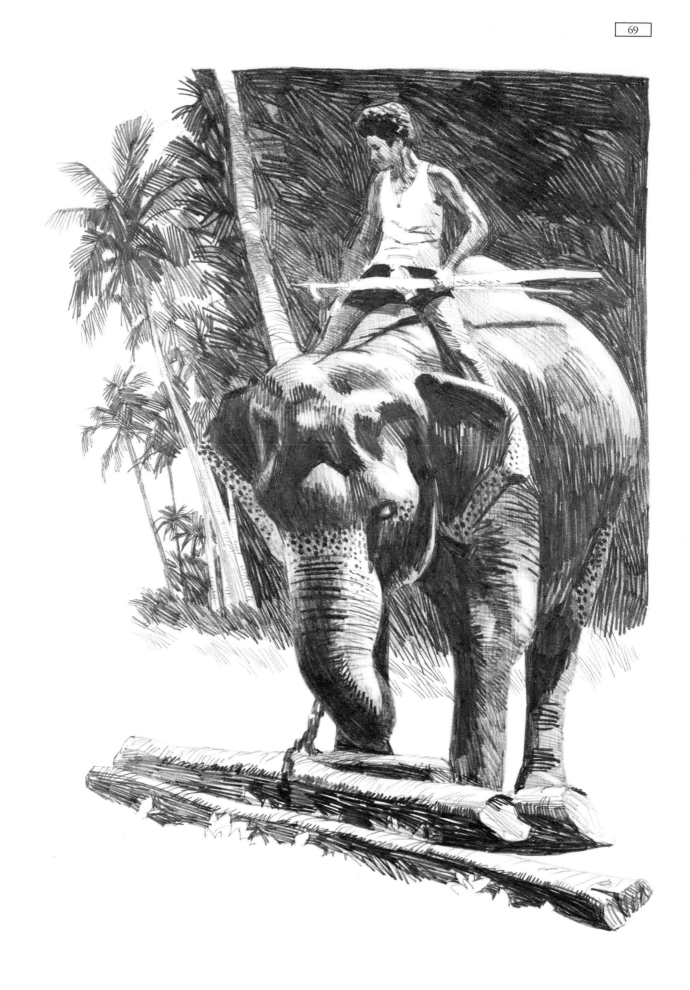

6

EXPLORING CHARCOAL AND PASTEL PENCILS

CHARCOAL PENCILS are excellent to draw with and have always been a favorite drawing tool for many artists. They are, however, a little more difficult to use than graphite pencils. For one thing, since charcoal pencils are a little more fragile, the leads tend to break easier. Such breakage can ruin your drawings. Another reason greater care must be exercised with charcoal pencils is that they create more pencil dust. This dust can make your drawings quite messy. Also, charcoal pencil points wear down more quickly than graphite pencils because the leads are rather soft. Thus, frequent sharpening is necessary.

Nevertheless, charcoal pencils have their advantages. They are generally more suitable for tonal work and for covering large areas. They create a deep black tone, whereas the black tones of graphite pencils have a slight sheen. If you tried the exercises in chapter two, you already know this.

Pastel pencils have very soft leads that break easily. Still, pastel pencils are quite nice to work with and have the advantage of being available in a variety of colors.

Because of their somewhat soft leads, these pencils have to be used with care to avoid smudged drawings. You can prevent smudging by placing a piece of tracing paper under your hand when you work with them.

As in the previous chapter, I will present many examples of drawing techniques for you to study. Examples include such techniques as line, line and tone, loose line and tone, and line and line-tone. A range of viewpoints, from decorative to realistic, will also be covered. The subject matter includes animals, buildings, outdoor scenes, and people. I have also drawn one scene in two techniques for comparison.

There are two step-by-step demonstrations in this section. They cover the use of charcoal pencil and charcoal stick. The first demonstration, which shows an outdoor scene, is done using a tone technique. The second demonstration shows a scene with buildings. It is done with a smudged-tone technique.

I suggest that you examine all the examples and step-by-step demonstrations carefully so that you will fully understand how the drawings were done. Then pick out a simple subject and try to duplicate the techniques that most interest you. You should also try techniques on a variety of paper surfaces so that you can get an idea of the many effects possible. Be careful about the pencil dust and try to keep your drawings clean. Carefully blow the pencil residue off the paper. This will get rid of most of it. You can clean off the remaining dust with a kneaded rubber eraser.

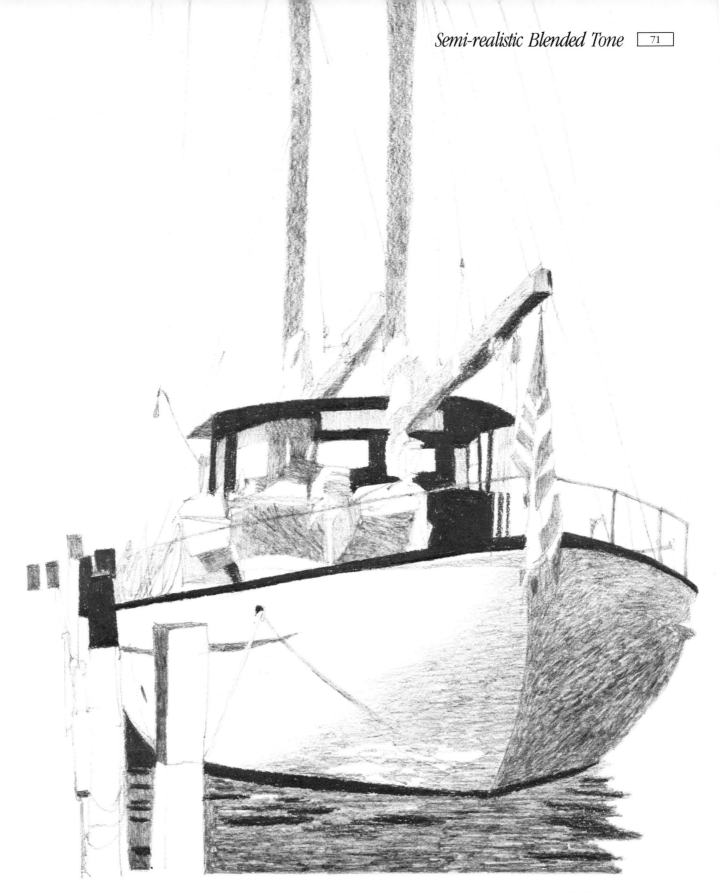

SAILBOAT, LAKE ST. CLAIR, *9⅞" × 12⅝" (25 × 32.1 cm).*
This drawing emphasizes design rather than realistic
rendering. It is basically a simple tone drawing with the
addition of a few intermediate grays. It was done on a
slightly textured bristol paper with an HB grade General
charcoal pencil for the outline drawing and a 2B and a
4B grade pencil for the tones.

Demonstration 8. *Working with Charcoal Pencil*

Step 1. *I began by freely drawing an outline sketch, using a 2B charcoal pencil on common drawing paper. This paper surface works well with charcoal as do the rougher surfaces. I drew in the larger foreground trees, then added the roots and foliage around them. Next, I indicated the middle-ground trees. The background trees were done by drawing vertical strokes. I indicated the sunlit areas on the forest floor. This helped me when I later added the tones to that part of the scene. I also drew in the sunlit areas on the foreground trees. The basic drawing was then ready for the addition of tones.*

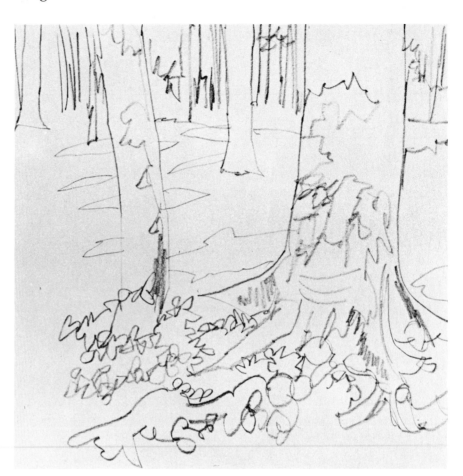

Step 2. *With the 2B grade charcoal pencil I carefully added a very light tone to the background area using horizontal strokes. I next drew in a medium gray tone in the foreground area, drawing these strokes at slightly different angles to create a surface texture. Notice how carefully I worked around the tree trunks and roots. A slightly darker gray tone was added to the middle-ground part of the forest floor. Next, I drew around the sunlit patches on the ground, using short pencil strokes. The difference between the two gray tones was now evident.*

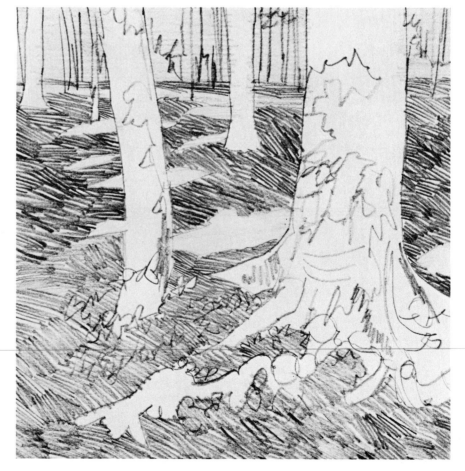

Step 3. *Here, the darkest tone was added, using a softer 4B grade charcoal pencil. I drew the shadow areas on the tree in the foreground and indicated the bark texture with curving horizontal lines. The direction of these strokes helped create the illusion of form and added an interesting texture to the drawing. I filled in the shadow area on the other foreground tree and delineated the bark texture with vertically drawn lines. A slight texture was drawn into the sunlit part of the forest floor, with short strokes drawn at different angles. Then I indicated small black areas in the background.*

Step 4. *Using the 4B grade charcoal pencil, I began to pattern the shadows of the leaves on the forest floor. I used short curved strokes drawn in different directions to create a varied, uneven surface. Notice that the leaf texture in the foreground is much larger than that in the background; this heightens the illusion of distance and perspective. Remember to be careful not to smudge or smear your drawing. As I work, I frequently remove surface charcoal dust by gently blowing it off the paper surface. I remove the remaining dust with a kneaded rubber eraser.*

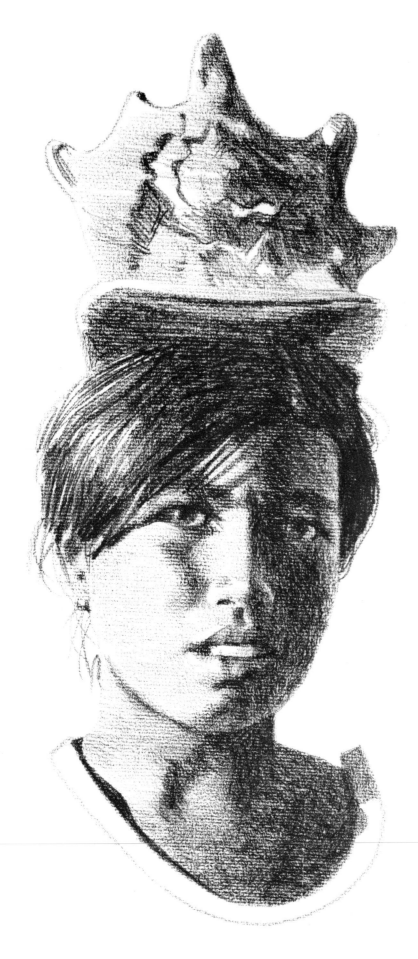

SUKRI, *6¼″ × 14¾″ (15.9 × 37.5 cm). This realistic portrait of a Balinese girl was done on a textured paper—MBM Ingres d'Arches—with a Conté à Paris 728B charcoal pencil. I began, as usual, by first doing my basic drawing in light outline. Then I carefully built up the intermediate gray tones. This girl was selling shells on the beach in Bali, and she always carried a large shell on her head.*

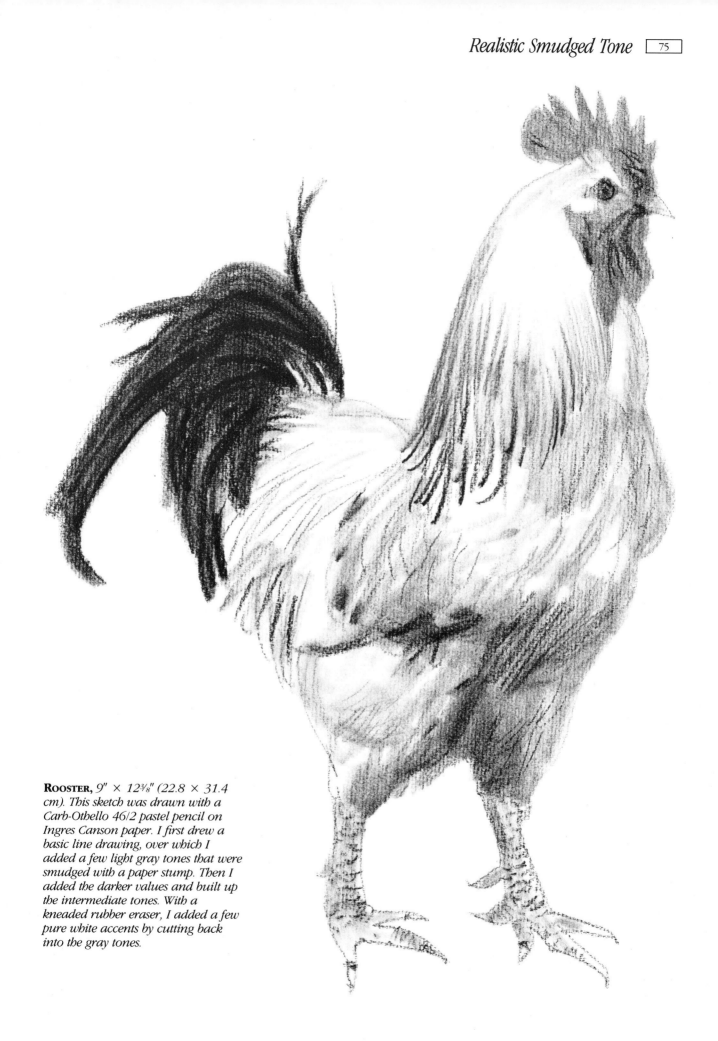

ROOSTER, *9" × 12⅜" (22.8 × 31.4 cm). This sketch was drawn with a Carb-Othello 46/2 pastel pencil on Ingres Canson paper. I first drew a basic line drawing, over which I added a few light gray tones that were smudged with a paper stump. Then I added the darker values and built up the intermediate tones. With a kneaded rubber eraser, I added a few pure white accents by cutting back into the gray tones.*

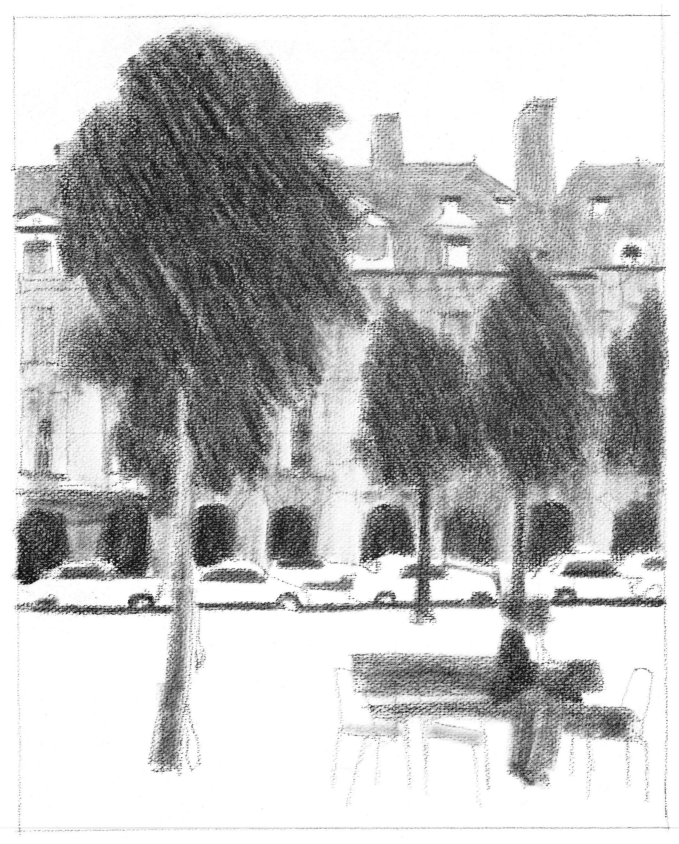

PLACE DES VOSGES, *9½" × 11½" (24.2 × 29.2 cm). This tonal sketch was drawn on Canson Montigolfier paper with a Carb-Othello 46/2 pastel pencil. The tones were smudged with a rolled paper stump.*

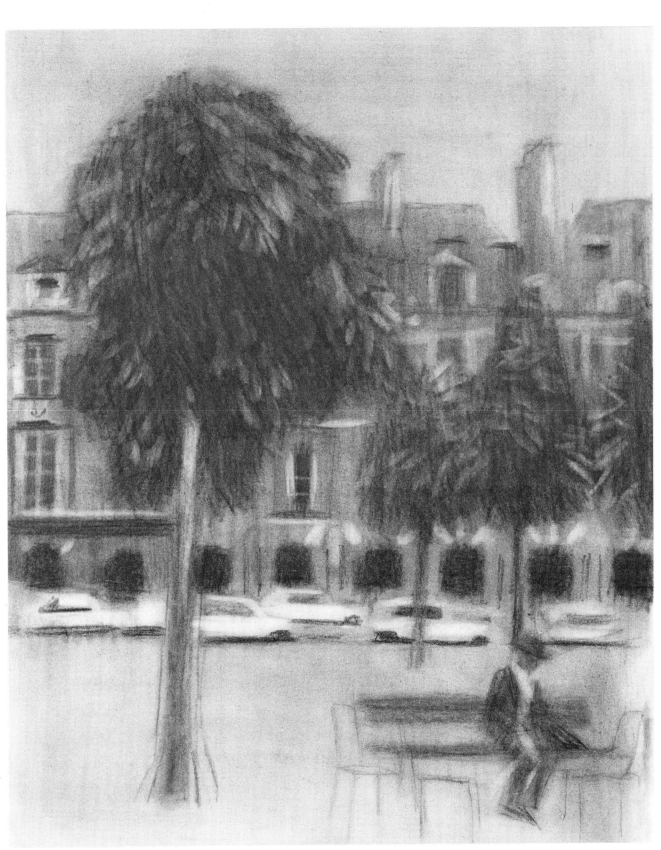

PLACE DES VOSGES, *9½" × 11½" (24.2 × 29.2 cm). As in the previous drawing, a Carb-Othello pastel pencil was used but this time on a smooth paper surface. The pencil tones were smudged with my fingers, a paper towel, and a paper stump. The highlights were created with a kneaded rubber eraser by lifting out some of the darker tones.*

Demonstration 9. _Composing in Realistic Smudged Tone_

With a minimum of lines you can produce a drawing composed entirely of tones. This is a good technique for a great many subjects, especially when you want to capture a mood.

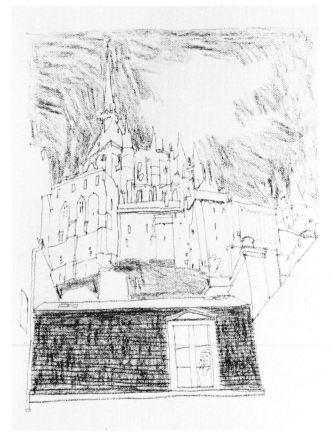

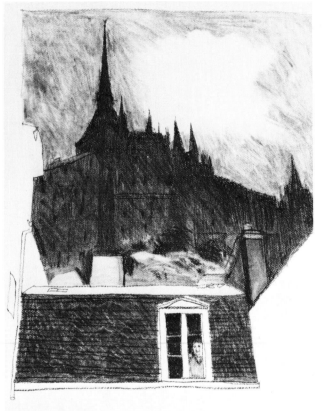

Step 1. _I began my drawing by doing a very careful line rendition of the subject with a 2B charcoal pencil sharpened to a fine point. I next added a few basic tones._

Step 2. _To create an interesting texture, I smudged the tones with a paper stump and then added a dark tone over the background building with the charcoal stick. After rubbing this tone with a rag, I used a kneaded eraser to work on the cloud shape, trying to create a feeling of movement there. One can learn to draw with this unique eraser, since it assumes such varied forms. I worked with it to erase sections of the ground just above the foreground roof._

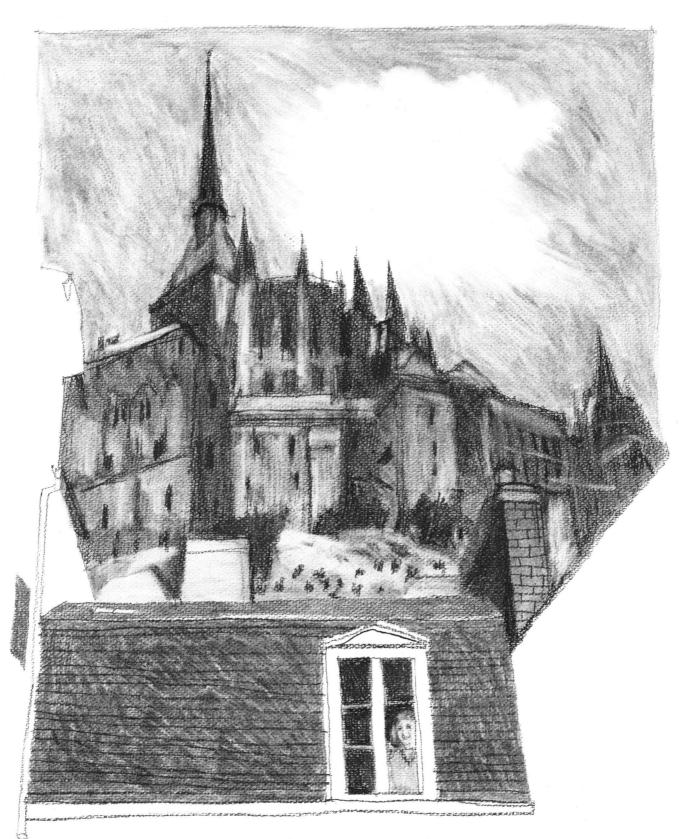

MONT ST. MICHEL, *11¼" × 13¼" (28.6 × 34 cm). Next I added details to the background buildings with a 2B charcoal pencil. Then I picked out more highlights with the kneaded rubber eraser and indicated some foliage on the hill. I finished the drawing by putting in the brick texture on the chimney and adding tone to the foreground roof.*

7
USING WAX PENCILS

THE TERM WAX PENCIL describes a wide variety of both black and colored pencils with waxlike leads. Some pencils in this category are available in degrees of hardness, but most come in only one grade. Black wax-type pencils are generally good for drawing jet-black tones, something difficult to do with most graphite pencils. A good brand is the Koh-I-Noor Hardtmuth Negro pencil. However, these pencils are difficult to erase, so plan your drawings carefully. Most wax pencils work best on very smooth paper, although they are not limited to these surfaces.

The examples presented in this chapter illustrate a sketching technique, line and tone, tone, line-tone drawing on colored paper, and a water-soluble technique. All the drawings are done on a variety of paper surfaces, and the subject matter includes animals, figures, and outdoor scenes. In one case I have drawn the same subject twice, using two techniques. The first example is drawn on a white, textured paper; the other is done on a colored paper, using both black and white pencils.

Following the examples of techniques is a step-by-step demonstration. It deals with the use of a water-soluble pencil technique.

Try to experiment with all of the techniques shown in this chapter.

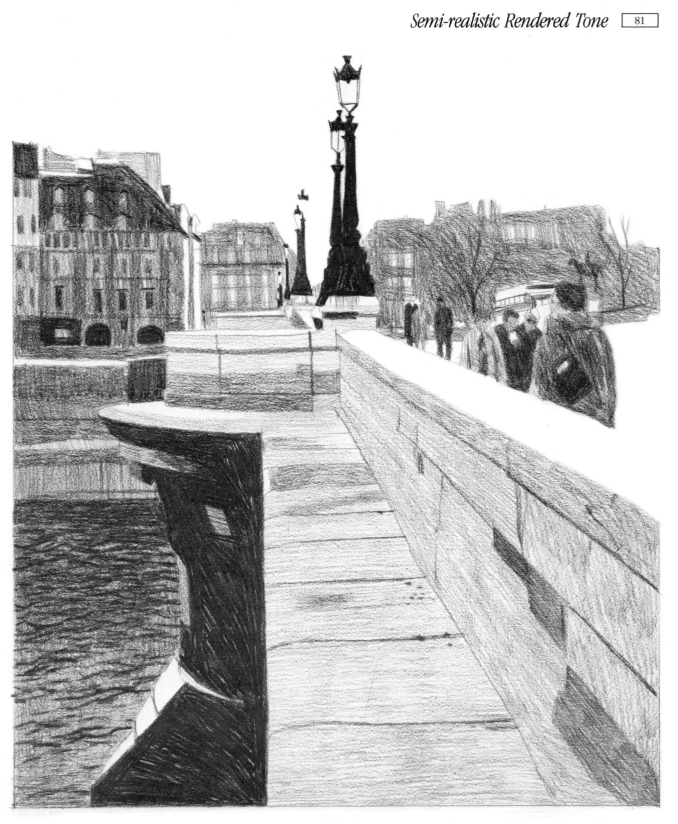

Pont Neuf, *10¼" × 11½" (26 × 29.2 cm). This drawing of my favorite bridge in Paris is basically a tonal rendition. Here I used the Koh-I-Noor Hardtmuth Negro pencil on a smooth, high-finish Strathmore four-ply bristol board. I began by first drawing in the darkest areas and then adding the intermediate and lighter tones.*

MISTY, *9″ × 11¼″ (22.8 × 28.6 cm).*
For this sketch I used a Stabilo All
8046 pencil on a smooth bristol
paper. Certain wax-type pencils such
as this one work well on this kind of
surface. Here I made no attempt to
achieve smooth tones, since I wanted
to create a textural effect with the bold
pencil strokes themselves.

REFLECTIONS *(right), 10⅛″ × 13⅜″ (25.7 × 36.6 cm). The Koh-I-*
Noor Hardtmuth Negro pencil is great to work with because with
it you can achieve a wide range of gray tones as well as jet
black. The highly detailed and meticulously rendered technique
shown here is rather difficult and time-consuming especially for
the beginner. Therefore, it is very important to have good
reference material when attempting a drawing like this. Since it
is difficult if not impossible to do such a drawing on the spot, it is
best to work from photographs.

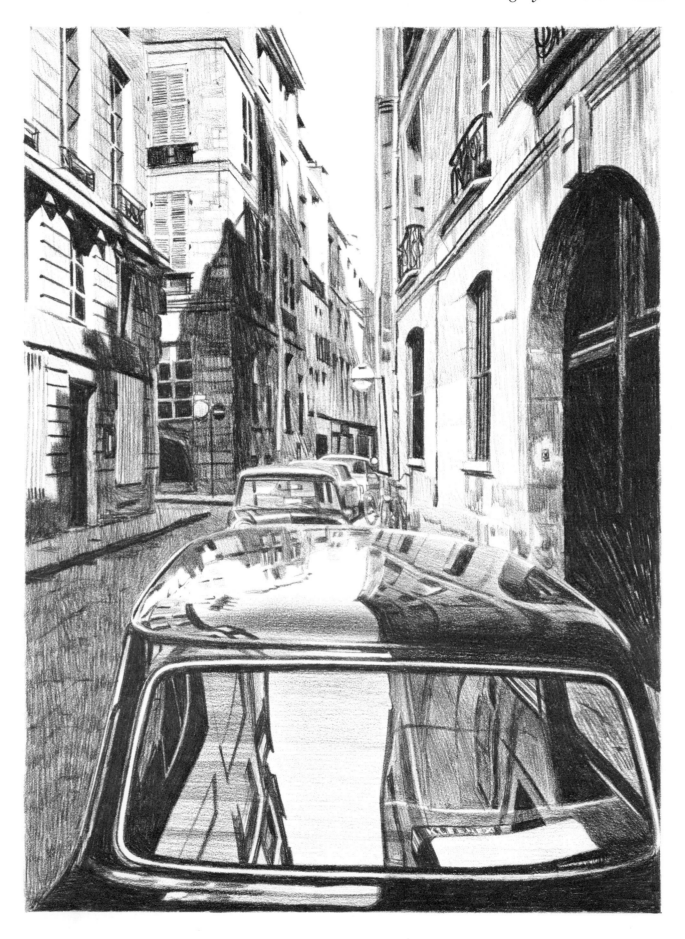

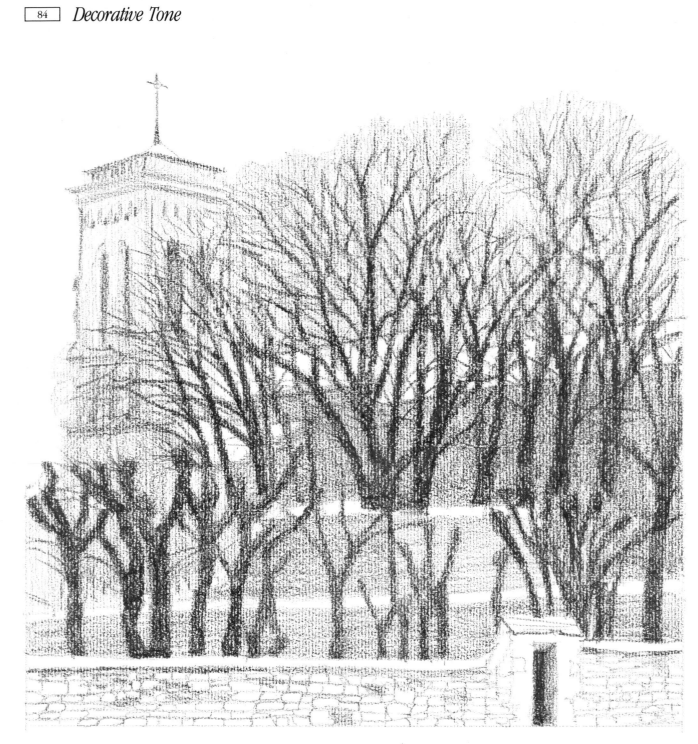

CHURCH AT VEZELAY, *11" × 11" (28 × 28 cm). Drawn on Ingres Canson paper with a Stabilo All pencil, this rendition is primarily made up of just tones.*

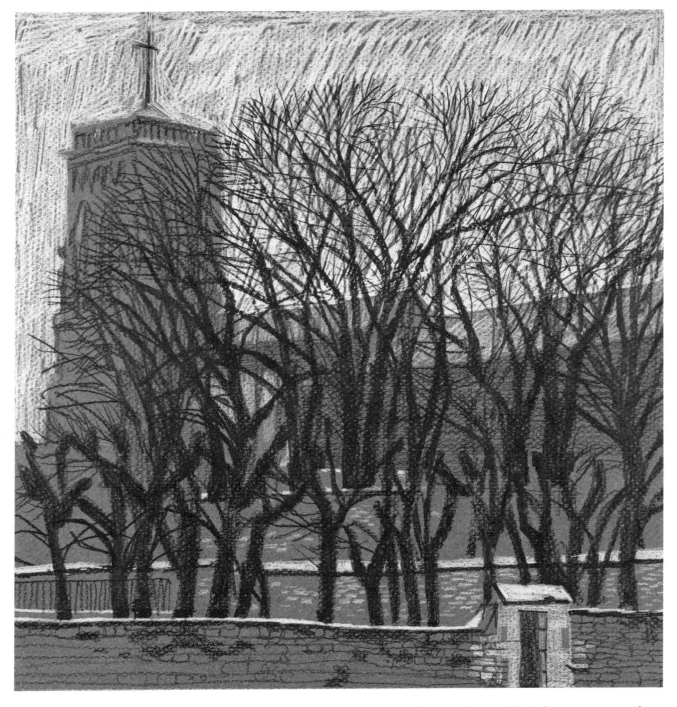

CHURCH AT VEZELAY, *11" × 11" (28 × 28 cm). This is the same scene as the previous example, but this time it is done in a different technique. Here I used an Eagle Verithin 734 white pencil and a Koh-I-Noor Hardtmuth Negro pencil on colored paper.*

Demonstration 10. Decorative Water-Dissolved Tone

The Stabilo All pencil, which works very well on smooth-surface papers, can also be used on very rough-textured papers such as those made for watercolor. This technique is especially good for sketching on the spot.

Step 1. *I used Arches paper mounted on a watercolor block of twenty-five sheets and the Stabilo All number 8046 pencil for this drawing. I added some tones in the background foliage and put a few darks in the vehicles as well as in the shadow areas after making my basic line drawing.*

Step 2. *With a watercolor brush—a red sable—I washed clear water over the mountain areas, dissolving the pencil tones into a dark wash.*

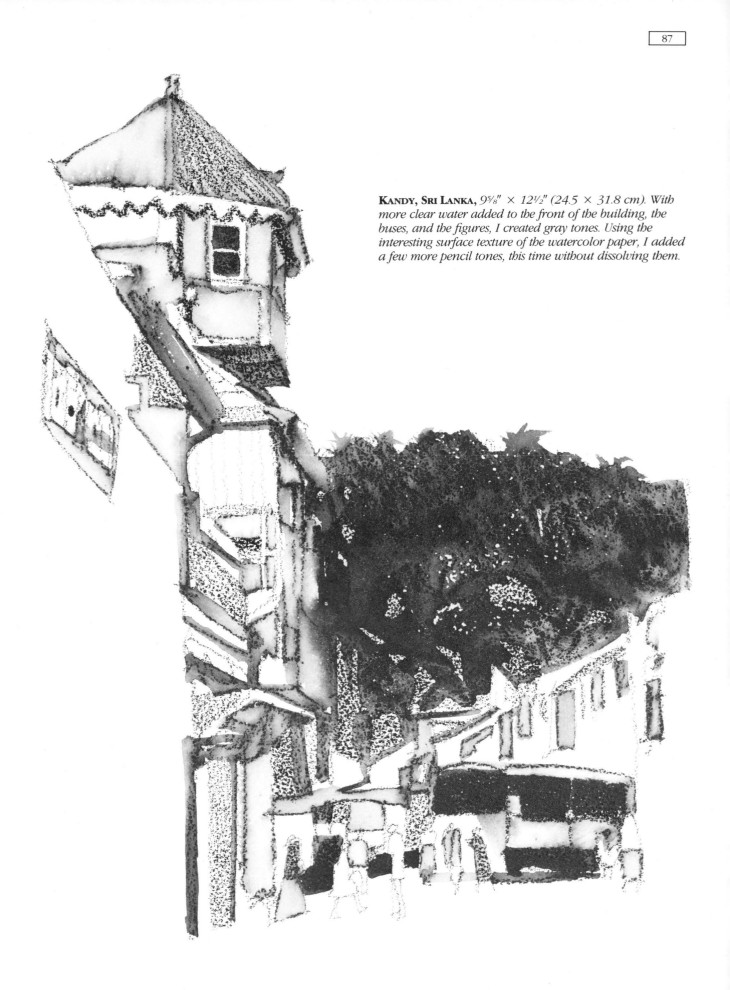

KANDY, SRI LANKA, *9⅝" × 12½" (24.5 × 31.8 cm). With more clear water added to the front of the building, the buses, and the figures, I created gray tones. Using the interesting surface texture of the watercolor paper, I added a few more pencil tones, this time without dissolving them.*

8

ADDITIONAL TECHNIQUES: SCRIBBLING, HATCHING, DISSOLVED TONE, SUBTRACTIVE TECHNIQUES

TRYING DIFFERENT TECHNIQUES or combining pencil drawing with other mediums offers unlimited opportunities for experimentation. In this chapter, I will demonstrate a number of approaches to creating variations on the basic drawing skills already explored in this book. My first example is a realistic line and acrylic paint combination. As you can see, the effect produced is unusual. Next, I will show you four drawings of the same subject done in very different styles, using line, tone, stylized rendering, or detailed realistic drawing. The two step-by-step demonstrations that follow show the scribbling and the hatching techniques; in the first instance, I used a

wax pencil on rough watercolor paper, and in the second, an HB grade graphite pencil and a 2B and 4B grade pencil on a smooth surface. The third demonstration shows a dissolved-tone technique, worked on rough watercolor paper, with HB and 4B grade graphite pencils and a cloth dampened with turpentine. In the example of the subtractive technique, I worked with an HB and a 4B grade charcoal pencil on charcoal paper, and used a kneaded eraser to accomplish the goal. These examples can set your mind in other directions as well. Although these are not major techniques, they are interesting and certainly merit consideration.

Line Dominates. *This line drawing was done on common drawing paper with HB, 2B, and 4B grades of graphite pencil. Tonal areas were created through drawn lines without blending. The direction of the lines suggests planes or texture, as you can see in the water and grass areas.*

Tone Dominates. *I used an HB grade charcoal pencil on common drawing paper for the lightest tones and a 2B grade charcoal pencil for the medium grays. All the tones were carefully blended pencil strokes, sometimes created by rubbing with my finger. Blacks were added with a 4B grade pencil.*

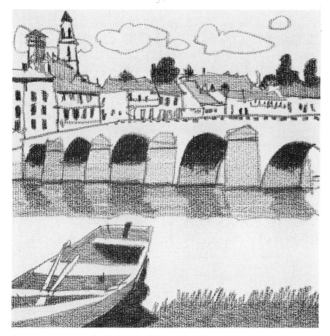

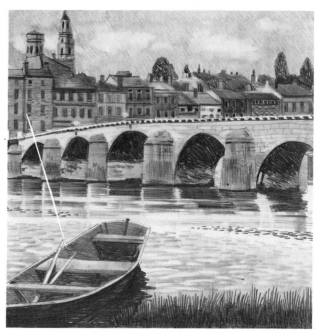

Decorative Style. *This highly stylized rendition was drawn with a wax pencil on charcoal paper. The light gray tones were drawn in by lightly stroking the pencil across the paper, using an even controlled pressure to ensure a flat tone. Black accents were added later.*

Sharp Focus Realism. *Here I used an HB, 2B, and 4B grade graphite pencil on smooth paper, a combination best for finely detailed work. For this realistic drawing, I built up the tones gradually, then carefully blended them with a piece of paper tissue. I picked out white accents with a kneaded rubber eraser.*

BALINESE CHILDREN *(left), 9¼" × 12" (24.8 × 30.5 cm). I mixed a gray tone from black and white acrylic paint and applied it to a canvas surface. I used a black Prismacolor pencil for the basic drawing and a white Stabilo pencil for the light accents.*

Demonstration 11. *Scribbling Technique*

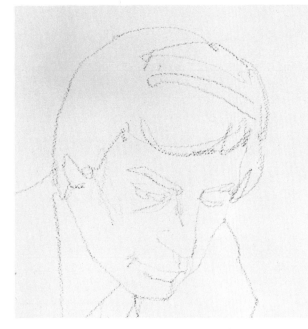

Step 1. *With a wax pencil I did a quick, basic outline sketch on rough watercolor paper using boldly drawn lines. I clearly defined the elements in the head and face. Some of the areas where the shadows would fall were indicated. Even a spontaneous sketch technique such as this required planning.*

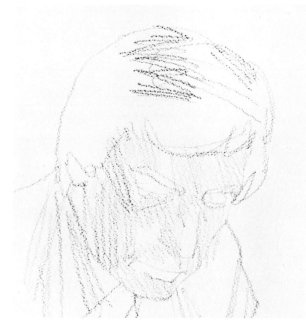

Step 2. *A light tone was added over the shadow areas of the face with quickly drawn pencil strokes. A light tone was also used on the highlight area of the hair, then shadow tones were drawn on the shirt. The tones appeared consistent because the same pressure had been used throughout.*

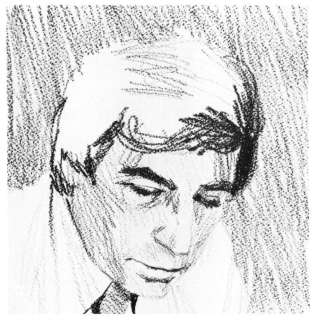

Step 3. *I added a medium tone to the background with quickly drawn, scribbled strokes. A few darker accents, such as the eyes and eyebrows, were used on the face and also on the hair. I drew in the shadow area under the tie and collar.*

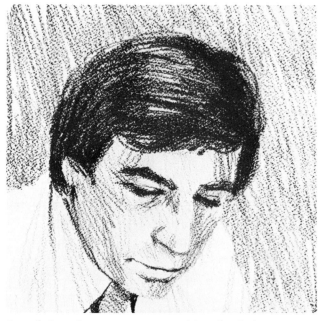

Step 4. *I used more pressure to achieve the dark tone in the hair. As I completed the hair, I followed the form and shape of the head. I sharpened the pencil to a fine point with a razor knife to draw in finer details more easily. For more contrast, I deepened the tone on the left side of the face.*

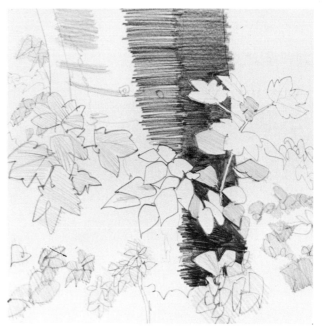

Step 1. *Because the hatching technique of drawing usually involves the use of finer lines, the ideal choice of paper is a smooth surface. This drawing was started by doing a sketch in outline form, first delineating the tree trunk, then the leaves, and finally the other foliage, using a sharpened HB grade graphite pencil.*

Step 2. *With a 2B grade pencil, I indicated light tones, using lines on the leaves to render shadow areas. With short, horizontal strokes, I added light tones to the left side of the tree and medium gray tones to the right side by using appropriate pressure. Notice that I drew around the leaves and stems, silhouetting them against the background.*

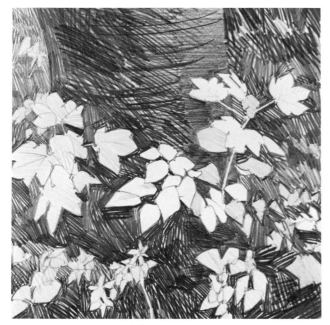

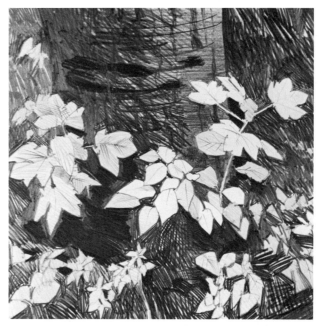

Step 3. *I drew in the background using random pencil strokes, applied with different pressure to create tonal variation. Random strokes were also used on the dark side of the tree, some of them drawn over one another in a crosshatch effect. Bark texture was created with horizontal curved strokes.*

Step 4. *For the darkest tones, I used a 4B grade graphite pencil. I added black tones on the dark patches of the tree trunk and in the shadows from the leaves, and toned down white areas in the background by drawing over them. Notice the various hatched tones I used to darken the leaves and deepen the shadows.*

Demonstration 13. *Working with Dissolved Tone*

Step 1. *This drawing was done on rough watercolor paper, which is the best paper to use for washes or dissolved-tone techniques. The pencils that can be dissolved the easiest are graphite or wax pencils. For the basic outline drawing I used a soft 4B grade graphite pencil, quickly sketching the scene and indicating a few gray tones. The lines helped characterize the various elements. Notice that the smooth, curved lines depicting the beach contrast nicely with the textural lines in the foliage on the mountain. The lines of the bushes and trees not only outline these objects but create a texture as well.*

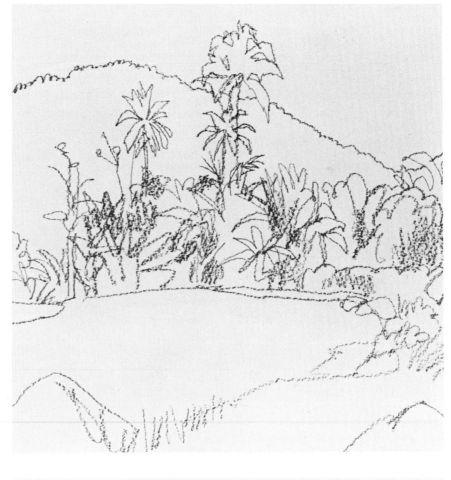

Step 2. *With an HB grade graphite pencil, I drew a light tone across the surface of the lagoon using horizontal strokes, which create the feeling of the water surface. Dark tones were added over this light tone with a 4B pencil to indicate reflections. Next, the background mountain was rendered by filling in the area with vertically drawn strokes, using the 4B grade pencil and the vertically drawn strokes emphasize the mountain's height. I indicated a few darker trees, then drew in the foreground grassy area using randomly drawn strokes. The shadow tones were drawn on the rocks in the foreground.*

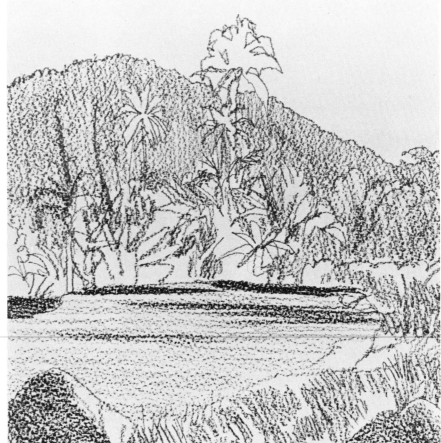

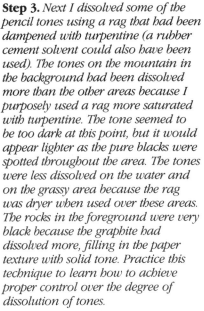

Step 3. *Next I dissolved some of the pencil tones using a rag that had been dampened with turpentine (a rubber cement solvent could also have been used). The tones on the mountain in the background had been dissolved more than the other areas because I purposely used a rag more saturated with turpentine. The tone seemed to be too dark at this point, but it would appear lighter as the pure blacks were spotted throughout the area. The tones were less dissolved on the water and on the grassy area because the rag was dryer when used over these areas. The rocks in the foreground were very black because the graphite had dissolved more, filling in the paper texture with solid tone. Practice this technique to learn how to achieve proper control over the degree of dissolution of tones.*

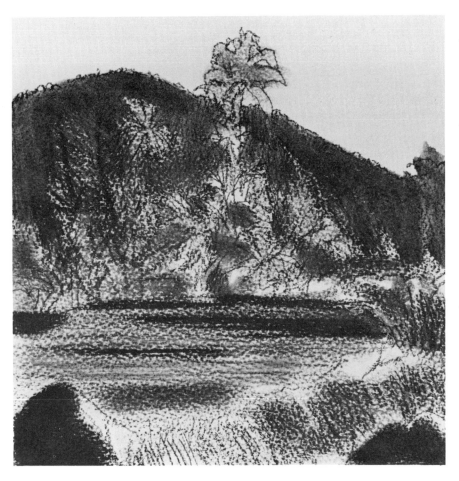

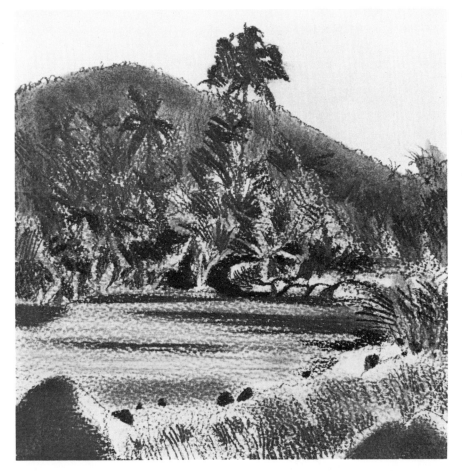

Step 4. *The 4B grade graphite pencil was used to draw in the foliage details and the tree shapes in the background. These solid black tones produced definition and form in this area. I drew in some rock shapes along the far edge of the lagoon, then added a few bits of foliage on the foreground beach at the right. A series of smaller rocks, drawn using solid black, helped to separate the beach from the water. This is an interesting technique, one well-suited to outdoor sketching, and it can be used to draw a variety of subjects. It is naturally more suited to outdoor scenes that include trees and foliage rather than those that include architectural subjects. Portraits and figure studies also make good subjects for this technique.*

Demonstration 14. *Subtractive Technique*

Step 1. *This technique is unique as it involves the removal of tones from a drawing with a pliable, kneaded rubber eraser. Since this type of eraser can be formed into any shape with the fingers, it can be used to erase small areas or even to create white lines. The charcoal pencil, used on charcoal paper, is best for this technique. I first drew a basic outline, with an HB grade charcoal pencil, then I drew a gray tone over the whole picture area with a 4B grade charcoal pencil. This tone was then smoothed out by rubbing it with a rag. I left the area on the far right unsmudged so that you can see how the pencil strokes were applied.*

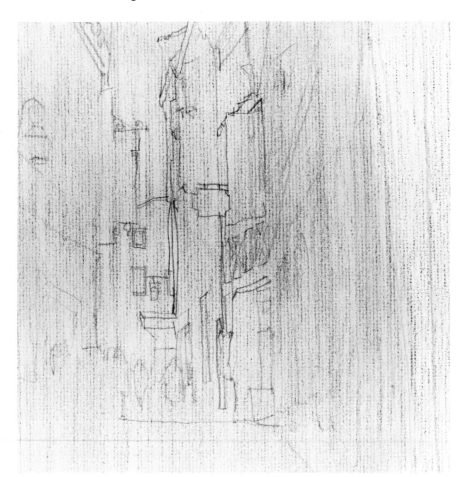

Step 2. *Next I added the very dark tone with a 4B grade charcoal pencil, carefully drawing strokes in a vertical direction. I kept this tone quite dark and even but allowed a little paper to show through to create a texture. A solidly drawn black tone would have no life. In the center and on the left, I added medium gray tones, again using vertically drawn pencil strokes. I indicated the lamp, building details, dark shadows, and the suggestions of figures. The overall effect at this point is of a strongly lit background, framed at the sides and bottom by shadow tones. As I drew, I kept a piece of tracing paper under my hand so that the charcoal wouldn't smear.*

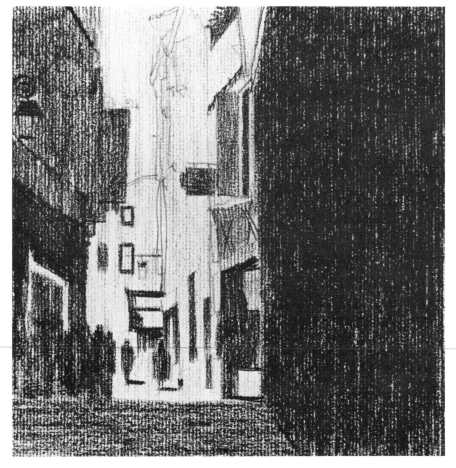

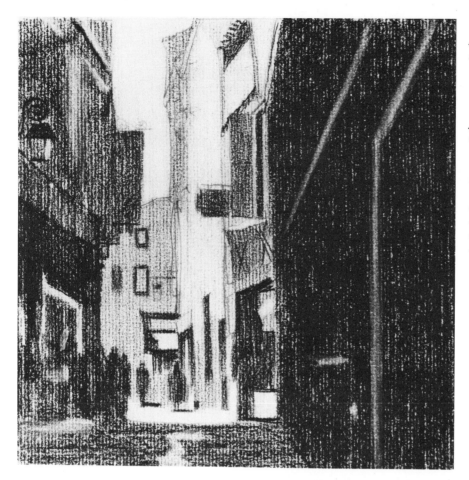

Step 3. *With a kneaded rubber eraser formed to a point with my fingers, I picked out white areas in the tones on the right-hand building, which is the one in shadow. The puddle in the center of the street was also lifted out with the eraser. I removed the tone from the sky as well and created the sunlit patch on the street with the eraser. The tone was removed from the building in the center, which is in direct sunlight. Again, the eraser was used to indicate a few architectural details as well as the reflected area on the street lamp. A slight tone was erased under the group of people standing in the street.*

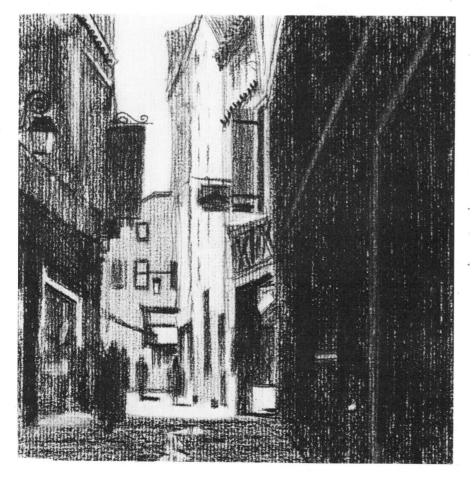

Step 4. *I sharpened the 4B grade charcoal pencil and brought it to a point on a sanding pad. This was done so that it would be easier to add smaller details. I drew in the windows, moldings, and other architectural accents, being very careful not to smear the drawing while working. I drew the storefront areas in solid black, then subdued the white erased lines on the right-hand building by rubbing my finger over the area. This type of a drawing may prove difficult for you at first, but practice this useful technique on different subjects. Make sure to study your subject matter carefully before starting—planning just where the tones will be is very important in this type of drawing.*

9
USING COLOR

MANY ARTISTS IGNORE or simply don't take color pencils seriously as a medium, though recently I have seen an increasing amount of color pencil work being done in both fine art and commercial art fields. Purists nevertheless argue that true pencil drawing is done in only black and white. Although this may be true to a certain extent, since most of the finest pencil drawings are in black and white, color does offer a unique challenge.

Color pencils are ideal as a dry-sketch medium for on-the-spot drawings or color studies. Such drawings or studies can be developed into more finished drawings or paintings later. Some very finished drawings can even be done with color pencils. And they will stand up well against other mediums. You can decide their merits for yourself, but do try to experiment with them as you explore color work.

Combining mediums can greatly enhance a drawing. Adding a watercolor or ink wash to a simple pencil drawing is probably the best way to begin working with combining mediums. You don't even have to use color; a wash of water-soluble ink will work nicely. Becoming familiar with color in this way will help you with more complicated mediums, such as watercolor, gouache, acrylic paints, colored inks, and dyes.

When you begin working in color, start out with watercolors or dyes, and use simple washes. It would probably be helpful to do a rough color sketch in markers before beginning to draw with combined mediums. Such sketches can be invaluable as guides for a final color rendering.

Obviously, color is complicated for the beginner, so don't attempt color work until you've mastered at least a few of the black-and-white techniques. In the examples that follow, you will find techniques that include line and tone, stump-blended tone, tone on colored paper, and dissolved tone. The subjects are varied and include animals, outdoor scenes, figures, and portraits. This section also includes seven demonstrations, showing various techniques, some using color pencils combined with dyes, gouaches, oil crayons, and acrylic paints. There are examples of color pencils combined with markers, designers' colors, watercolors, and oil crayons.

Keep in mind that color is much more difficult to work with. After you've gained a lot of experience working in black and white, you can try color.

ALONG KANDY LAKE, *10½" × 12" (26.7 × 30.5 cm). In this example I used Prismacolor pencils on MBM Ingres d'Arches paper. I began this study by first doing a basic line drawing, building up my color tones over this. The colors were then blended with a paper stump dampened with Bestine. Some of the effects achieved with this technique are very similar to those attained with paint. Notice the effective use of the white paper in this picture. Keep in mind that you don't have to cover every square inch on your paper with tones or color when doing a drawing. Fifty percent of this drawing was composed of the white paper.*

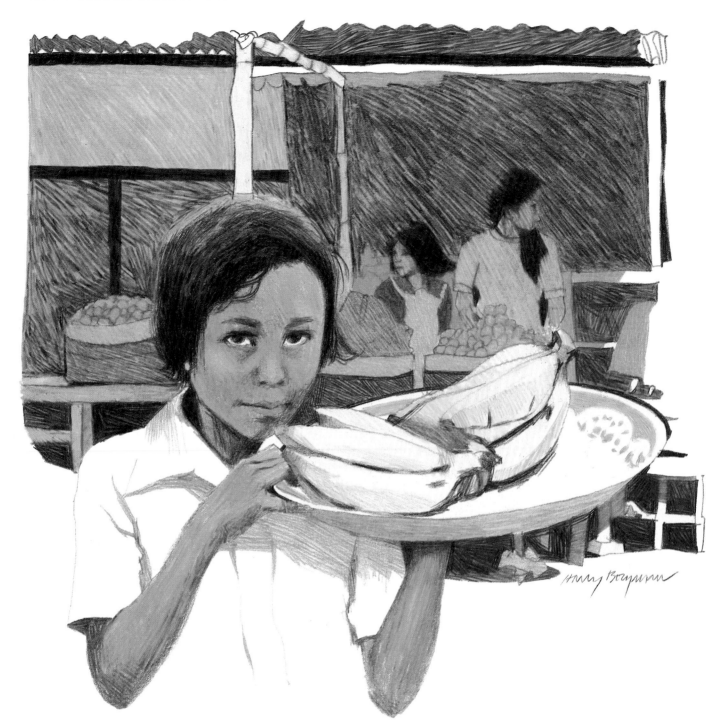

Banana Girl, Besakih Market, Bali *(above), 11½" × 11⅜" (29.2 × 28.9 cm). For this drawing I used Prismacolor pencils on a smooth-surface bristol board. The basic drawing was done with a dark cold grey 965. Gradually I built up color values and tones, being careful not to make any area too dark. If you do happen to overwork an area and the tones become too dark, it is fairly easy to erase these pencils and start over. This rendering is quite realistic, but I kept the background flat and simple for a strong design effect.*

Besakih, Bali *(right), 10⅞" × 13⅜" (27.5 × 34 cm). Certain pencil brands, such as Prismalo and Stabilo, are water-soluble, a unique quality that can be used to create some very interesting effects. You can actually make paintings with these pencils, really extending the possibilities of the pencil medium. This pencil painting was done on a four-ply medium-surface bristol board. I completely rendered the scene with pencils, then stroked on clear water with a brush, dissolving certain tones into washes. I accomplished some of the interesting leaf textures by first putting drops of water on the area, then blotting up the dissolved color with a paper towel.*

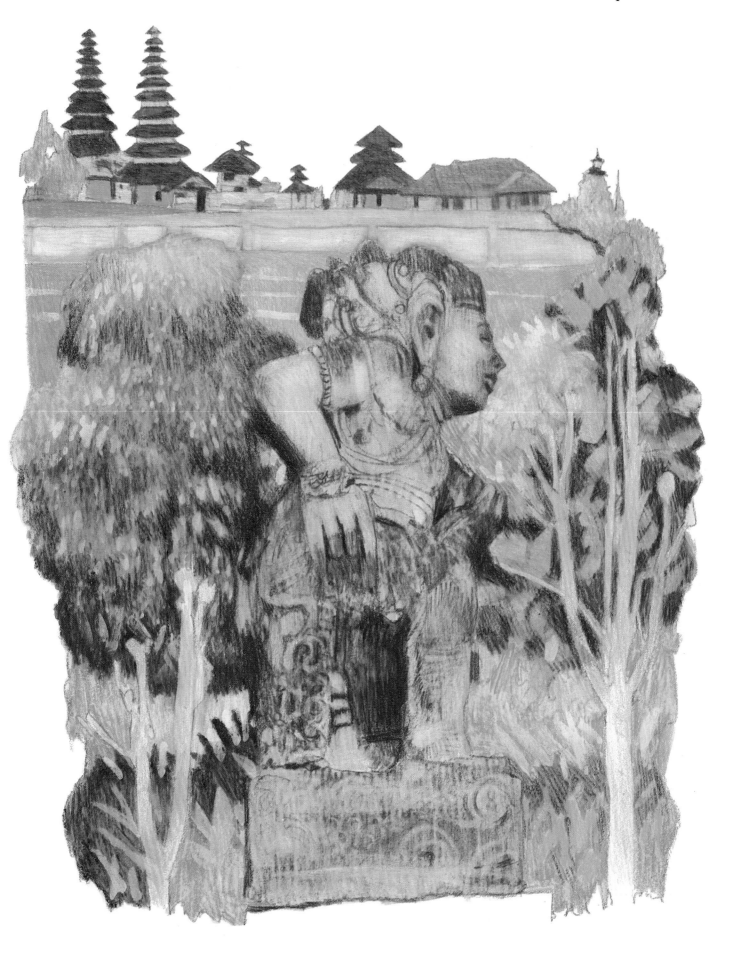

Kongoni

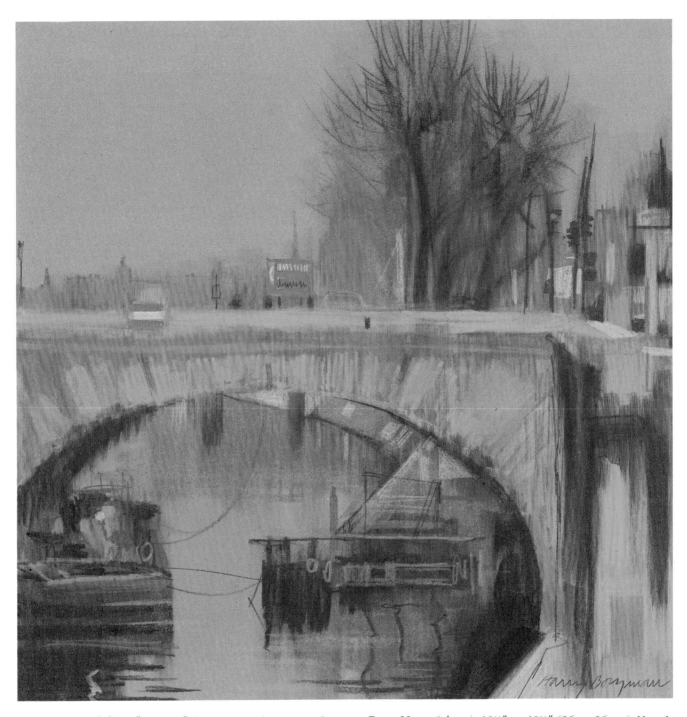

KONGONI *(left), 11" × 15¾" (28 × 40 cm). Prismacolor pencils and oil crayons were used for this drawing done on MBM Ingres d'Arches paper. Very bold strokes throughout created an overall texture. This is an ideal technique for sketching on the spot, but this particular example was drawn from photographs taken in Kenya.*

PARIS MOOD *(above), 10¼" × 10¼" (26 × 26 cm). Here I used Prismacolor pencils on a sheet of Pantone paper, number 535. This was a typical gray day in Paris, and the bright-colored signs accented the scene perfectly. This is primarily a tone study with little use of line. The color pencils I used were dark cold gray 965, light cold gray 964, medium cold gray 966, and white 938. When I completed the rendering, I blended these colors with a Bestine-dampened paper stump. Then I used a canary yellow 916, light blue 904, and carmine red 926 for color accents. This is a simple but surprisingly effective technique using a minimum of colors.*

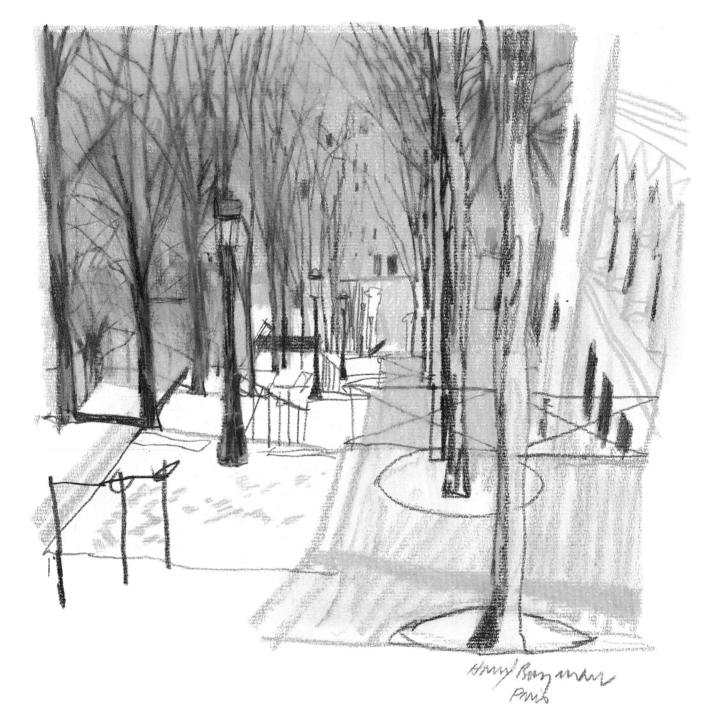

MONTMARTRE *(above), 11¼" × 10¾" (29.2 × 27.3 cm). Color pencils, oil crayons, water, and turpentine were used in this example. After the tones were rendered, water was washed over certain areas, dissolving the water-soluble pencil tones. Then I added some oil crayon tones and blended these with a rag dampened with turpentine. The sketch was completed by redrawing certain things, such as the trees, that had been dissolved. By the way, the tree trunks really were green because they were covered with moss.*

PARIS BIRD MARKET *(right), 8½" × 12⅛" (21.6 × 30.8 cm). Color pencils, markers, oil crayons, pastel pencils, and Bestine were all used on Pantone paper, 443, for this study. Don't be afraid to try any combination of mediums with pencils—inks or even dyes will work very well with them. It's fun to experiment, and you'll often achieve interesting results that would otherwise be impossible. If you explore, you'll never get bored with this kind of pencil drawing.*

Demonstration 15. *Color Pencils on Textured Paper*

This demonstration is drawn on MBM Ingres d'Arches paper with Prismacolor pencils. It is done in a pretty straightforward technique with no blending of tones. The texture of the paper adds a great deal of interest to the drawing.

Step 1. *Not being quite sure how the color should be handled on this drawing, I decided to do a color sketch. I placed a sheet of transparent layout paper over my basic pencil drawing and roughly traced the general shapes with a Pentel Sign pen. Then, using markers, I filled in the rough sketch until I achieved the effect I was after. Since my first sketch worked out well, I proceeded to the finished pencil drawing. It is a good idea, especially if you are a beginner, to do two or three rough color sketches before starting your finished color drawings.*

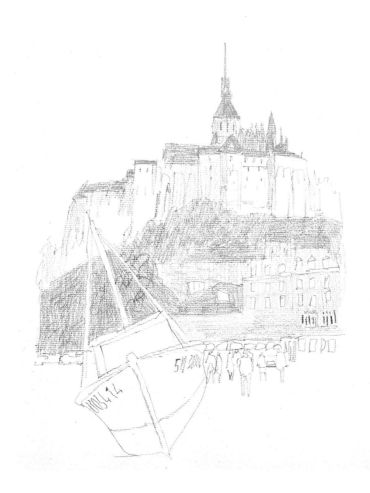

Step 2. *I next began putting color in the pencil drawing, using the marker sketch as a guide. I drew in the foliage using an apple green 912 pencil. I used an orange 918 as an undertone on the buildings and sketched it lightly over the foliage as well, warming the color up a bit. I then filled in the roofs with a light cold gray 967.*

Step 3. *Using a raw umber 941 pencil, I drew a tone over everything—the foliage, the buildings, and the hills. With a sand 940 I lightened up the foliage and then added some soft shadows over the background with a sepia 948. I then used a light, cool gray 964 tone on the foreground boat and placed in the red accents with a scarlet red 926. To complete this stage, I added a tone of flesh 999 over the buildings and a tone of sand 940 over that.*

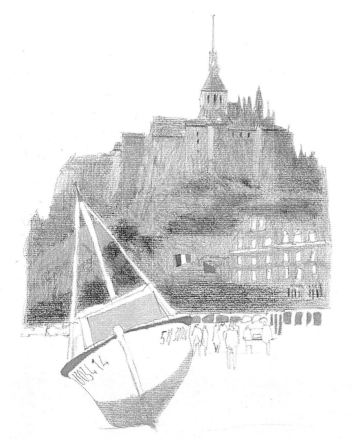

MONT ST. MICHEL, *15" × 9⅞" (25.1 × 33 cm). With the black 935 I added windows and other building details as well as texture to the foliage. I put a few bright spots of color on the people, added the reflections, and finished the drawing. This is a good technique for almost any subject.*

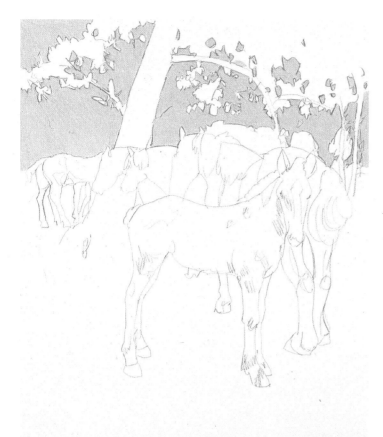

The slightly textured bristol surface can be used to achieve very realistic effects with certain techniques. The technique demonstrated here is quite similar to some of the other highly rendered examples shown earlier in the book. But this is not a drawing project for the beginner. It is probably more appropriate for the advanced student. If you are a beginner, don't attempt drawings like this until you have had a lot of experience with some of the simpler techniques.

Step 1. *On a sheet of regular-surface bristol, I did a basic drawing using a medium warm gray 962 pencil. I began adding color by filling in the sky background with a light flesh 927. Over this color I used a light cold gray 968.*

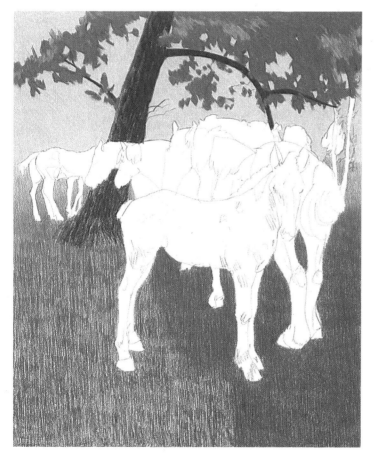

Step 2. *I drew in the dark tree with a medium warm gray 962 and put green bice 913 over the background grass area, with orange 918 over that. I then painted raw umber 941 over the whole foreground area. To the leaves I added green bice, light green 920 for the highlight accents, and some slate gray 936 for the shadow areas on them. I also began to use slate gray to darken the foreground shadow area.*

Step 3. *I continued to darken the foreground shadow area, and with a dark cold gray 965, I also darkened the leaves. I then went over the whole foreground area carefully, deepening the dark gray areas. This takes a great deal of time and cannot be rushed if an even tone is to be achieved. Then I added ground textures and other details to the shadow area.*

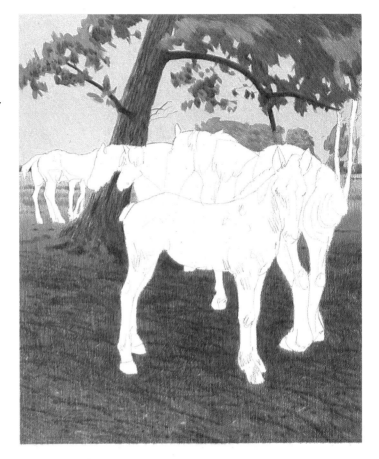

Step 4. *I colored in the colt with a light flesh 927 and a raw umber 941. I then used a sienna brown 945, a dark cold gray 965, and a light cold gray on the other horses. I slightly softened all these tones with a paper stump dampened in Bestine and used the paper stump on the trees and foliage. I even picked out details and rock shapes in the foreground with the paper stump.*

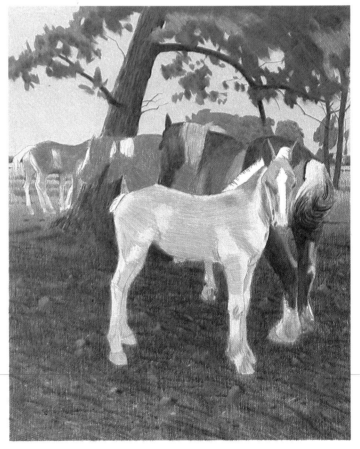

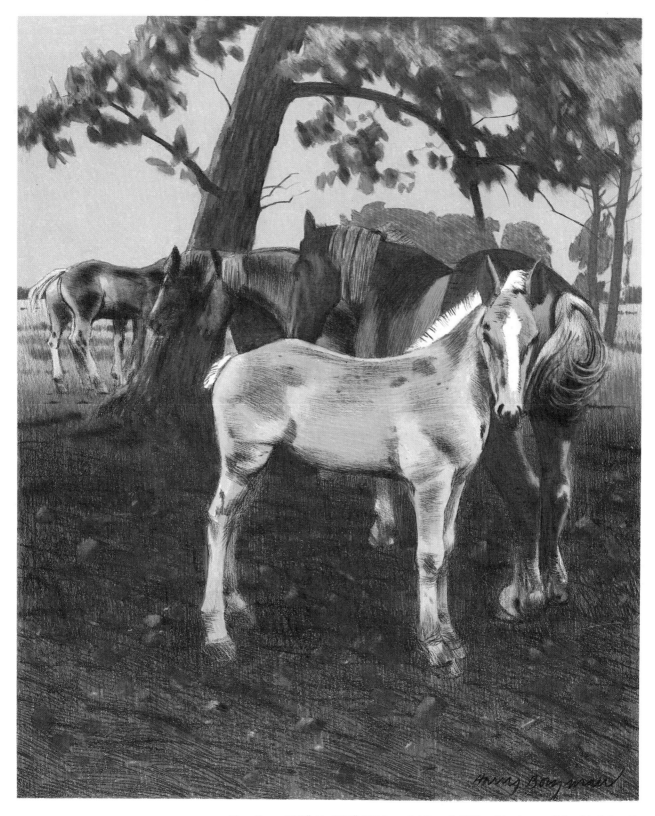

THE COLT *11⅛" × 13½" (28.2 × 34.3 cm). With a black pencil I added details to the horses and finished them. Then, I slightly blended the tones on the horses with the paper stump. And with the paper stump dampened in Bestine, I picked out a few highlights in the leaves and brightened these areas with a green bice pencil.*

Step 1. *One of the best methods for adding color to pencil drawings is to combine this medium with watercolor. The pencil is used for the outline drawing and a few tones, and the watercolor washes are used for the color tones. The watercolor washes can be painted in very flat with no variation in tone or blended from light to dark in a more realistic manner. This is one of the best techniques for doing outdoor sketches on location. Watercolor paper with a rough or medium surface works best with this technique because it responds well to washes and stays damp longer, but other papers will also work well. The least desirable are those with smooth surfaces. Here I used a dark gray wax pencil on watercolor paper to draw a simple sketch of the scene. I worked from photographs taken while traveling.*

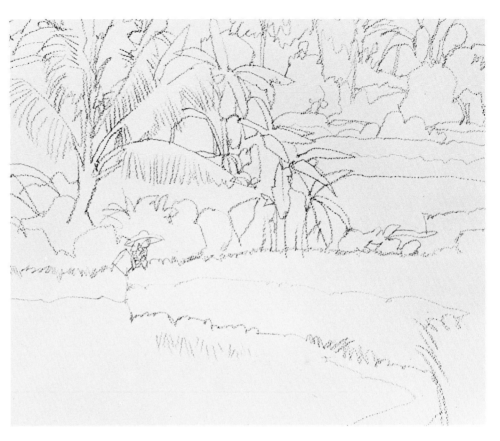

Step 2. *I decided to add tones in the foreground to indicate the grass texture as well as the shadow areas. Planning makes the job of adding the color tones much easier. It is important to draw in these tones because once you've decided on them, you can concentrate on the colors and values while painting. Shadow indications were done with a uniform medium-gray pencil tone. The tone drawn in the foreground area on the shadow side of the field is indicated by curved lines that simulate grass texture. Compare this stage with the one above; you will notice that the addition of just a few simple tones has helped create definition.*

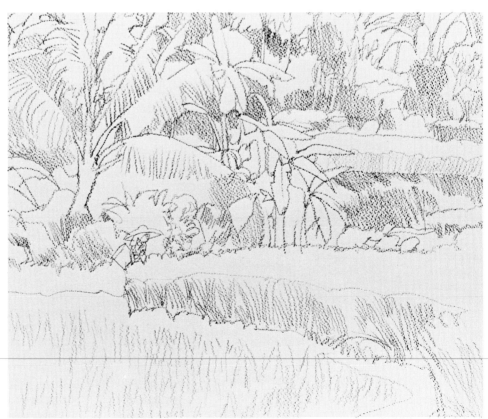

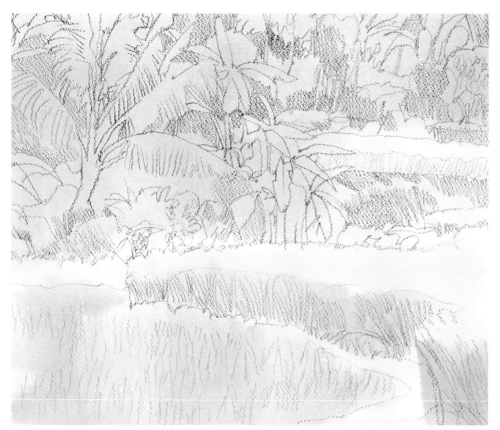

Step 3. *I mixed a light lemon-yellow wash in a mixing tray, then painted this tone over the whole background with a number 8 red sable brush. While the tone was still wet, I painted washes of viridian green over it. I mixed a brighter green, combining viridian and lemon yellow, which is painted over portions of the background jungle as well as over the foreground grassy area. Before proceeding, I let these tones dry thoroughly. Notice that even though these washes have blended together a bit, there are still distinct tone and color differences. If the paper surface had been too damp when the tones were added, the colors would have blended more. If the surface had been too dry, the tones would not have blended at all.*

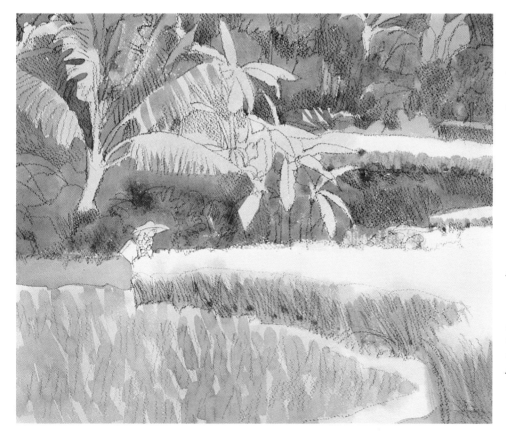

Step 4. *I mixed Winsor green with lemon yellow, creating a medium green tone, which I painted on the background with a number 8 brush. I was careful to paint around the leaves and tree shapes so they would be silhouetted against the background. I painted this color in quite flat, but where I have washed it back over certain areas, the tones appear darker. I mixed more lemon yellow into this same color and used the resulting lighter green to paint in a wash over the background field; then I spotted this same color on some of the sunlit trees in the background. A wash of olive green was applied over the shadow edges of the fields in the background and foreground.*

Step 5. *At this stage, it was important to add the darker tones so that I could determine whether my color values were correct. The dark tone was mixed from olive green and French ultramarine blue. This color was painted into the background. As I worked, I drew with the number 6 brush, delineating shadow areas, tree leaves, and foliage to create the jungle effect. As I worked, I tried to create a feeling of depth while retaining the sunlit effect. Care has to be taken not to paint over areas that are to be lighter so that they are silhouetted against the darker background. Darker accents are painted into the shadow edges of the fields in the foreground and background.*

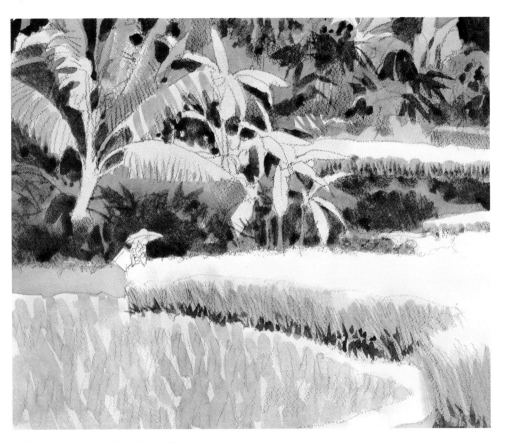

Step 6. *Using a mixture of viridian, lemon yellow, and a bit of French ultramarine blue, I painted strokes over the foreground field, accenting the texture. I mixed a brighter tone of green from lemon yellow and viridian, and brushed it over some of the background leaves and on the field just behind the figure. Using a lighter value of this same color, which I obtained by adding water to the original mixture, I painted over the field in the background and on the field in the right foreground, indicating grass textures. Notice that I worked over the whole picture rather than just one area. This prevents overworking and ensures unity throughout the rendering.*

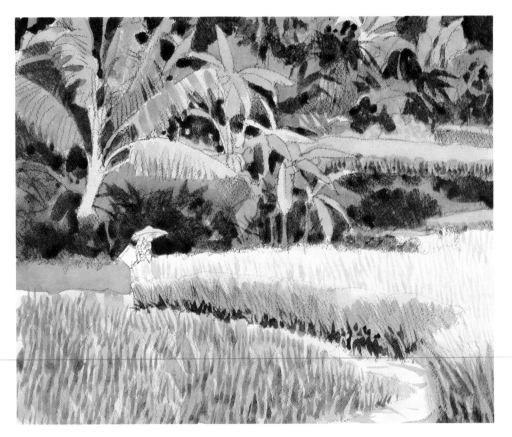

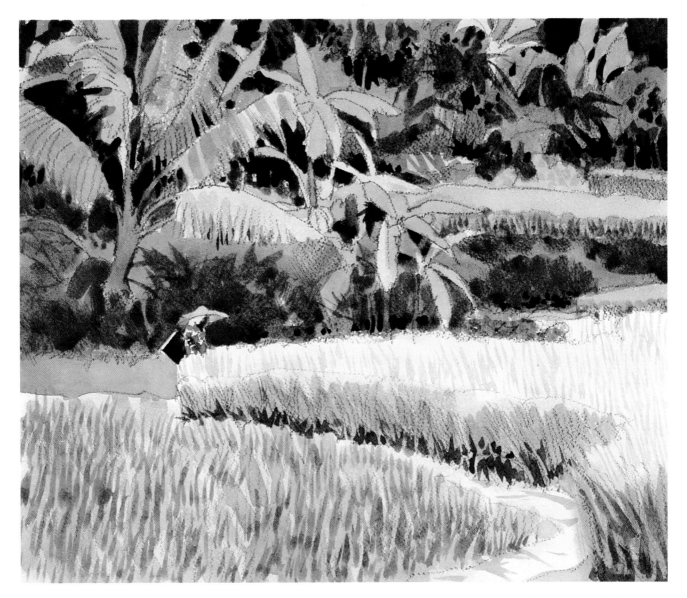

Step 7. *I now worked on the figure, using vermilion to paint her dress. A tone was mixed from vermilion and lemon yellow and used to paint in the hat. A tone was painted on the face, using burnt umber, and the basket was rendered with a dark tone mixed with French ultramarine blue and burnt umber. This near-black tone was painted into the background jungle areas, creating deep shadows that helped to accent the sunlit portions of the foliage. Notice how clean the colors are, not overworked or muddy. It is important to try to keep the colors fresh when working with this medium. Much of the jungle foliage was created through careful work around the leaf and tree shapes, to keep them silhouetted against the darker background. Notice that the pencil drawing is still an important part of the picture and most of the pencil indications are still visible. The key to doing a successful color sketch like this is to analyze your subject carefully and use a limited color palette. Most scenes can easily be broken down to only six or seven basic colors. Too many*

colors on the palette can be confusing, especially for the beginner. In this scene only seven colors were used— Winsor and viridian green, French ultramarine blue, burnt umber, lemon yellow, olive, and a small amount of vermilion red. With these seven colors I created all the colors and tones used here by mixing some of them together. This is a very good technique for outdoor sketches on location. Another method would be to do the basic pencil drawing on the spot, then add the color wash tones in the comfort of your studio, using color notes or even a marker color sketch as a guide to work from. It is important that you practice washing color tones on dampened paper so that you will be able to determine the effects you want to use in your work. Colors blend more when the paper surface is wetter and less as the paper dries. Each type of paper will react differently under similar conditions of dampness. The only way to understand the special features and limitations of different paper surfaces is to practice painting wash tones on them.

Step 1. *Certain types of colored pencils are not waterproof, so the drawn lines can be dissolved into tones by washing clear water over them. These pencils can be used in the same way as other types of colored pencils, but their unique property can also be used to advantage. In this demonstration, I used the water-soluble pencils on a rough watercolor paper—a good surface for this technique. I started by making a sketch with a dark gray pencil, drawing in all the outlines as well as the details on the bridge. Notice that the outlines are quite accurate as far as shapes and proportions go.*

Step 2. *Using a yellow pencil, I drew a tone over the sky and on the river. I kept the tone uniform using strokes that are about the same weight and fairly evenly spaced. A slightly different yellow, a warmer ochre color, was drawn over the bridge and its towers.*

Step 3. *Next a light green color was drawn over the trees, then an olive color was used over this to indicate shadow areas. I then drew a gray tone over the background buildings. A darker warm gray suggested shadow details on the bridge and defined shadows on the water surface.*

Step 4. *I added a light gray tone over the sky and on the bridge with the pencil. This was done to build up the tones and to subdue the overall yellow cast of the drawing. The tones had to be dissolved at this point to see if they were the proper values. Since it is difficult to judge what the values will be after the pencil lines are dissolved, it is best to build up the tones gradually.*

Step 5. *Using a number 8 red sable brush, I applied a wash of clear water over the sky area, dissolving the pencil lines into tones. I was careful to work around the buildings and bridge towers so as not to dissolve them into the sky tone. The river tones were dissolved next, using the same brush with water. The brush was cleaned after each use. When these wash tones dried completely, I worked on the bridge and then over the trees. The tones on the buildings in the background were dissolved last. Notice that I worked on the various sections separately, being careful that the tones did not blend together.*

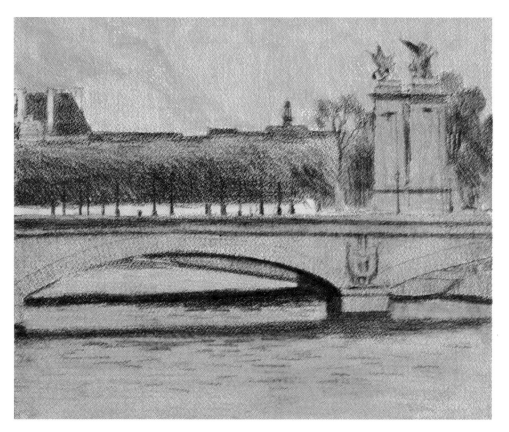

Step 6. *More gray pencil tones were added to the sky and the bridge. I strengthened the shadows in the scene, then drew a tone over the bridge with a white pencil, darkening the tonal value and subduing the color somewhat. The details of the bridge had been obscured because of the tonal change, so I drew them back in with a dark gray pencil. I used this same pencil to strengthen the tones on the roofs of the buildings in the background. The shadows on the bridge and on the tower were also darkened. I worked further on the trees by building up and darkening the shadow tones.*

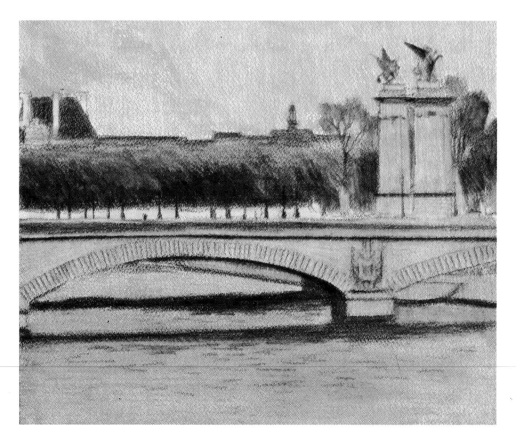

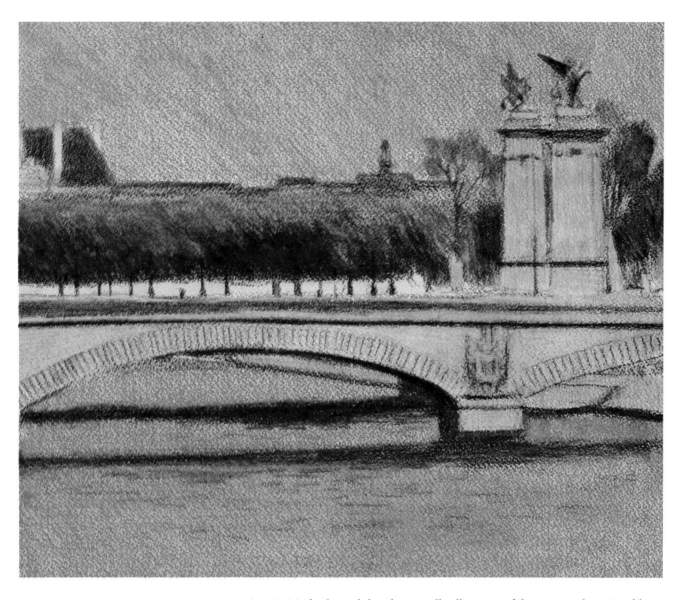

Step 7. *To further subdue the overall yellow cast of the scene, I drew in a blue tone over the sky area. The same blue was drawn over the river. Then, over this, I added a subtle pink color, which successfully neutralized the dominant yellow cast. The blue was also drawn over the area of the trees, and some of these lines were strongly accented. This method of working offers more latitude than one might think. Tones can be removed by dissolving them, and new colors can be drawn back in. How much you can work over the tones on the paper really depends upon the quality of the paper surface. The finest quality papers can take more of a beating than the cheaper varieties. The mounted papers or illustration boards are more suitable for use with this technique because they will not wrinkle or buckle when the surface is dampened.*

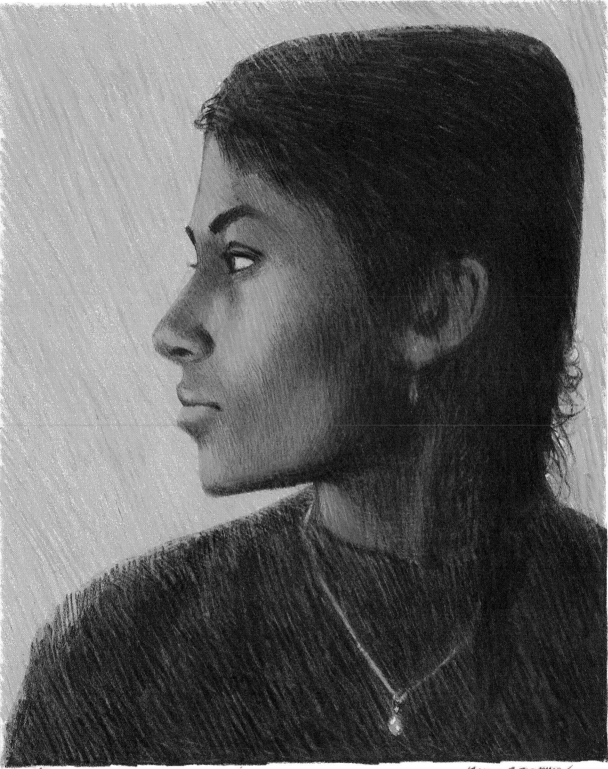

Sandra

Kathy Bonyun

SANDRA, *9¾" × 11¾" (24.7 × 29.8 cm). I first did a basic line drawing with a Negro pencil on a medium-surface bristol board, over which I painted a flesh-tone watercolor wash. Then I started color and form with the Prismacolor pencils. When working with these pencils, it's only possible to build up your color layers a certain amount, after which it's difficult to add more tones. I soon reached that point on this drawing, so I sprayed the drawing with a workable fixative that allowed me to continue working without any problem. Oil crayons were used also on this drawing, and most of the background was done with them.*

Dyes work very well when combined with pencil drawings. You can use just a few simple flat washes of color to create very effective drawings. I should remind you that you should always use the finest quality red sable brushes when you paint because cheap brushes do not work well.

Step 1. *Using a medium warm gray 962 Prismacolor pencil, I did my basic drawing on a four-ply Strathmore regular-surface bristol board. I then mixed a bright orange from Dr. Martin's dyes, using pumpkin and amber yellow. I washed color on the appropriate areas with a large number 8 red sable watercolor brush.*

Step 2. *Using water-soluble ink, I added the dark markings to the dog's back and indicated a few details on its head, such as the eyes and nose. With a light flesh 927 pencil, I added a tone to the face.*

Step 3. *With a warm gray 962 pencil I began to add shadow tones and details to the dog's head and various parts of the body. For the shadow tone on the white area of the fur, I used a light, cold gray 968. Then I added a little light fleshtone to the dog's face.*

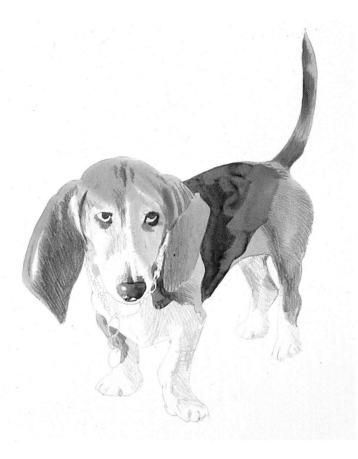

Step 4. *I continued to add subtle shadow tones with the medium gray and to darken the fur color by using an orange 918 over the washes. I finished the eyes and nose details with the black pencil, and on the tongue I used flesh 927 and pink 929 pencils. I then worked with black pencil to intensify some of the fur tones and the shadow areas.*

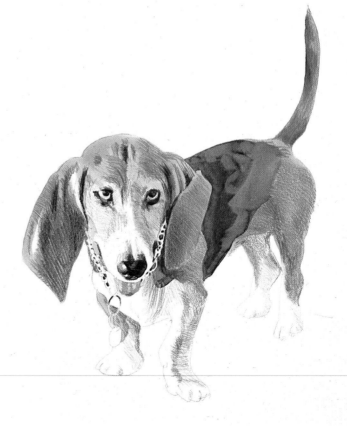

LUCKY DE LA PETITE SOLOGNE, *9⅜" × 12¼" (24.8 × 31.1 cm). With a paper stump and Bestine, I blended all the colors, creating a soft effect. I added darks to the black portion of the fur with a black pencil. I completed the drawing by adding a few more details with the black pencil.*

Demonstration 20. *Color Pencils, Oil Crayons, and Gouache*

Gouache or Designer's Colors work very well when combined with color pencil and oil crayons. Just a simple wash of color will work quite well; you don't have to get very involved with painting when using this technique. Working with opaque paints and pencils will help to prepare you for working with these other mediums.

Step 1. *I did a line drawing on Strathmore four-ply regular-surface bristol, using a medium-warm gray 962 Prismacolor pencil. I washed Designer's Colors ivory black over the hair portion of the drawing.*

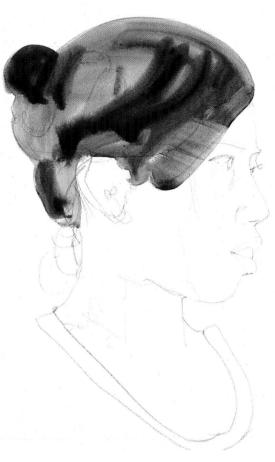

Step 2. *On the highlight portion of the face I washed a tone of raw umber and then a wash mixture of raw umber and black on the shadow area.*

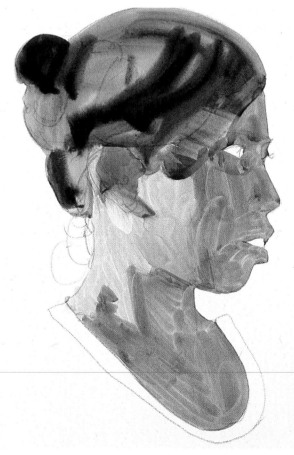

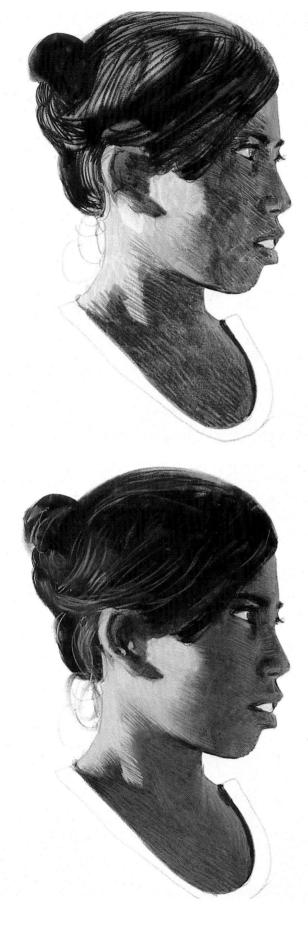

Step 3. *I began to draw in the facial details, the nose, the eyes, and the mouth with a black pencil and used the nonphotographic blue 919 for the reflected light in the shadow portion of the face. I then added burnt umber 947 over the shadow tone on the face, and with the black pencil, I drew a line texture in the hair.*

Step 4. *With a Neo-color oil crayon, russet 056, I added color to the shadow portion of the face. Then, using a Neo-color salmon 31, I applied additional color in the highlight areas. I used Neo-color grays on the hair and softened these lines with Bestine and a paper stump.*

SUKRI, *6¾" × 11" (17.1 × 27.9 cm). I blended all the facial tones and softened them with the paper stump and Bestine so that the colors would dissolve more easily. Then, with the Neo-color russet 065 and black, I worked on the face, carefully blending my strokes as I drew. I used Neo-color grays 005 and 002 to put reflected light into the shadow face tones, since the blue I had applied earlier was too strong. I gradually built up all my tones until the drawing was finished. The last touch was the collar, which I drew in with a light violet 956 Prismacolor pencil.*

Acrylic paint is another medium that can work quite well with color pencils. If you try to keep everything very simple, you shouldn't have too much trouble with this technique. Usually a simple color wash will work just fine. This is not really like doing a painting; the paint, in this case, just supplements your pencil drawing.

Step 1. *I first drew the scene on Strathmore regular-surface bristol board with a 2H grade graphite pencil. Next I mixed a wash, combining cobalt blue, Mars black, and titanium white, which I painted over the foreground shadow area. Then I mixed titanium white, cadmium yellow, and a little cobalt blue and painted it on the sky portion of the picture. I used the paint rather thick here so that it would dry evenly without any texture.*

Step 2. *I mixed orange and titanium white and painted this color on the distant mountains. I painted the snow in with white paint.*

Step 3. *I began to draw with a color pencil, using Copenhagen blue 906 on the mountain shadows. I also added sienna brown 945 on the mountain. I went over this with a slight tone of pink 929. I also added the pink to the hill just in front of the mountain. With a light cold gray, I drew in some bushes in the middle ground. Then I began working on the foreground bushes.*

Step 4. *I finished the foreground bushes and added light flesh 927 and flesh 939 over the foreground rock formation. I used black over this to draw in the shadows and other details and darken the hill in the middle ground with a medium warm gray 962 pencil. I then softened some of these tones with Bestine and a paper stump.*

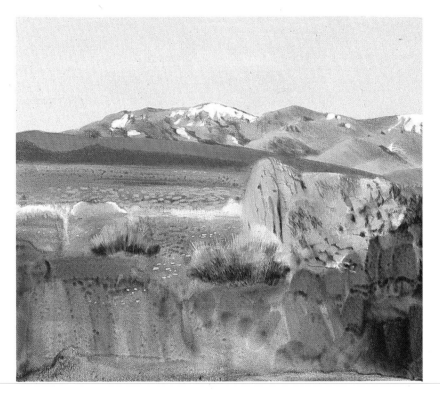

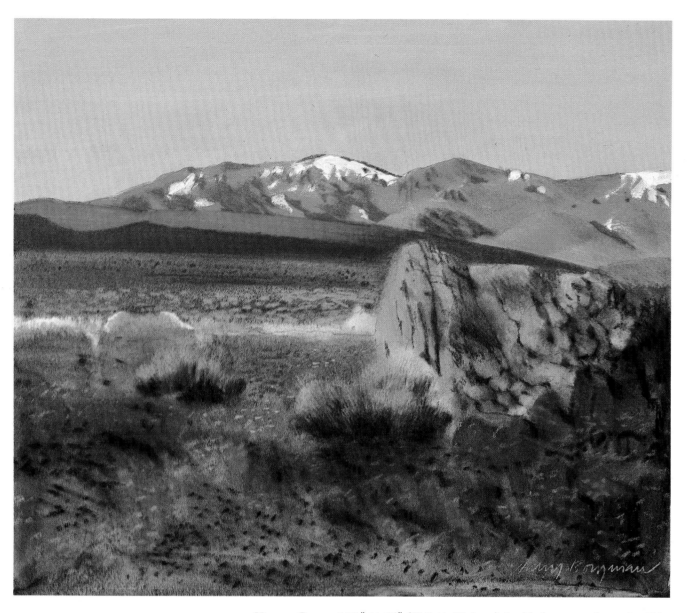

Nevada Dawn, *11¾" × 10" (29.8 × 25.4 cm). I added more rocks and pebbles over the ground area and drew in more cracks and shadows in the foreground boulder. I softened and blended all these tones with the paper stump, and thus finished the drawing.*

10

TECHNICAL TIPS

IN THIS CHAPTER I will review various technical and useful points. Many of these points have been covered in previous chapters, but discussing them together and in more detail should prove helpful.

There are many drawing problems that you can become aware of only through experience. Many of these problems are taken for granted and seem relatively unimportant, but they really aren't. Some of these problems include: how to sharpen a pencil correctly; how to keep drawings clean; how to handle tough erasures; how to protect your drawings; and drawing from life, models, and photographs. These are all problems you will be confronted with, and they are important to think about.

In this chapter I will discuss a few of these basic problems and give you a few suggestions on how to develop yourself as an artist.

SHARPENING PENCILS

It's really much better to sharpen your pencils with a single-edge razor blade or an X-Acto knife and then to shape the lead with a sandpaper block. Forget about using a hand or mechanical pencil sharpener. You can do a much more professional job of sharpening with the other method.

First cut away the wood from around the lead, making sure you don't cut away the identity number of the pencil. Yes, there is a wrong and right end of a pencil to sharpen. On the harder grades, 9H through HB, you can cut away more of the wood, leaving a rather long lead that can be shaped with a sanding block. Be really careful when sharpening

the softer grade leads, B–6B, because they break easier. With them it's best to cut less wood away, leaving a short lead. The points, after sharpening, can be shaped in many ways, depending on the effect you want in your drawing. The point can be blunt, chiseled, or needle-sharp.

Another way to achieve different effects in your drawings is to try holding the pencil in different ways. Normally while working and sitting at a drawing table or desk, you would hold the pencil in much the same position as you would for writing. You will

This is the best way to sharpen a pencil. Use a single-edge razor blade or an X-Acto knife to first cut away the wood from around the lead and then shape the lead with a sandpaper block.

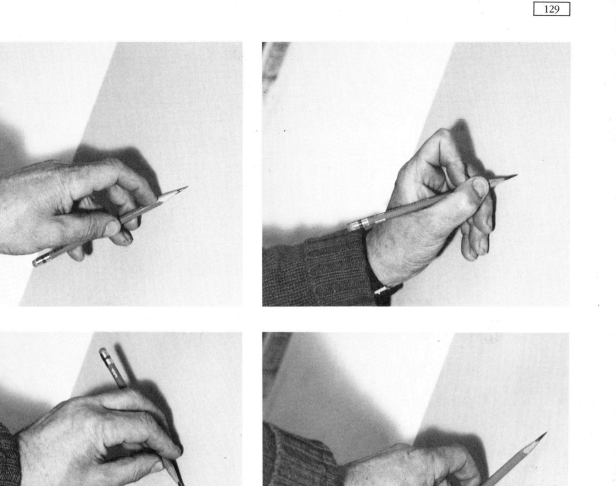

These are different positions that can be used for holding your pencil when drawing. Experiment with some of these to see which ones suit you best.

To spray a drawing properly with fixative, hold the can about fifteen or twenty inches away from your drawing, which should be in an upright position. Using a side-to-side motion, apply a light coat of fixative, but be careful not to overspray or flood the surface, as this will probably ruin your drawing. Two or three light coats of fixative are much better than one heavy coat.

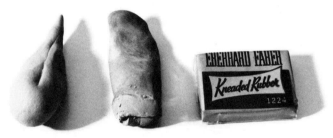

A kneaded eraser is very handy, since it can easily be shaped for special erasing problems. You can even draw into pencil tones with this eraser.

find that if you stand while drawing, you will hold the pencil differently from when you are sitting. The angle of your drawing board will also determine how you hold your pencil. When doing a tight, meticulous rendering, you will hold the pencil quite differently from when you are doing a rough sketch. Experiment with different hand positions and ways of holding the pencil.

If you sharpen several pencils at a time, you can draw longer without interruptions—a very good thing to keep in mind. Remember too, you must be especially careful when sharpening charcoal, carbon, pastel, and wax pencils, since they are generally a little more brittle than graphite pencils. Of course you can always draw with a mechanical pencil or a lead holder, but you won't achieve the variety of lines possible with a regular pencil. Most leads for mechanical pencils are quite thin and are not easily shaped.

KEEPING YOUR DRAWINGS CLEAN
Since drawing with most pencils can be quite messy, certain precautions are advisable. Try remembering to use a piece of tracing paper under your hand when drawing. This can help a great deal in keeping your work clean. Often, especially when using charcoal, carbon, or pastel pencils, pencil dust will cover your paper. Usually this can be blown off, and it should be at frequent intervals. If you don't get rid of such pencil residue, it will show up much more after you've used a fixative on your drawing.

To be certain you've gotten rid of this unsightly residue, you can carefully erase the white paper areas of your drawing with a kneaded rubber eraser. Since the eraser can be easily shaped, you can erase in very tight spots. You can also confine your erasures by using an erasing shield for certain areas. For very difficult erasures, try a fiberglass eraser. But these erasers can only be used on robust surfaces, such as illustration boards, because they cut surfaces.

PRESERVING YOUR DRAWINGS
The best way to preserve a pencil drawing is to spray it with a varnishlike fluid called a fixative. If you don't fix your drawings, they may become smudged or otherwise damaged.

Fixative is available in a spray can or in a bottle for use with an atomizer. Since a more even coat of fixative can be attained with a spray can, I recommend using this type. Fixative is available in either glossy or nonglossy, also called a matte finish. The latter is preferred for pencil drawings.

To properly fix a drawing, tape the drawing to your drawing board and set it somewhat vertically against a wall. Hold the spray can about 15 to 20 inches away from your drawing. Then spray a light coat on the artwork, moving the can back and forth until an even coat has been attained. Two or three light coats are preferable to one heavy coat, since

the fixative will ruin your drawing if it begins to run. First practice spraying rough sketches until you have learned to control the spray. Because some brands of fixative have a strong odor, you may prefer the odorless variety, as I do. Also be careful not to spray surrounding objects when fixing your drawings. In fact, just to be on the safe side, do your spraying in the basement or garage.

By the way, there is a fixative on the market that enables you to continue working on your drawing after it has been fixed. You can fix newly drawn areas with a light spray.

DRAWING FROM LIFE

Recruit family members and friends as models. If you feel a little uneasy about drawing in front of someone, take a few Polaroid photographs of your subject and work from them. This way your subject won't get impatient or move while you're working. You will also be much more relaxed, which will enhance your ability to work. One subject that won't move is a still life. You can easily set up a simple still life of fruits or flowers and leisurely draw them. The most convenient way to draw from life is to work directly on a sketch pad. You can also tape a piece of drawing paper to a portable drawing board. But a sketch pad is really more convenient, since all your drawings will be in one place. Making comparisons or finding references is then much easier. Sketchbooks are also best if you will be drawing while traveling or on vacation. Your sketches can then provide an interesting and easily accessible record of your travels.

For outdoor sketching, the same basic equipment works well. You might want to buy a small portable stool, however, which folds up for easy carrying. If at first you feel a little uncomfortable about drawing outside, work from Polaroid photographs or regular photographic prints for a while. When you become surer of yourself, take the big step and draw on location. Actually, drawing on location is fascinating, and you invariably meet some interesting people.

DRAWING FROM PHOTOGRAPHS

The Polaroid camera is a convenient tool, since you can quickly see the picture you've taken. Polaroid photographs are, however, rather small and can be difficult to work from. So I prefer working from larger prints whose details are clearer. I usually shoot most of my reference photographs with a 35mm reflex or range-finder camera. I then have the photographs blown up in to 8″ × 10″ (20 × 25 cm) prints.

If you are going to draw, you should own a camera. But it needn't be an expensive one. Check some of the used-camera bargains in newspaper ads or at your local camera shop. Your best choice would be a 35mm reflex-type camera.

All 35mm film comes in either 20- or 36-exposure rolls, and your negatives can be printed together on a contact sheet. Such sheets will enable you to see a roll of pictures at one time. If you want to later blow up some pictures, you can order them from your contact sheet. But be sure to keep your negatives with the contact sheets so they can be easily found. Contact sheets will also help you to become organized, as many professional artists have discovered.

By using the 35mm method, you can also take color slides. Such slides also make good reference photographs.

This loose line and wash drawing is on a plate-finish bristol board. I did the inking with a technical pen and the washes with numbers 2 and 6 brushes. I used the larger brush to dampen the paper and to render the larger gray wash areas and the smaller one for the smaller details, such as the bricks and the stripes in the clothing. Plate-finish bristol board is a very nice surface to work on because the smaller details are much easier to put in than they are on a rougher-textured board or paper.

INK DRAWING

NK IS A FASCINATING MEDIUM—you work with simple materials that encourage bold, direct work. The limitations of ink compel you to eliminate the nonessentials, especially when doing simple outline drawings where line becomes all-important. Working with line can actually help you develop your ability to see, and thus make you a better draftsman. Don't disregard the function of line—it will always be a part of any artistic problem you encounter, whether in oil, watercolor, or ink.

A line can be many things—subtle, gentle, graceful, undulating, energetic, vigorous, and even agitated. Contour drawings, a form of line drawing, can suggest volume and mass as well as shape.

Before you get involved with rendering, you need a good knowledge of basic sketching and drawing. For some artists, technique has become an end in itself. However, as important as technique can be, your first concern should be with actual drawing of the subject and its content. The problems of drawing are closely related to ink techniques, and ink ren-

dering is one of the many possible ways to draw. The term *drawing* covers a wide range of techniques and includes line drawings, tone drawings without line, and any combination in between, including wash tones. Markers add a whole new dimension to the ink medium; they are well suited for preliminary sketches for pen or brush drawings.

Many of the assignments I receive as an advertising illustrator are done in ink—and examples of my work are reproduced in the following chapters. I show graphically how I handle some of my assignments from the first rough sketch right through to completion. Also included here are several detailed exercises and demonstrations.

Whenever possible, study the work of other artists in magazines, newspapers, and books—as well as in your local art museums and galleries. A great deal can be learned through observation. If you discipline yourself to practice the exercises in this book, you'll be on your way to mastering ink rendering techniques and styles.

11

MATERIALS AND TOOLS

THIS CHAPTER COVERS the many tools and other materials you can use to draw with ink. Supplies range from a few simple, basic tools to innumerable kinds of highly specialized artist's paraphernalia.

If you're a beginner, all you really need to get started is a penpoint, such as a Gillott 659 crowquill or a Hunt 102 crowquill, a penholder, a bottle of waterproof ink—Artone, Higgins, Pelikan, Winsor & Newton, or Rapidograph are all of good quality—a number 2 red sable brush, and a pad or a few sheets of bristol board. A small drawing board, about 20″ × 26″ (50.8 × 66 cm), would be helpful to tack the bristol board on. You can use the drawing board on a desk, at the kitchen table, or even outdoors when you sketch on the spot.

My advice to the beginning artist is to keep your supplies down to a bare minimum. Many beginners have a tendency to buy all kinds of interesting tools and drawing items, but it's not necessary to burden yourself with an expensive array of gadgets and highly specialized tools at this point.

SKETCHING MATERIALS

You may want to sketch your drawings in advance. In that case, you'll need a pad of tracing paper and some good drawing pencils, such as Eagle turquoise, Koh-I-Noor, Mars Lumograph, and Venus. A few brands have an eraser on the end, which I find convenient. For sketching, I use a drawing pencil in the middle range, an HB, for most of my general work and a 2H for drawing on a plate-finish board. You can sharpen the pencils with a standard pencil sharpener, or you can use an X-Acto knife and shape the point with a sandpaper block. Erasers—Artgums, Pink Pearls, and kneaded rubbers—will be helpful for cleaning up artwork.

BRUSHES

The best brushes to use for ink drawings are the highest quality red sable watercolor brushes. Red sable is very expensive, however; there is a more moderately priced, white nylon substitute. A number 3 or 4 is good for line work and a number 7 is fine for painting washes. A larger flat, wide brush is useful for wetting the paper surface when doing wash drawings (a cheaper brush will serve the purpose in this case). Grumbacher, Robert Simmons, and Winsor & Newton all make very fine quality brushes. For adding gray wash tones to ink drawings with these brushes, I recommend water-soluble ink thinned with water. You should get a porcelain or plastic mixing tray to mix these washes, unless you want to use a dinner plate. You'll also need a small container for water to clean your brushes—and be sure to clean them after each use. Shake the brush vigorously in the water and wipe it clean with a rag. Every once in a while, wash your brushes in cold water with a mild soap.

PENS AND ASSORTED TOOLS

There are a large number of pen points and holders available (see the chart "Pen Points and Their Lines" on pages 136–37). Each point has a different range of flexibility and of line weight. Pick out a few and try them out until you find the ones that suit you best. Speedball pens, which are useful in lettering as well as drawing, come in a variety of shapes and sizes—style A has a square point, B a round one, C a flat tip, and D an oval tip. Felt pens and markers are really nice for sketching and drawing—Dri mark, Eberhard Faber Markette, Pentel, and Pilot are all good brands to use.

Technical pens are also very fine tools, since they contain their own ink supply. There are several brands to choose from, the most popular of which are Castell TG, Koh-I-Noor Rapidograph, Pelikan Technos, and Mars. I prefer the type that refills with a convenient cartridge, such as the Pelikan Technos. (The refillable cartridge comes in many colors besides black.) This pen has interchangeable points

(Left) For general use, the best all-around ink is the regular waterproof, or India, ink. Special inks are made for technical pens, and there are extra-dense black inks for brushing in larger areas. Nonwaterproof inks are used primarily for washes over waterproof ink drawings.

(Below) Assorted tools, clockwise from bottom left: (A) compass; (B) ruling pen with an adjustable point; (C) Pelikan Technos technical drawing pen and its ink cartridge refill in a box; (D) stylus for tracing drawings or photostats on illustration boards; (E) marking pens for sketching and drawing—Pilot, Pentel, Design Art Marker, and Eberhard Faber Markette are shown here; (F) 4B graphite stick, excellent for bold sketches or for making a graphite tracing sheet to transfer drawings to illustration boards; (G) special tools for use on scratchboard; (H) complete set of Castell TG technical drawing pens.

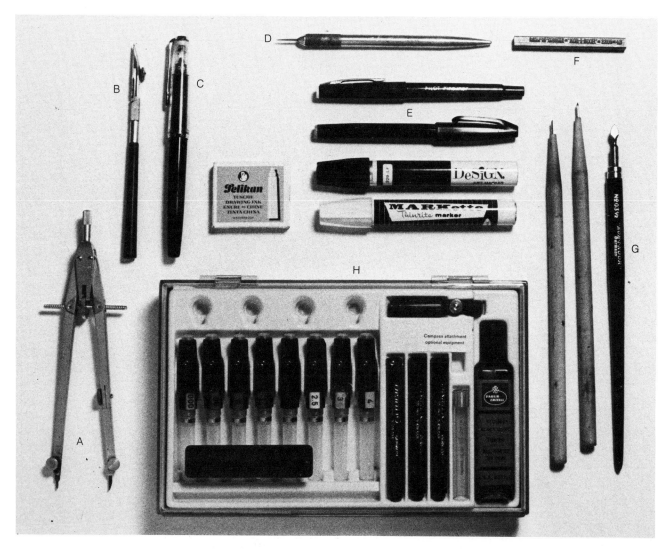

PEN POINTS AND THEIR LINES

Hunt 22, a fairly stiff point with a heavy basic line and a shallow range of flexibility.

Hunt 56, a stiff point with a heavy line and medium flexibility.

Hunt 99, a stiff pen capable of a wide range of line weight.

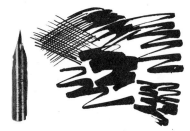

Hunt 100, an extremely flexible point resulting in an unbelievable range of line weight.

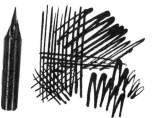

Hunt 101, a stiff pen with a heavier line weight and a limited range of flexibility.

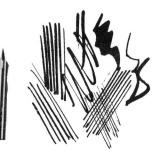

Hunt 102, a fairly stiff pen that still offers a good range of line weights and gives a nice fine line.

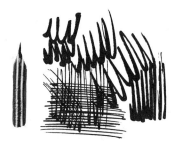

Hunt 103, a point that isn't as flexible as the 100 but has a great range in line weights.

Hunt 104, a very stiff pen capable of drawing a very fine line.

Hunt 107, a very stiff point with little range of line weight— excellent for drawing even lines.

Hunt 108, an extremely flexible point with a superb range of line weights.

Hunt 513 EF, a good stiff point with a heavier line and a shallow range—very good for drawing an even line.

Gillott 659, a quite flexible point offering a great range of line weights as well as a nice fine line.

Gillott 1950, a stiff point with a limited range of flexibility—capable of drawing very fine lines.

Gillott 303, a fairly stiff point with a heavier line and a limited range of line weights.

Wm Mitchell 0851, a stiff, flat-pointed lettering pen producing a heavy line in one direction and a finer line in the other.

Wm Mitchell Script pen 0870, a stiff pen of little flexibility having an ink reservoir and drawing a thin even line.

Iserlohn, a stiff point with a heavier line weight and a medium range of flexibility.

Iserlohn 515, quite a stiff point with a limited range of line weights.

Speedball A-5, a stiff point (with an ink reservoir) that draws a heavy, uniform line—there are many other points in this series in every size and weight imaginable.

Speedball LC-4, point made for left-handers for lettering—it is fairly flexible and offers a good range of line weights.

made of noncorroding alloy steel—it's a good general drawing tool, especially for outdoor sketching.

The Mars 700 series of technical pens also functions on the refillable cartridge principle; the Mars 720 series has an automatic piston-action filling system. Both Mars pens are produced in a range of nine sizes, all color coded.

The Castell TG technical pen uses a drawing cone that has no screw-threading that can become encrusted with dried ink. The cone can be removed and replaced in seconds with a cone extractor for cleaning and refilling. Specially tempered, long-wearing, replaceable steel points are available in nine different sizes.

The Koh-I-Noor Rapidograph pen has its own automatic filling system—again, replacement points are available in nine different sizes and two styles.

You can purchase technical pens singly or in sets that include several pens and points. I recommend that you try out a couple of different brands before you invest in an expensive set. Each brand differs slightly in features or in operation—you'll have to decide which one you prefer.

INKS

You should use black India ink for most of your drawings. It is a permanent waterproof ink. A water-soluble black is also available, which is excellent for adding washes to India ink line drawings. Colored inks are brilliant, creating vibrant tones, and they are a pleasure to use, working well on most papers. Colored inks can easily be used to achieve flat tones, and they blend well. Other paints, such as watercolors, are more difficult to use.

MARKERS

Markers are available in a multitude of shapes and sizes, and they are equipped with a wide variety of drawing nibs. Some are capable of producing very fine lines, others medium and bold lines, and some can be used to draw a variety of lines with the same nib. The nibs are usually pointed, bullet-shaped, or of multifaceted, wedge-shaped styles. The wedge-shaped style is the most versatile, capable of producing an amazing variety of lines. This type of nib is also the best for rendering large, flat areas of tone. The shapes of the marker pens themselves vary a great deal. Some are shaped like regular pens; others are tubular or flat-shaped. Most come with waterproof ink, but some have water-soluble ink. Both kinds can be used for special effects. Color markers also come in various styles, but the most versatile has the multifaceted, wedge-shaped nib.

PAPERS AND BOARDS

The many fine papers for drawing in ink are generally available in hot-pressed, cold-pressed, or rough surfaces. A hot-pressed surface is smooth; it is sometimes referred to as a plate or high-finish surface. Its smooth surface is excellent for pen techniques because the pen can glide over the surface without catching its point in a toothed texture. A cold-pressed finish is versatile and has a medium-toothed surface suitable for pen, brush, pencil, paint, and washes. Rough surfaces are coarsely textured and more suitable for watercolor techniques than for highly detailed work.

Of course, all paper surfaces can be used for almost any purpose, your own imagination being the only limitation. Experiment with all of them to learn how they respond to different pens, brushes, and ink. Also try illustration boards—fine-quality papers mounted on stiff backing boards. They are easy to use because of their stiffness; they come in lightweight, single-weight, and double-weight thicknesses. Illustration boards come in three sizes—22″ × 30″ (55.9 × 76.2 cm), 30″ × 40″ (76.2 × 101.6 cm), and 40″ × 60″ (101.6 × 152.4 cm). Bainbridge, Crescent, and Strathmore are all fine brands that make both illustration boards and papers of good quality.

Bristol boards are 100 percent rag-content papers available in plate or kid finish, the latter having a slight surface texture and the former a smooth one. The thickness of bristol boards is indicated by the term *ply,* the number of plys being the number of sheets of laminated bristol. The weights range from 1 to 5 ply. Bristol boards are generally found in two sizes—22″ × 29″ (55.9 × 73.6 cm) and 30″ × 40″ (76.2 × 101.6 cm). Bristol is also available in conveniently bound pads 11″ × 14″ (27.94 × 35.56 cm) and 30″ × 40″ (76.2 × 101.6 cm).

Of course, many fine-quality papers—including rice papers—for printing, etching, block prints, and lithographs can be used for drawing in ink.

DRAFTING TOOLS

At some point, you may want to buy a T square and a triangle, both of which are useful for drawing horizontal and vertical lines and for squaring up drawings. You may also want French and ship curves for ruling curved lines with technical pens on mechanical drawings. Other drawing instruments, such as a ruling pen and ink compass, are very important to the advanced artist when he is drawing mechanical objects. You may find sets of drawing templates in circular and oval shapes, which enable you to draw perfect circles and ovals of varying degrees and sizes, a must.

Most of the items listed here are required only for very advanced work, but you should become familiar with what tools are available and how they are used. Many of these special tools are designed expressly for the convenience of the artist and to help the professional be more efficient and more diversified in his work.

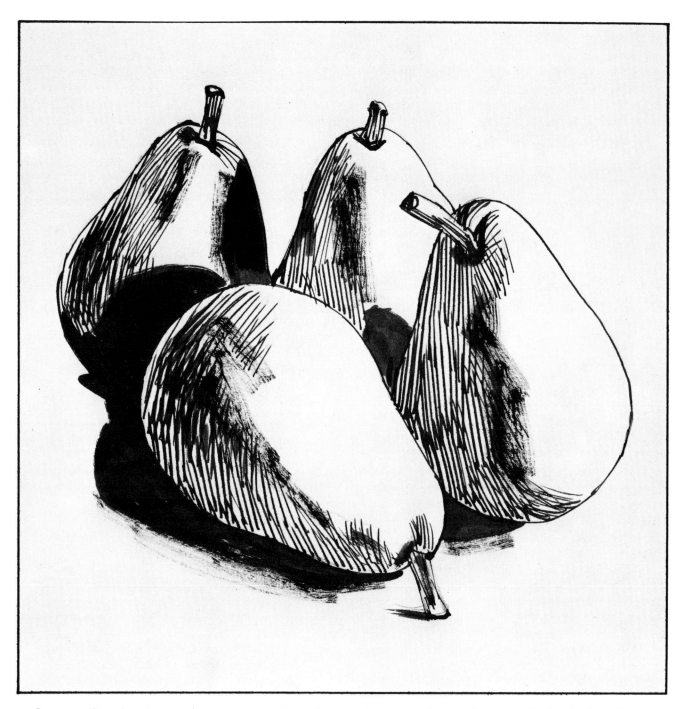

Common Drawing Paper. *The most commonly used paper for drawing has a standard, medium surface texture. It is found in art stores around the world, available in separate sheets or in bound pads of varying sizes. This paper is called cartridge paper by the British. Common drawing paper is good to use for pen and brush ink drawings and even to achieve dry-brush effects. This drawing shows some of the effects that can easily be created with this paper and pen, brush, and India ink. Because the surface texture is very slight, the pen does not catch on the surface. For this reason, quickly drawn pen*

sketches can be also done on it. The kinds of quickly drawn lines I am referring to can be seen on the shadow areas of the pears, which were drawn with a crowquill pen. A number 6 red sable brush was used to indicate the black shadows and the dark division between the light and shadow areas. The soft drybrush edges on the brushstroke-rendered shadows is accomplished by using a brush that is not fully loaded with ink but rather dry. Most types of pens can be used with this paper surface, and it is well suited for brush drawings. Average erasers are no problem, but the paper is not durable enough for fiberglass erasures.

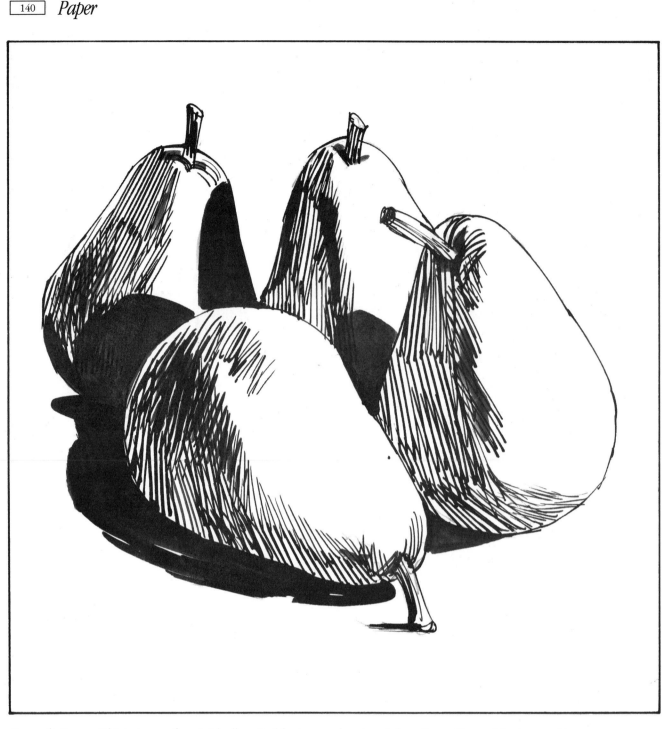

Smooth Paper. *This paper surface is ideally suited for pen sketches. Almost any pen, from the finest to the boldest, will perform well on it. Smooth papers, however, are not suitable for brush drawings. The smooth surface does not catch or offer resistance to the brush. This reduces control slightly. When you become accustomed to smooth papers, brush drawings are possible, but the surface offers a completely different feel from a textured paper. Even with the pen, care must be exercised while drawing so that the pen won't slip. To achieve the proper control in this*

drawing, I drew the outlines of the pears with a common drawing pen, using short strokes rather than a single flowing line. The real advantage to the smooth surface is that highly detailed, finely drawn renderings can be accomplished with ease. Textured surfaces often cause the pen nib to catch or snag, spattering the ink. The pears have been shaded using freely drawn pen strokes without any danger of the pen catching the paper surface. Shadows were added with a number 7 red sable brush. The edges are crisper here than on common drawing paper.

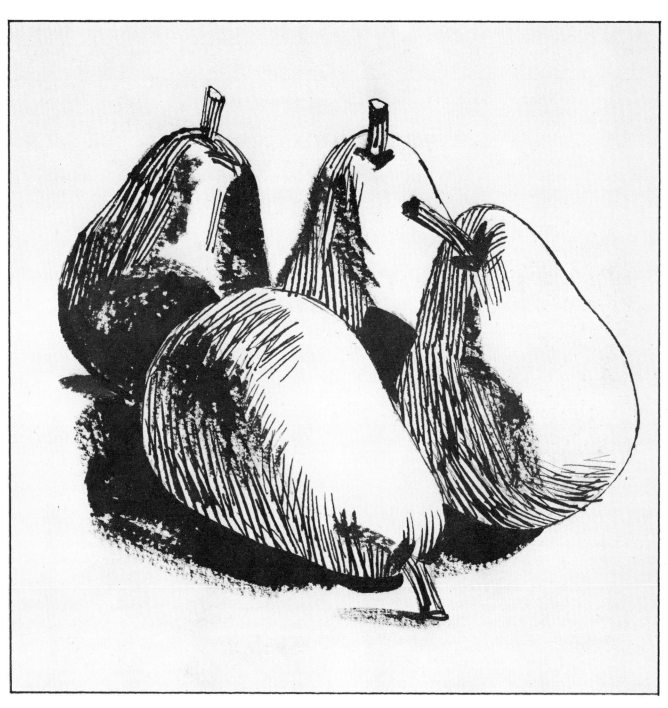

Rough Paper for Pen and Brush. *Although pen drawings can be accomplished on a rough paper surface, this surface is more suited for use with a brush. Because of the surface texture, a pen can easily catch on the paper and cause spattering. If you use a pen on a rough paper, the best approach is to work quite slowly, which alleviates the problem. The advantage of working on a rough surface is that many interesting textures can be created through the use of the drybrush technique. Of course, it is also the perfect surface for wash tones. On this drawing, I first drew in the outline of the pears, working slowly so that the pen would not catch on the surface. The shadows were drawn with a brush. It is much easier to draw a textural line or edge on this paper. To achieve a crisp, hard edge, use a fully loaded brush. Practice working with this paper until you better understand its advantages and limitations. Then you can even learn how to execute quick pen sketches on rough paper.*

12
STROKE TECHNIQUES

DRAWING WITH A PEN or brush may be difficult at first, but with a little practice you'll learn to control these tools and become familiar with their limitations and capabilities. Just as you learned to write the alphabet by practicing the formation of letters that make up words, you'll learn to draw by practicing lines and textures that in combination can represent specific objects. In addition, the combinations of drawn lines and textures that can represent objects, such as grass, wood, trees, or hair, communicate what they represent to the person viewing the drawing the same way a combination of written letters conveys words.

There are an extraordinary number of drawing styles and methods that you can use when drawing in ink. You can develop a very personal style as distinct as your own handwriting. In fact, many artists have developed styles that are easily recognizable even when their drawings aren't signed.

It's very important that you practice drawing, every day if possible—which is as often as you would practice if you were learning how to play the piano. If you do this, drawing with the pen and brush will come to feel very natural, just as writing does now. And as you become more familiar and comfortable with the tools, you'll gain the confidence that will help you to improve and grow as an artist.

The pen and brush have certain limitations that can be learned only by practicing on different illustration boards and paper surfaces. Certain boards have textures that can limit the freedom of your drawing strokes. While the pen may catch on the surface and cause a splatter on a rough surface, the brush will give you great freedom on this same paper. On the other hand, a very slick and smooth surface, the pen will glide along with ease. I personally like to do pen drawings on a slightly textured surface—and being conscious of the possibilities of the pen snagging the surface, I tend to draw more carefully.

Most pen points offer varying degrees of flexibility, resulting in a wide range of line weights (see the chart on pages 136–37). Some points are extremely flexible and capable of a remarkable range of line weights, whereas others are very stiff, producing an even, uniform line. The technical drawing pen also produces an even line because its point is actually a small tube. Its great advantage is that you can draw in any direction on most surfaces without catching.

Brushes are also versatile drawing tools that offer a great variation in linear quality. With a well-pointed brush, you can draw both fine lines and bold lines. To draw a very bold line with this kind of brush, you have to fully load the brush with ink. If this brush is flattened and used with a small amount of ink, it can create a unique dry-brush effect.

The exercises and step-by-step demonstrations in this chapter are designed to help you become confident in the use of the pen and brush. Try to practice at least one or two hours a day and you'll soon gain the necessary control of these drawing tools. This is your first step in becoming proficient with the pen and brush.

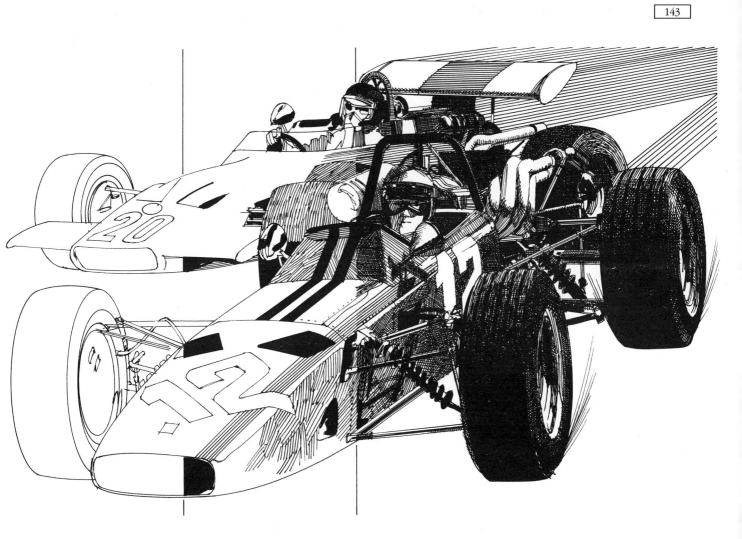

This is how I build up a line and tone drawing (from left to right):
I first pencil in the drawing on the illustration board as a guide for the ink line,
which I do in outline form in ink with a pen (here I used a technical drawing
pen). Next (moving to the right), I add the solid blacks with a number 3 red
sable brush. Adding the solid blacks is an aid for determining the gray tones—it
gives me something to work against. After adding the blacks, I put in the very
lightest linear gray tone. The intermediate tones are built up gradually until the
drawing is finished (right half of the illustration).

Exercise 1. *Shapes and Lines*

Practice drawing various shapes and lines—both fine and heavy, as shown—on a piece of plate-finish bristol board with a crowquill pen. Since the plate-finish board is very smooth, the possibility of the pen snagging the surface is minimized. See what range of line weights you can produce with this particular point. Also try writing with the pen to loosen up. Draw both fast and very slowly, and notice the different line quality. Bear down lightly and then draw using more pressure on the pen point. Hold the pen in a variety of positions and take note of the different results. A little practice like this and you'll learn how the crowquill pen reacts to this particular paper surface. When you finish, try the same thing on other board and paper surfaces.

Here I'm using the crowquill pen as if I were writing. Note how many line variations and textures I am making while the pen is in this position—and try it yourself.

I've changed the position of the pen, and therefore I'm producing a different kind of line. I'm stroking the pen sideways, quickly drawing a series of lines.

Also practice writing with the crowquill pen....

Practice drawing groups of lines and textures, such as the ones below, with first a pen and then a brush. Try a variety of pens and brushes to see how they differ.

Very quickly done, drawn with an even pressure.

Lines drawn slowly, moving the pen up and down slightly.

Same as above, but using more pressure on the point.

Lines of different weights drawn using a zigzag motion.

Lines drawn with a nervous motion and even pressure.

Drawn by varying the pressure on the point.

Lines formed by drawing short overlapping strokes.

Series of small loops.

Various dotted or broken lines.

Quickly drawn brush lines.

Slowly drawn brush line.

Zigzag brush line.

Line using more pressure on the brush tip.

Loose, short brushstrokes forming a scratchy line.

Brush line drawn with a nervous motion.

Split brush line.

Exercise 3. *Pen Lines*

Now concentrate on all sorts of pen lines, experimenting with spacing, pressure on the point, and curves. In the following nine groups of lines, draw the first lines (at the top or on the left of the square) straight, uniform, and evenly spaced. Draw the next lines closer together; the ones following as close to each other as possible without touching; next, nervous and scratchy lines; nervous, scratchy lines drawn with more pressure; and finally (at the bottom or on the right of the square) loose random lines.

Horizontal lines.

Vertical lines.

Varying the pressure on the point.

Controlling the weights.

Lines of varying weights created by increasing pressure on the point.

Quickly drawn lines of different weights.

Vertical strokes drawn by varying pressure on the point.

Curved lines drawn slowly.

Curved lines drawn very quickly.

Ruling with the pen is a very useful technique. Try drawing first thin and then heavier lines by varying the pressure on the pen point—try to duplicate the lines illustrated below. After a while, use a brush—this is a little harder to do and you may find it quite difficult at first. Rest the ferrule of the brush against the ruler and very carefully draw a straight line, maintaining an even pressure on the point.

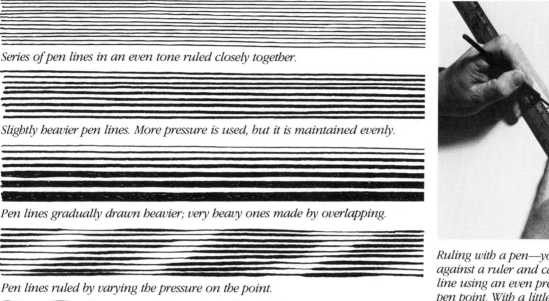

Series of pen lines in an even tone ruled closely together.

Slightly heavier pen lines. More pressure is used, but it is maintained evenly.

Pen lines gradually drawn heavier; very heavy ones made by overlapping.

Pen lines ruled by varying the pressure on the point.

Pen lines ruled using a nervous motion, creating a texture.

Ruling with a pen—you rest the pen against a ruler and carefully draw a line using an even pressure on the pen point. With a little practice, you'll gain the necessary control to draw in this manner. Please note that you can also do this with a brush instead of a pen.

Series of lines in an even tone ruled closely together with a brush.

Slightly heavier brush lines, drawn with more pressure.

Brush lines gradually drawn heavier.

Lines ruled by varying the pressure on the brush point.

Brush lines ruled using a nervous motion, creating a texture.

Exercise 5. *Brush Lines*

These brush exercises are the same as those suggested for the pen in Exercise 3. Practice them many times until you can do them with ease. Be sure to use a high-quality red sable brush—numbers 2 or 3—or you'll have problems. Cheaper brushes either won't maintain a good point or will split, making it impossible to draw fine lines.

Horizontal lines.

Vertical lines.

Varying the pressure on the point.

Controlling line weights.

Lines of varying weights created by increasing pressure on the brush point.

Quickly drawn lines of different weights.

Vertical brushstrokes drawn by varying the pressure on the point.

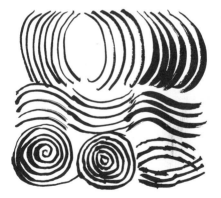

Curved lines drawn slowly.

Curved lines drawn very quickly.

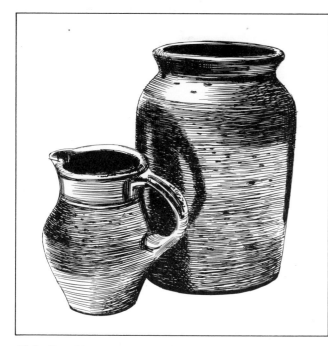

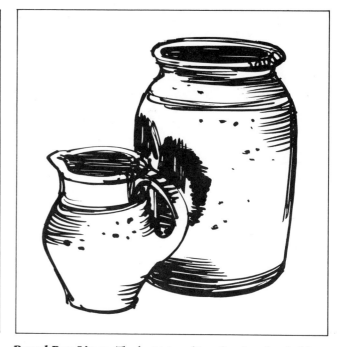

Thin Pen Lines. *A variety of tones can be created with thin pen lines. The best materials to use are a crowquill pen, which produces thin lines easily, and a smooth paper surface. The tones here depend on how the lines are drawn: close together, overlapping. Very fine lines and delicate shading are possible with this pen.*

Broad Pen Lines. *The best type of pen for drawing bold lines has an ink reservoir and a round or oval point. This drawing, done on a smooth surface, uses bold, linear strokes of the pen. The pen was used very much like a thick sketching pencil, first sketching the outlines, then adding the form and shadows with quickly drawn pen strokes.*

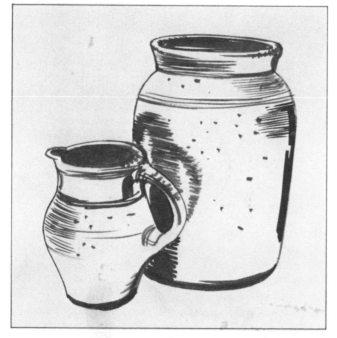

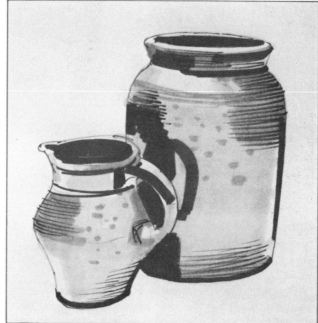

Brushstrokes. *For this sketch I used a number 7 red sable brush on drawing paper. This paper has a slight surface texture, which makes it quite suitable for brush drawings. I first carefully inked in the outline of the jugs, then added the tones using brushstrokes that follow the form of the objects. The heavy black accents and shadows were drawn in last.*

Marker Strokes. *I drew this sketch on common drawing paper. The outline was drawn first with a fine marker pen, then the light tone was added, followed by the darker gray tone. The heavy black accents and shadows were drawn in last with a bold marker. Without the tone, this drawing would resemble the broad pen or brush drawing.*

Make ink drawings of various objects around your house. Do careful, simple outline drawings at first, and try to use as few lines as possible. Study the object and visualize the lines that are important to explain the object graphically. As you may know, you can create a great deal of form with a line by paying attention to perspective and by drawing the right lines in front of one another. Line without tone can be a very effective technique if properly handled.

After doing a few very simplified outline drawings, try some that are more detailed—but still without tone. Next, do some drawings with shading. All of these drawings can be done with pencil, Pentel, or Pilot felt pen if you wish, but I suggest using a crowquill pen so that you become familiar with its qualities and limitations.

I picked these objects—the ink bottle, shoe, candlestick, and jar— at random to demonstrate the kinds of drawings I mean. Pick out fairly simple objects like these at first, and later go on to tackle more complex subjects such as houseplants or even outdoor scenes.

This sketch, of the ink bottles on my taboret, is very fast and loose. You should practice doing many drawings in this vein. Don't worry about drawing through objects and lines— this will help you understand form much better.

I did these shoes in two ways—the one on top is a simple linear representation, carefully done. In the bottom version I added a few simple tones that create the illusion of form and depth.

The candlestick at the left is drawn in very simplified form, devoid of any detail. Try to think in these terms for your first attempts—break everything down to bare essentials and draw using as few lines as possible. To the right of this candlestick is a very carefully done drawing in which all the important details are included. The center candlestick is a more advanced representation—even the shine of the metal is simulated. Moving to the right again is a very loose pen sketch. It takes a good deal of confidence in yourself and knowledge of your tools to be able to do very free direct sketches like this. When you do free drawings, don't be too concerned if a line here or there isn't quite in the right place. These are sketches, and some of the accidental qualities that result can enhance a drawing. The candlestick on the far right is a brush drawing done with a number 3 red sable.

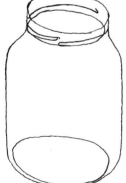

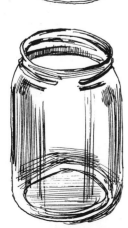

The jar on top is very simply yet fully rendered—but it takes just a few moments to do sketches like this. Neither of the jars is perfect (the ovals are off a little), but it really doesn't matter. Your drawings don't have to be perfectly accurate; if you feel you've made some major errors, just start over. Your next attempt will be much better. The important thing to remember is to do a lot of drawings of many different objects. This type of practice will be the foundation of your later work.

Step 1. *Drawings done with a fine pen are much easier to do on a smooth-surfaced paper than on a paper with a pronounced surface texture. When attempting a complicated subject with pen and ink, first do a pencil sketch on the paper that you will be using. This sketch will serve as a handy guide for doing your ink rendering. Here I used an HB grade graphite pencil for the underdrawing, first drawing in the long branches and vines, then adding the leaves, flowers, and other foliage. All were drawn in outline form.*

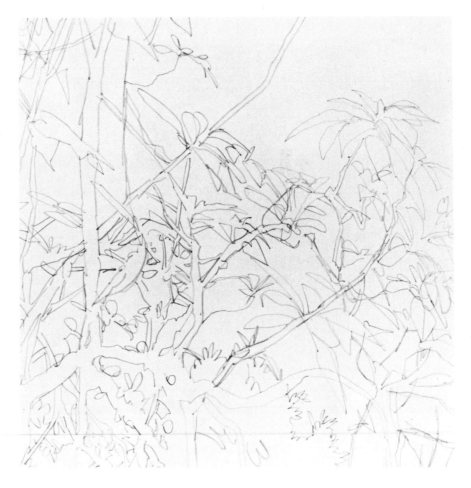

Step 2. *Now, using a crowquill pen— the best choice for drawing thin lines—I began to ink in the drawing using India ink. Uniform black lines were created with India ink, which dries waterproof. Other inks created lines that are gray and can smudge if not waterproof. Because of the overlapping branches and leaves, this is a rather complicated subject. Great care must be exercised during this stage to ensure a drawing that will not have to be corrected. Since this is not a quick sketch but a detailed rendering, it must be inked more carefully. After completing the outline drawing and letting the ink dry completely, I erased the pencil underdrawing with a kneaded rubber eraser.*

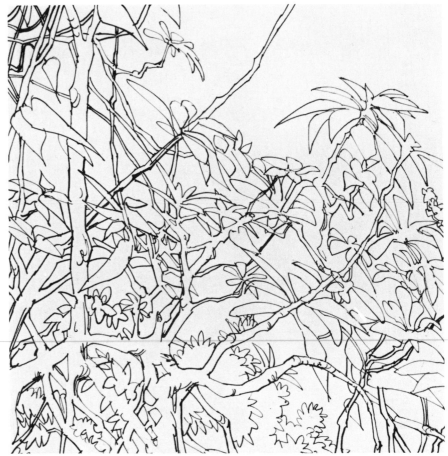

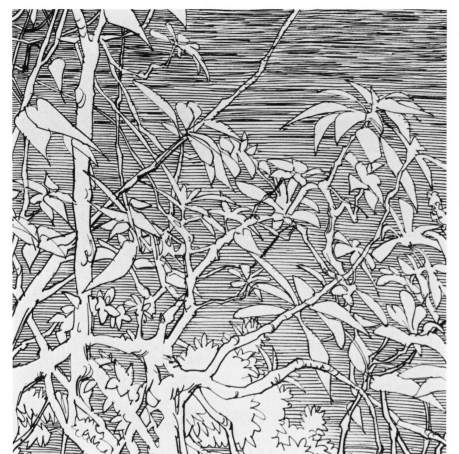

Step 3. *On the river behind the foliage, I drew a tone, covering the whole background before proceeding with the rest of the inking. This tone, with its carefully drawn horizontal lines, is fairly even because the lines are of equal weight and uniformly spaced. To darken the top portion, I added more horizontal lines, some drawn over the others, creating a slight tone variation on the water. Drawing horizontal freehand lines can be difficult for the beginner, but practice will help you master this in a short time. The lines used for a tone like this need not be perfectly drawn, as you can see in this drawing.*

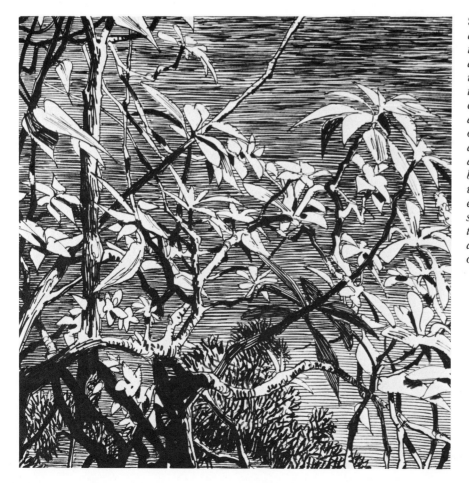

Step 4. *Using the pen, I added the darkest tones to the branches, filling them in so they are solid black. This also can be done with a brush. I waited before continuing because it takes some time for the ink to dry completely. The background tone appeared too light, so another series of lines was drawn over the area, darkening the tone sufficiently. I also darkened the upper area of the water by drawing in more lines, many of which overlapped, creating a rippling effect in the river. Using short zigzag strokes, I drew a leaflike texture over the bushes. The leaves in shadow were drawn, and some texture was added on the bark of the thicker branches.*

Demonstration 2. *Working with a Broad Pen*

Step 1. *Planning is an important part of any ink drawing. I began this scene by first doing an accurate pencil sketch with a 2B grade graphite pencil on common drawing paper. Because the scene has so many elements, the pencil underdrawing was invaluable for doing the ink rendering. Notice that in my pencil drawing it was quite easy to determine which areas were the rocks and which consisted of foliage-covered areas. This is clear because of the different lines used to delineate the various elements. The squiggly lines are easily identifiable as foliage areas. When I drew the rocks in the foreground, I indicated the division between light and shadow.*

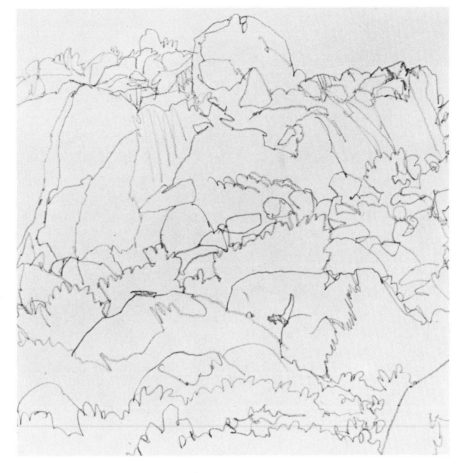

Step 2. *There are several types of pens suitable for drawing bold lines. Some pens are equipped with an ink reservoir, which holds more ink, enabling an artist to draw longer without refilling. Some of the choices of points are round, oval, flat, square, or chisel-shaped. Some normal pens are quite flexible and can also be used to draw bold strokes. I decided to use a pen that has a flat chisel shape. This enabled me to draw bold strokes as well as finer ones, depending on which way I held the pen while drawing. I inked in the basic drawing using the flat edge of the pen, which creates bold lines. Some of the shading on the rocks was done using the pen in a manner to draw finer lines.*

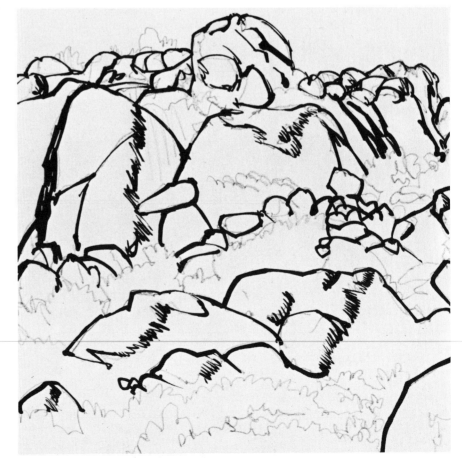

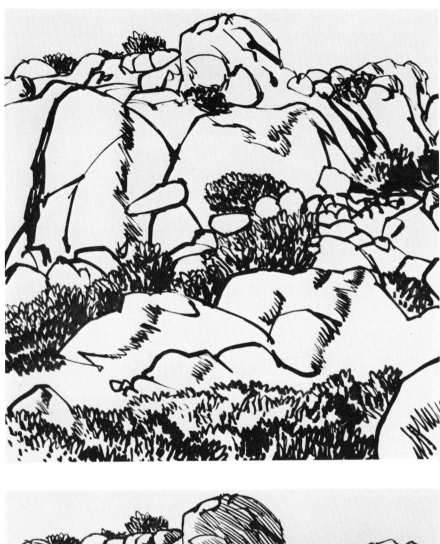

Step 3. *I now added the tone to the foliage-covered areas, simulating the texture of leaves by drawing zigzag strokes. I also spotted black shadow areas throughout the foliage. Because the ink had built up in these areas, I had to be sure it was thoroughly dried before continuing the rendering. The scene was developing, with all the rock formations and foliage areas clearly defined. When the ink had dried completely, I erased the pencil underdrawing with a kneaded rubber eraser.*

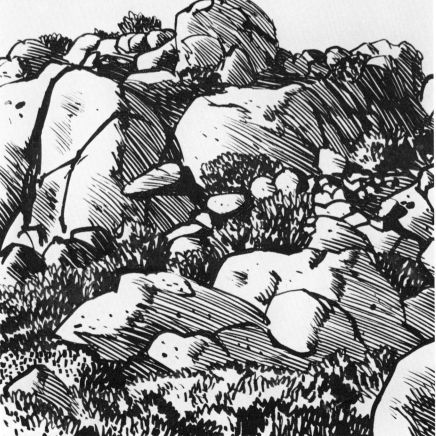

Step 4. *I added the medium-gray shadow areas on the rocks, drawing with the pen in a horizontal direction to create finer lines. Many of these lines were drawn to follow the form, which helped create the illusion of depth. When I drew these tones I began at the top and worked down, eliminating the possibility of smearing the freshly inked lines. Next I added some textures to the rock formations using short strokes and dots of ink. Then, I finished the foreground grassy area by drawing with short vertical strokes. The shadow areas were darkened by drawing overlapping pen strokes. Notice that much of the outline that was first drawn has disappeared and the various elements are separated by tones.*

Demonstration 3. *Working with a Brush*

Step 1. *Drawing with a brush and India ink is possible on most papers, but I prefer a rough surface so that the textures can be used as part of the picture. When you do brush drawing, use only the finest-quality brushes because the cheaper ones are difficult to use and will not hold up very well. For this drawing I used a number 4 red sable watercolor brush with India ink on a rough-surfaced watercolor paper. Before I did the inking, I first did a pencil sketch of the scene with a 2B grade graphite pencil. This drawing was done quite simply, but it accurately depicts the scene.*

Step 2. *Using the number 4 red sable brush with India ink, I carefully began rendering over the pencil sketch, outlining the various elements in the scene. I spotted in a few shadow areas on the ground and on the rocks, and then added the pine needles to the trees by drawing short strokes with the brush. I indicated some bark texture on the trees using less ink in the brush, which resulted in a drybrush effect. I used this same effect when drawing in the division separating the light and shadow areas on the large rock. Then I drew in the foreground bushes and indicated the shadow areas.*

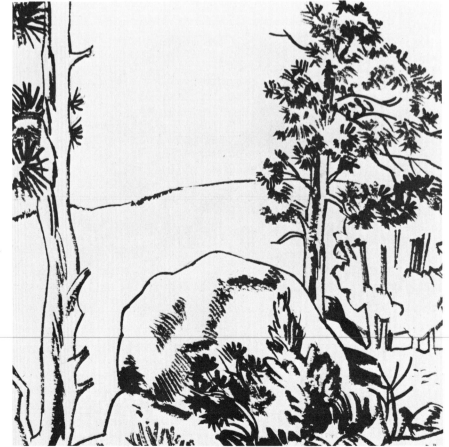

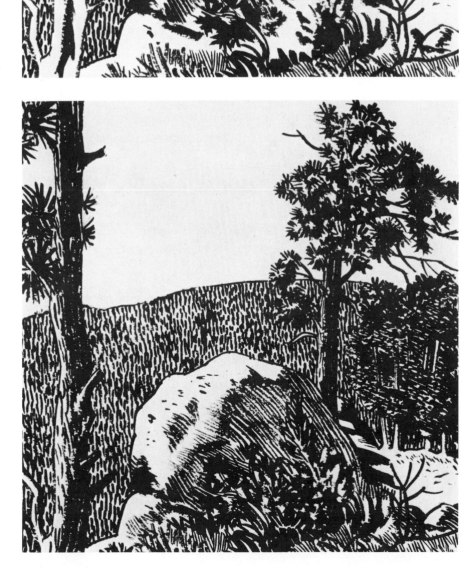

Step 3. *I drew in the foreground grass using finer brush lines. Then, over the background mountain, I drew a series of vertical strokes to depict the texture of the distant trees. I next drew a leaf texture over the trees on the right side of the picture and drew the shadow areas over this tone. Notice that I have been careful not to ink over the tree trunks; I let them remain white. I drew all the foliage and shadows on the large pine tree on the right, then rendered the trunk of the tree in shadow. At this point, the picture was almost completed.*

Step 4. *Next, I drew the shadow area on the large boulder in the foreground, using carefully inked lines that follow the form. I darkened the division between the sunlit area and the shadow using a brush more loaded with ink to achieve a dense black. Details were drawn in the foreground bushes to complete this area. I darkened the tree trunk on the left, leaving a little paper texture showing to create the effect of bark. I also added brushstrokes on the sunlit side to simulate the ridges of the bark. I added more strokes to the mountain in the background to create a variation in this tone. Notice how all the different textures helped define the various elements.*

Demonstration 4. *Working with a Thin Marker*

Step 1. *Marker pens are very handy drawing tools that can be used on most paper surfaces with ease. The pen I used for this drawing had a medium-sized fiber tip and nonpermanent ink. The tip was firm but soft enough to make it possible to draw lines that vary in weight. I did the basic line drawing directly on smooth-surfaced paper with the marker pen.*

Step 2. *I drew the medium gray tone on the background wall using random strokes to simulate the unevenness of the wall. Although I drew the lines freely, I was careful not to render over the door area. I drew the wood grain texture on the wooden door. This obscured the lines that separate the wooden boards, so I redrew them, using heavier lines.*

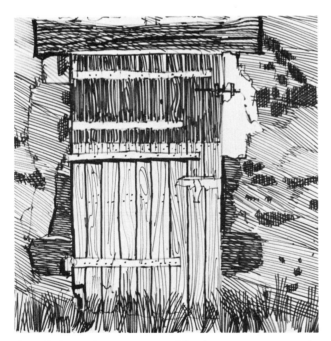

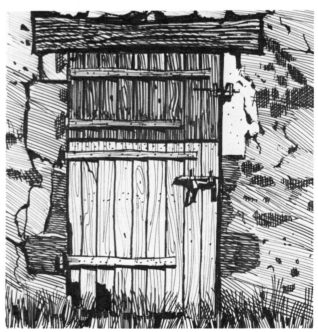

Step 3. *Since the top section of the door was constructed of darker wood, I drew this area with closely spaced lines to create a dark tone. Some of the stones in the wall were also dark, and for them I used a crosshatch effect. The use of these various textures helped clarify the different elements in the drawing. The dark beam was drawn above the door.*

Step 4. *Shadows were added around the door and under the hinges and door latches. A bit of texture was added to the wall area, finishing the drawing. The marker pen is a perfect drawing tool for outdoor sketching because it carries its own ink supply and doesn't need sharpening like a pencil. Try out a number of types until you find the size and tip you prefer drawing with.*

Step 1. *Broad-tipped markers are available in a variety of styles. For this demonstration I used a bottle-shaped marker with permanent ink and a multifaceted, wedge-shaped nib—a very versatile drawing tool. I began by first doing the basic drawing with a 2B grade graphite pencil on common drawing paper. I drew the foreground tree first, then added the background.*

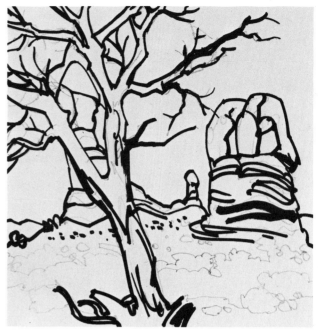

Step 2. *Since it is impossible to draw fine lines with this marker nib, I inked in the drawing with boldly rendered strokes with few details. Different weights of lines can be achieved by using the various edges of the wedge-shaped marker nib. The thinnest lines on this drawing were done by using the very front edge of the nib; the heaviest lines were done using the widest edge.*

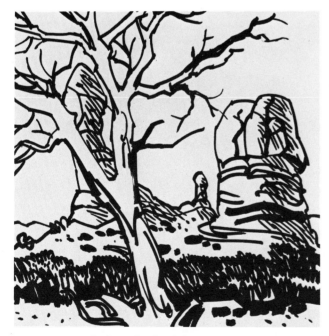

Step 3. *Using the broad side of the nib, I drew in the middle-ground underbrush areas. These appear quite dark, but some paper texture is left showing through. I next added tones to the buttes in the background, indicating the shadow areas by using linear strokes. More bushes are spotted in by drawing short strokes with the widest edge of the nib. I erased the pencil underdrawing with a kneaded rubber eraser.*

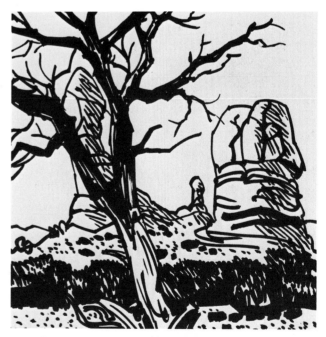

Step 4. *Next, I darkened the upper branches of the tree so that they were silhouetted against the background. More darks were added to the middle-ground bushes, and dot textures were drawn on the ground to simulate stones and rocks. This very fast sketch technique can be used to draw just about any subject, but you must work in a simple, bold manner without drawing many details.*

13
BASIC TONAL TECHNIQUES

THE ADDITION OF TONE to a drawing can add a great deal of dimension, texture, and mood. A good way to establish where the tones should go is by doing rough pencil sketches of your drawing on tracing paper. After working out the sketch to your satisfaction, you can use it as a guide when adding the tones to your ink drawing.

To establish tone in a pen drawing, you can use a variety of lines. By making the lines different weights of varying sizes, your tonal values can range from light to heavy. You can use a hatching technique, straight lines, zigzag lines. Washes can be added to your drawing for tone. Markers can introduce a note of spontaneity, giving a drawing a fresh appearance. On the following pages, you will see various exercises and demonstrations to assist you in learning how to work with pen and ink to achieve interesting gradations of tone in your work.

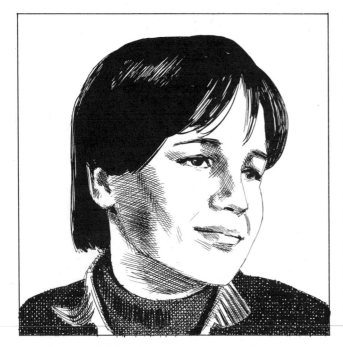

Hatching. *I did this drawing on common drawing paper with a crowquill pen for the lines and a brush to render the solid black areas. When drawn over one another in a crosshatch method, lines create tones. Their values are determined by how thick the lines are and how close together they have been drawn. You can see how thick the lines are in the darkest tones in this drawing.*

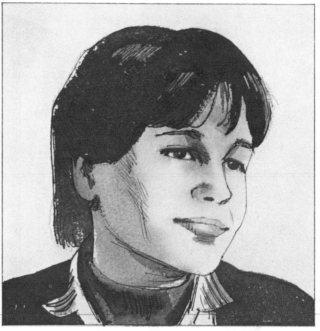

Pen Line and Wash. *Water-soluble ink washes are excellent for adding tones to India ink drawings. The best paper to use for this method is rough watercolor paper. The ink is diluted with clear water to the desired tone, then it is washed over the appropriate areas in the drawing. Additional tones can be added or blended over the first wash while the paper is still damp.*

Experiment with the pen again, exploring tonal value created by straight, crosshatching, and zigzag lines.

Top: short, vertical strokes. Center: strokes drawn with more pressure. Bottom left: lighter lines drawn close together. Bottom right: heavier lines drawn very close.

Top: vertical strokes with horizontal lines drawn over them create a crosshatched effect. Bottom: heavy vertical and horizontal lines.

Top: lines drawn close together and then gradually farther apart produce a gradation of tone. Bottom: a crosshatched tone gradation.

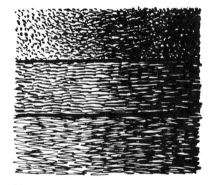

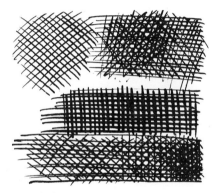

Top: up-and-down pen strokes drawn close together form a gray tone. Bottom left: a heavier zigzag line. Bottom right: zigzag lines crosshatched.

Top: very short pen strokes, graduated. Center: longer dash strokes, graduated. Bottom: zigzag lines, graduated.

Top left: crosshatched lines. Top right: crosshatched lines over the previous tone. Center: crosshatched lines with more pressure. Bottom: graduated crosshatched lines.

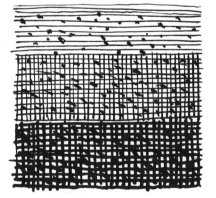

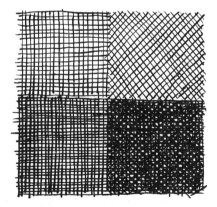

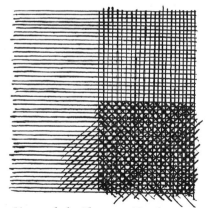

Straight and crosshatched lines with dots drawn to create a different texture.

Top left: even crosshatching. Top right: 45°-angle crosshatching. Bottom left: a heavier but even crosshatched line. Bottom right: the top right and left patches drawn heavier and over one another.

Lines ruled with a pen. Total square: lines drawn horizontally. Right: lines drawn vertically. Bottom right: two sets of lines at 45° angles.

Exercise 9. *Simplifying Drawings*

A drawing can be made more effective and interesting with tones. As you may know, simplifying drawings isn't always an easy task—it sometimes takes a great deal of planning to decide what lines to leave out of a drawing. These examples demonstrate the variety of ways textures and tones can be added and how different the drawings can look as a result.

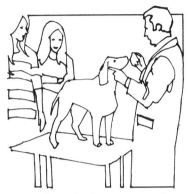

Notice how few lines are used to portray the girls. And the man's collar isn't even drawn in.

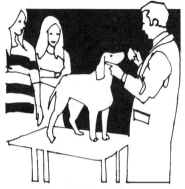

A simple, solid black is added—it makes a very effective combination with the line.

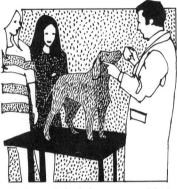

Stipple and dash lines are added—the dots in the background, fairly even spaced, create a flat tone.

Papers on the table break up the outside shape.

Three flat gray tones and black accents augment the outline.

An almost solid black version is very strong and dramatic.

Again, the outside shape is broken at the girl's head.

Two simple line tones and a strong black shadow are added.

Rule pen lines create a tone here— a brush adds accents.

This exercise will help you learn to interpret gray values into ink line. Take a black and white photograph—your own or one from a magazine—preferably of an outdoor landscape scene. Try to break the photo down into simple gray tones before making a line drawing of it. It's a good idea for you to actually do a few value breakdowns such as this of several photographs.

I used Winsor & Newton designers colors, black plus grays Nos. 1, 2, 3, and 5 for this example, but you could also use gray markers on layout paper. I frequently do marker sketches to solve value problems on complex ink drawings.

When you finish one of these diagrammatic value studies, set it next to the photograph and stand back to view them. If properly done, the gray-toned sketch will be difficult to distinguish from the photograph. After that, make your line drawing.

Photograph of a landscape.

Try to visualize the photograph broken down into simple gray tones and shapes—like the ones I painted here. I don't do sketches like this for every drawing, but this is how I try to visualize every scene or object before starting.

I left this ink line interpretation unfinished so that you can study how it was done. First I did a pencil drawing, and then I put in the light gray tone of the grass. Next, I added a darker background and the very dark areas. Finally, I added textures to the trees to simulate leaves.

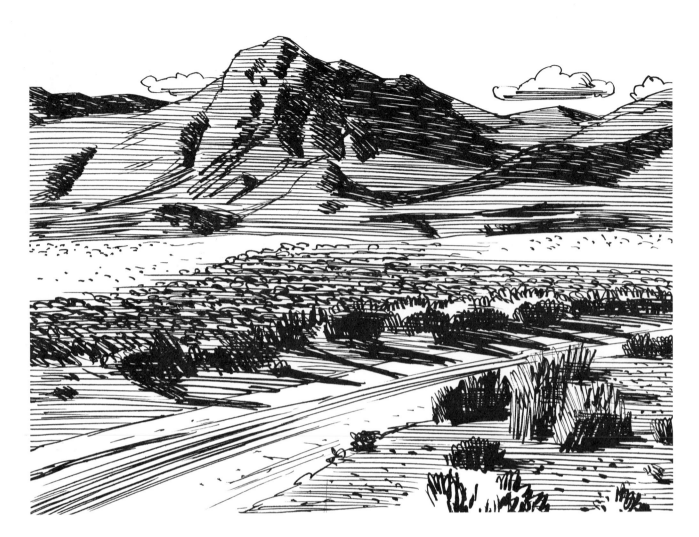

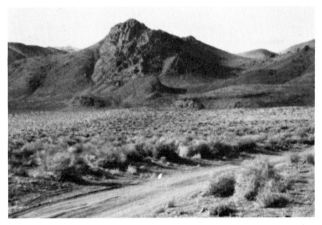

Two Values Plus Paper. *This drawing, done with a crowquill pen on common drawing paper, is an interpretation of the photograph reduced to two gray tones and the white of the paper. As the darker tone would be used on the shadow areas, the key to the simplification was to determine just which areas would be pure white and where the light gray tones would appear. I decided that the sky, middle-ground area, and the road in the foreground would be pure white. All other tones would be a light gray, and darker tones would be used for the shadows. I used horizontally drawn lines for the light gray tone. In the middle-ground area I darkened the tone by adding a texture to simulate foliage areas. The dark gray tones are made up of lines drawn very close together, most of them overlapping, creating an interesting textural quality. You can see the three distinct tones used here: the white of the paper, the light gray, and the darker shadow tone. Some of the tones have been altered slightly because of the lines and textures drawn over them to indicate the bushes and foliage.*

Three Values Plus Paper. *This drawing was done on common drawing paper with a crowquill pen and a number 4 red sable brush. In simplifying this scene, I first determined that the pure white areas should be the sky, the light portion of the arch as well as the area directly behind it, and the details of the ruins on the right side of the picture. The rest of the scene would be made up of a light gray value, a medium gray, and black. I felt that the road in the foreground would work better in a light gray value because if I used the same value as the photograph, the whole drawing would appear too dark. I began by drawing the first value, the lightest gray tone, working over a basic pencil underdrawing using a crowquill pen with India ink. This tone can be seen to the left of the arch, through the arch, on some of the ruins at the right side of the drawing, and on the street in the foreground. The second value, the medium gray tones, was then drawn on the darker portion of the arch, on the wall next to the road, and throughout most of the background using the same pen. The third value, the solid black, was added next, using a number 4 red sable brush. I silhouetted the trees on the hill against the background and carefully drew in details on the arch.*

Demonstration 6. _Working with Three Values Plus Paper_

Step 1. _This demonstration was drawn on common drawing paper using only three tonal values plus the white of the paper. A complicated scene with architectural elements, it required an accurate basic underdrawing. This drawing was done with an HB grade graphite pencil, starting with the foreground lamppost, and then the middle-ground area with the statue. Next, the figures and the background buildings were drawn in. I also added most of the details, such as roofs and windows on the buildings. The paving stones, which created the pattern on the sidewalk, were carefully drawn in, maintaining the correct perspective._

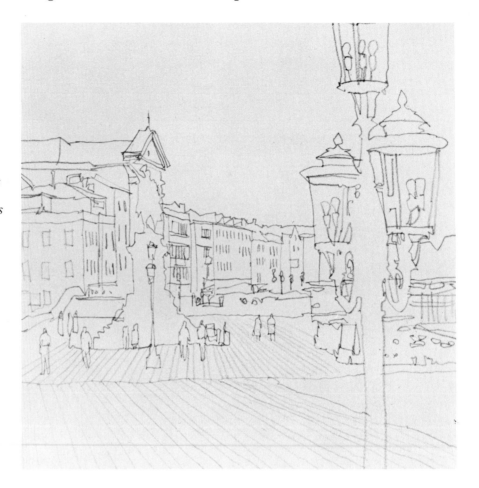

Step 2. _To begin the ink rendering, I added the lighter tones on the buildings in the background with a crowquill pen and India ink. A few tones were drawn on the lamps in the foreground. The lines formed by the paving blocks were drawn in—a job made easier because I could use the pencil lines as a guide. The inked lines, however, had to be drawn carefully so that they would be the same weight and spaced fairly evenly to create a uniform tone. After drawing the railing on the background bridge, I added a few pen strokes on the foreground area to the right to indicate the pattern of the paving blocks._

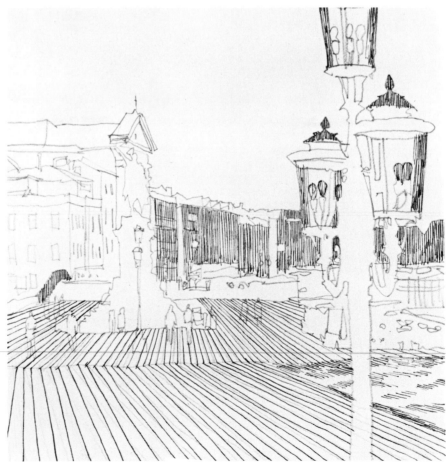

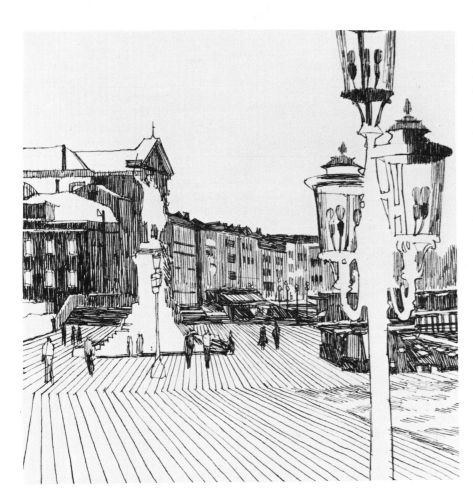

Step 3. *Next, I added the second tone, the medium gray value, making certain that the tone was uniform by spacing the drawn lines evenly. Actually, the same kinds of pen strokes were used to render the medium tones as the light value, but the lines were slightly heavier and they were drawn closer together to create a darker tone. Compare the medium tone on the buildings at the left with those in the center of the drawing. The heavier lines were achieved by using more pressure on the pen while drawing. Using the medium tone, I now indicated the remaining elements in the scene. I sketched the awnings and other details on and around the buildings. I began to add more darks to the lamps.*

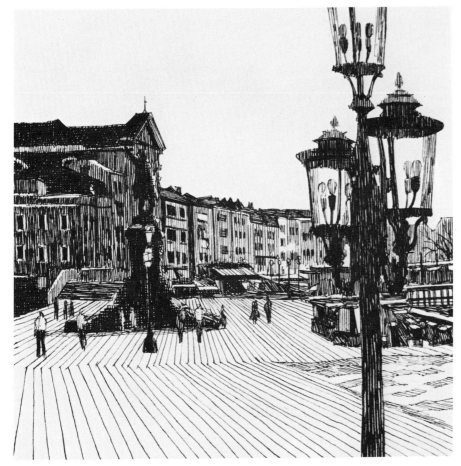

Step 4. *The darkest tone, the third value making up the scene, was drawn using lines drawn very closely together, almost creating a solid black. In some of the areas, such as on the statue and the roof of the larger building, I used a crosshatch technique, drawing lines at right angles to one another. This creates a uniform dark tone that has a slight surface texture. The right-hand edge of the statue was left light to indicate the sunlit areas. The lamppost was filled in next, using vertically drawn overlapping pen strokes to create a dark tone. More details, such as the windows, some tree branches, and solid black accents of shadows, were drawn. The paving stones on the right were outlined with a fine pen line.*

Demonstration 7. *Working from Sketch to Tone*

A good way to establish where tones should go is by doing rough pencil sketches of your drawing on tracing paper. After working out the sketch to your satisfaction, you can use it as a guide when adding tones to your ink drawing.

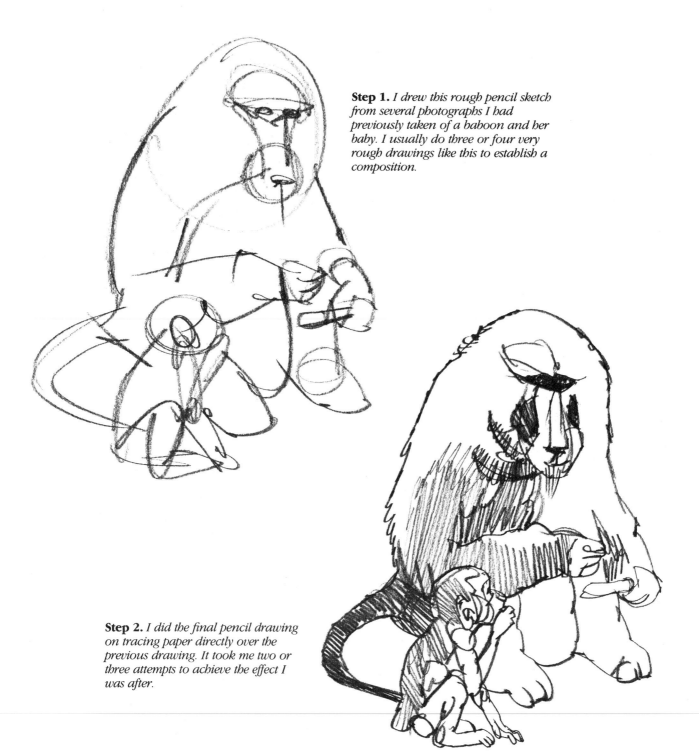

Step 1. *I drew this rough pencil sketch from several photographs I had previously taken of a baboon and her baby. I usually do three or four very rough drawings like this to establish a composition.*

Step 2. *I did the final pencil drawing on tracing paper directly over the previous drawing. It took me two or three attempts to achieve the effect I was after.*

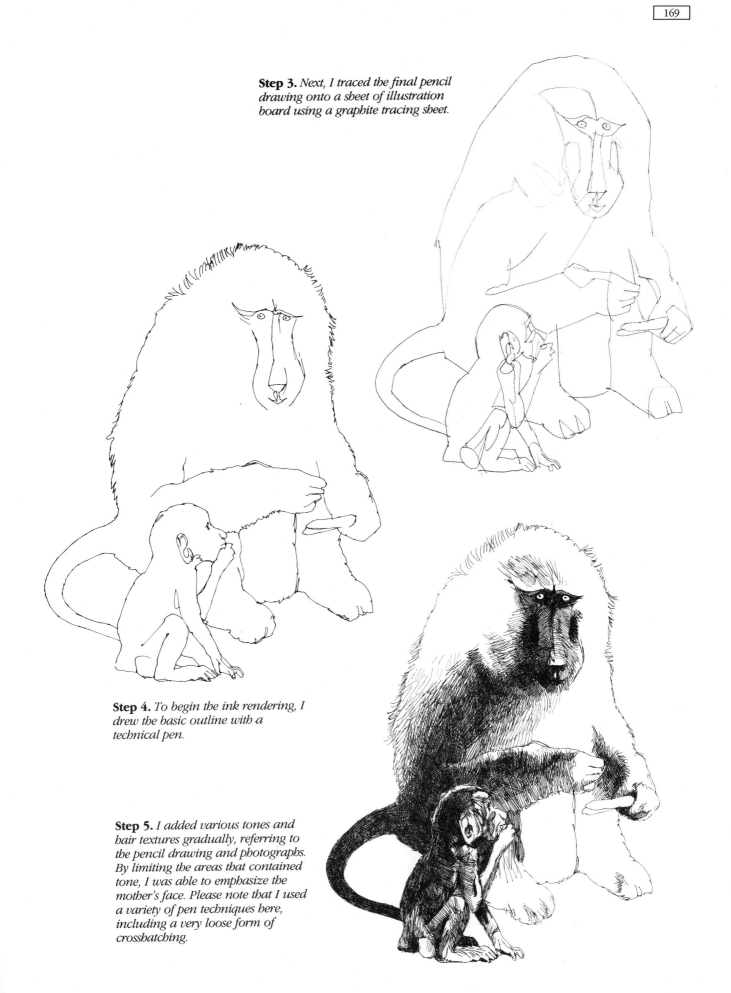

Step 3. *Next, I traced the final pencil drawing onto a sheet of illustration board using a graphite tracing sheet.*

Step 4. *To begin the ink rendering, I drew the basic outline with a technical pen.*

Step 5. *I added various tones and hair textures gradually, referring to the pencil drawing and photographs. By limiting the areas that contained tone, I was able to emphasize the mother's face. Please note that I used a variety of pen techniques here, including a very loose form of crosshatching.*

Demonstration 8. *Using Pen Outline and Hatching*

Step 1. *After making a pencil drawing, I used a standard pen nib in a holder to outline the various elements. I drew rather freely, taking care not to actually trace the pencil underdrawing so that the finished rendering wouldn't look too rigid. At this point the ink outline was completed, but I did not erase the pencil underdrawing lines. They would be useful as a guide for rendering the tones.*

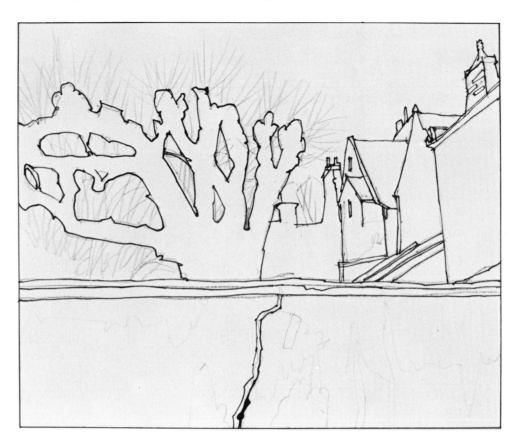

Step 2. *Next I added a light tone to most of the drawing, using carefully drawn horizontal ink lines. The lines were parallel but freely drawn, since it is unnecessary to be too precise when drawing this tone because other lines will be drawn over it and any unevenness will be negligible in the finished drawing. On the houses at the right side, I drew the lines that follow the perspective of the buildings, helping to create the illusion of depth in the picture.*

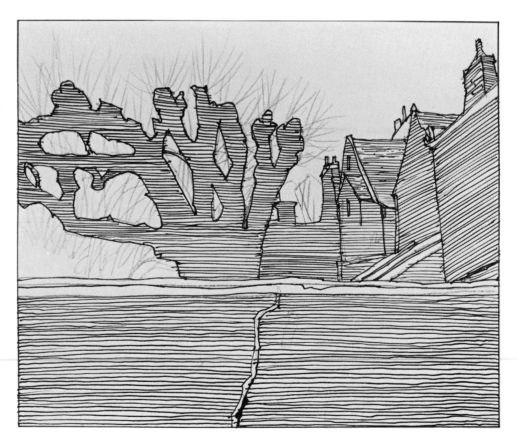

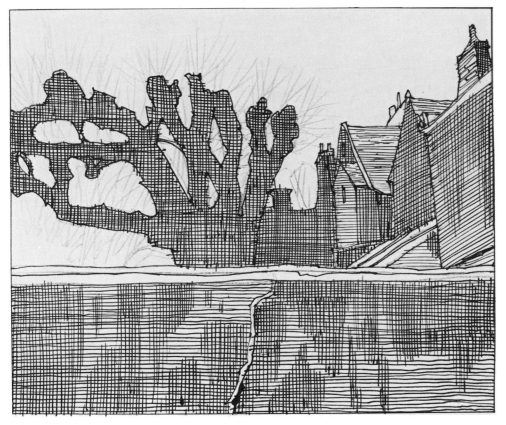

Step 3. *When using the crosshatch technique, you build up tones by drawing lines over one another at right angles, creating a new tone that is twice as dark as the first tone drawn. The newly drawn lines must, of course, be drawn about the same weight and the same distance apart as the first group. On the areas where I wanted a darker tone, lines were drawn perpendicular to the first group, creating the tone. I allowed these lines to dry thoroughly before going on to the next stage.*

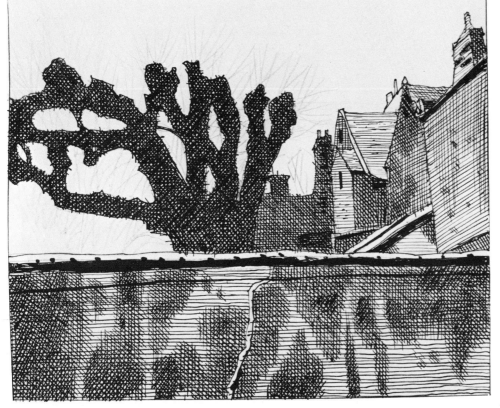

Step 4. *The tree was darkened more by drawing another group of lines over those previously drawn. These were again drawn at a 45° angle, but this time from the other direction, that is, from right to left. Next, I began to build up some of the tones on the wall in the foreground by drawing short strokes over these areas. Some of the darkest accents in the scene were now added to the windows, roof shadows, and the shadow of the tiles on the top of the foreground wall. The addition of these black accents helped me judge the gray values in drawing better.*

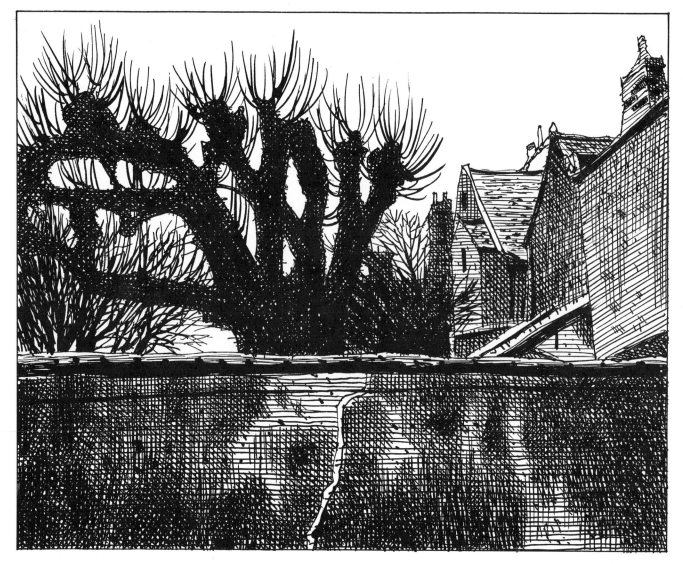

Step 5. *Additional textures were drawn on the walls and roofs of the buildings with randomly drawn strokes of the pen. The wall in the foreground was darkened by drawing more lines over most of the area, then textures were drawn over this tone to give the wall an ancient look. The branches of the trees were drawn next with curved strokes of the pen. The addition of the branches made the large tree appear too light, so I darkened it further by drawing over it with more pen strokes. A slight texture was drawn onto the tiles on the foreground wall with horizontally drawn strokes, finishing the drawing. The pen used for this drawing was a normal drawing pen with a medium point, which created a heavier line than those achieved with a crowquill pen. While there are many ways to create tones in pen drawings, the crosshatch method is one of the most unique and it affords a great deal of control. The method of building up the tones is easily understood and a vast range of tones is possible through controlling the thickness and spacing of the lines drawn. This technique is probably the closest thing to what might be called a formula in drawing because of the system which is used to build up the different tonal values. It is a very interesting technique to experiment with, and it reproduces very well, which explains its popularity in the commercial art field.*

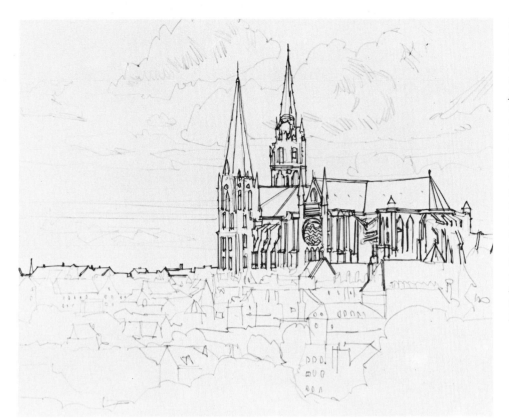

Step 1. *I worked on very smooth-surfaced paper, which is ideal for working with pen. The pen I chose for this drawing was a crowquill pen. I decided to use the crowquill pen because it is capable of drawing very fine lines, important when drawing a subject that has many details. I used India ink and began by carefully doing an outline drawing of the cathedral. Next, I started to add the details on the church, such as windows and roof lines. I was careful not to smear the wet, freshly drawn lines while I worked. I started to draw in a few of the rooftops on the other houses.*

Step 2. *I wanted to keep the cloud edges soft, so I did not outline them in ink. They were formed by the light sky tone. I now added darks to the bottom parts of the clouds, drawing some of these lines so that they followed the form. For most of this shadow area, however, I used random strokes to create an interesting texture. When I finished inking the clouds I didn't erase the pencil lines since I wanted to use them as a guide for drawing the sky tone.*

Step 3. *I added more darks to the bottom of the clouds, then rendered in the lower dark band of clouds. For this, I used random pen strokes to achieve an interesting textural effect. I put in the sky tone next, using carefully drawn horizontal lines. Notice how this light tone forms the edge of the cloud without any outlining. I began to work on the church towers and started to draw a few shadow areas on the surrounding buildings. These shadows were composed of evenly drawn, carefully spaced lines, which created the illusion of tone. After waiting for the ink to dry completely, I erased the pencil underdrawing.*

Step 4. *Now the darkest areas were added, the roofs and the shadows that defined the architectural details on the church. These were done with pen strokes, which were drawn closely together creating a dark tone. I drew a few horizontal pen strokes on the sunlit parts of the church roof to indicate a slight surface texture. A medium gray tone was drawn over the foliage areas. To simulate a leaflike texture here, I used short, zigzag pen strokes. On the ground area in the lower left part of the drawing, I used a crosshatch technique to separate this area from the surrounding tone.*

Step 5. *I felt that the trees and foliage should be darkened considerably. I began to do this by first drawing vertical lines across the trees, continuing until the whole area was covered. I blackened in a few of the tree shapes and added many shadow areas by spotting darks in with pen strokes. A few more of the roofs were darkened by shading them, completing the drawing. There are several things to keep in mind when doing pen and ink drawings. If you are not drawing from nature, you need good reference material to work from. Always start out by doing a pencil sketch of the subject right on the paper or board that you will use for the ink rendering. For finely detailed drawings, it is best to use a smoothly surfaced paper and a pen such as the crowquill, which is best suited for this type of work. After doing an outline pen drawing over the pencil sketch, add the lighter gray tones. Then render the medium and darker tones, always building up your tones gradually so as not to overwork your drawing. Remember that you can use varied pen strokes to enhance your drawings with interesting textures. This might seem a little difficult at first, but you can practice drawing various textures until you become familiar with all the possibilities. Be careful to allow the ink to dry thoroughly so there is no danger of smudging your drawing as you work. As you progress with pen drawing techniques, you will want to try other paper surfaces. While the pen moves easily on a smooth surface in any direction, a paper with a surface texture can cause the pen to catch or snag the surface. A paper with a soft surface will require more delicate handling because the pen point can easily dig into the surface, causing blotted effects. This is quite common with the cheaper grades of paper. When doing pen and ink drawings, it is best to use only the highest quality papers. If you make mistakes in your drawing, do not paint out the mistake with white paint; this will be too apparent. There are gritty ink erasers; for stubborn areas, a fiberglass eraser works best. Ink erasing is possible only on the finest quality papers; cheaper grades won't hold up under this kind of treatment.*

Demonstration 10. *Drawing with Varied Pen Strokes*

Step 1. *I outlined all the elements in this scene using ink, drawing very freely but using a pencil underdrawing as a guide. The inking was done with the crowquill pen because I wanted finer lines at this point. The large foreground trees were drawn first, then the middle-ground group. Next, the lines indicating the hills were drawn in. The trees and bushes in the background were added last. You can see that everything was drawn quite freely and that I indicated a few of the tree branches with very sketchily drawn strokes.*

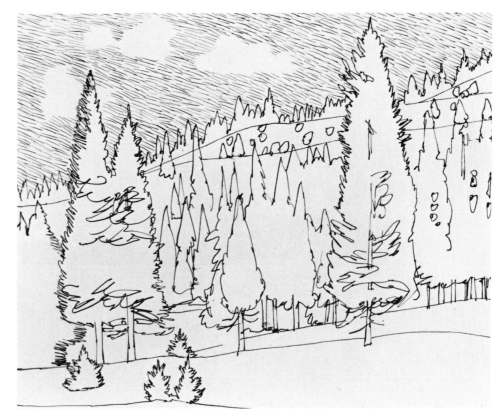

Step 2. *Compare the strokes used on the trees, which were drawn to create a texture, with the ones used for the sky tone, which were drawn to create a uniform tone. Note that the lines drawn on the trees were drawn less carefully and they often overlap, creating an unevenness that simulates the boughs of the trees. I drew a texture over the trees in the background with the finer crowquill pen because the trees in the background are much smaller. The strokes were exactly the same as those used for drawing the texture over the larger trees.*

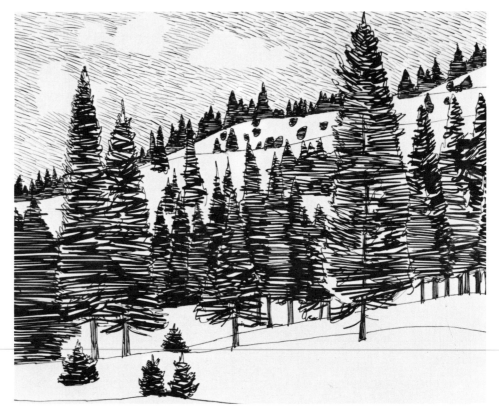

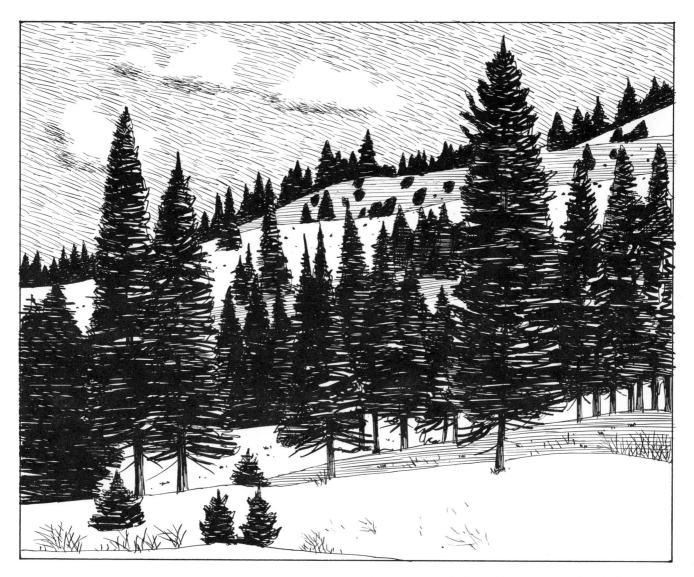

Step 3. *Next, I darkened the background row of trees, so that they separate better from the others. To clarify the various planes and ground areas, I drew tones in the appropriate areas, separating them from the adjacent planes, by drawing thin horizontal lines over the areas to create a flat tone. The choice of which areas to add the tone to was critical, and the decision to use the tones on the smaller areas was correct because this accentuates the snow effect more. A few more twigs were drawn in the ground areas and some dots were added throughout, suggesting detail as well as creating texture. Using very finely drawn pen lines, the darker areas were drawn on the clouds, suggesting shadows and adding some form. Finally, I finished the drawing by adding shadows on the trunks of the trees. Notice that I used several kinds of pen strokes in this drawing. Some were finely drawn and uniform to create an even tone, whereas other strokes were drawn much heavier and less uniformly to depict a texture. Study the different pen strokes carefully, then practice drawing various kinds of strokes, trying to create uniform tones and also unusual textures. These exercises should be done on different paper surfaces: smooth, medium, and rough.*

14
EXPLORING DIFFERENT LINE TECHNIQUES

To DEMONSTRATE a variety of pen techniques, I'll focus on two popular types of pens. Both of these pens are favorites of mine—the technical drawing pen and the crowquill pen. I like the technical drawing pen because it contains its own ink supply. This can be advantageous when sketching outdoors because it eliminates the need to carry around an ink bottle. In addition, the ink line is always uniform with the technical pen since the point consists of a small metal tube. This type of point allows you to draw lines in any direction on the drawing surface. Here I use the Pelikan Technos.

The crowquill pen is a versatile tool that offers a great range of line weights because of the flexibility of its point. The crowquill is a very handy tool, since it's used with a small, light holder. You can create an amazing variety of lines, textures, and tones with this pen point by applying varying degrees of pressure while drawing. Please note, though, that many of the techniques on the following pages can also be duplicated using the other pens.

At the end of the chapter is a demonstration that illustrates the building up of tones by lines and by crosshatching.

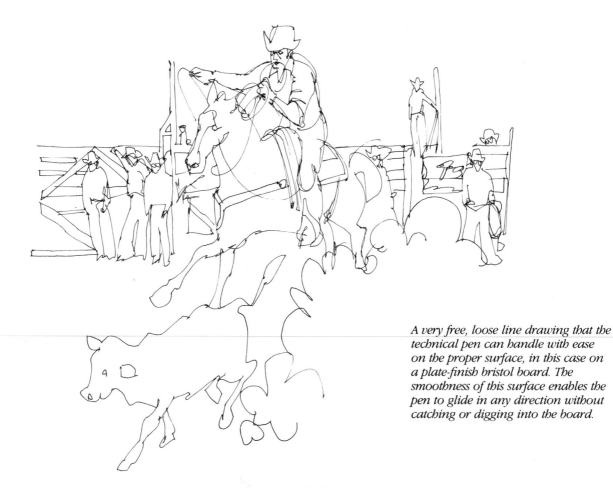

A very free, loose line drawing that the technical pen can handle with ease on the proper surface, in this case on a plate-finish bristol board. The smoothness of this surface enables the pen to glide in any direction without catching or digging into the board.

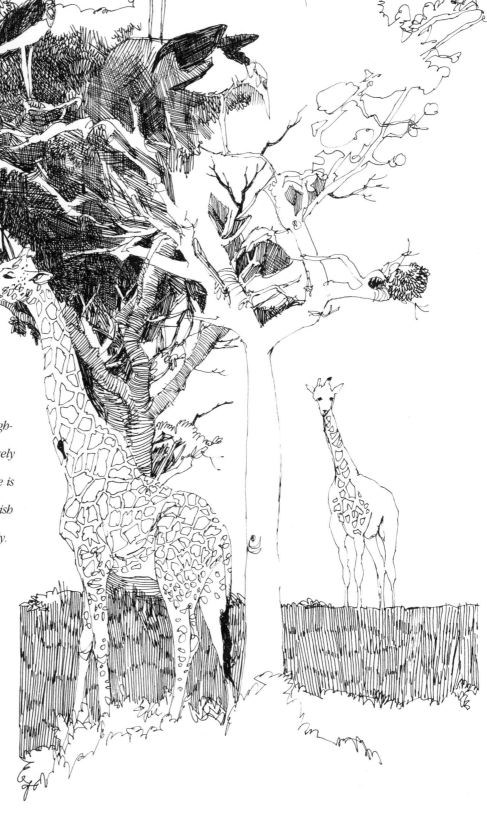

A technical pen drawing rendered on a sheet of mount board. Although it lacks the durability of a high-quality illustration board, mount board takes ink nicely and has a very interesting surface. The surface texture is very slight, between a cold-pressed and hot-pressed finish on illustration board, and the pen responds to it nicely.

This is probably the most common use of the technical pen—a very tight line rendition of a mechanical object. The uniformity of its line weight makes the technical pen a perfect choice for drawings of a mechanical nature. A triangle and French curves were used to rule the lines in, and an ink compass was used for the wheels.

(Below) A loose sketch rendered on regular-surfaced Strathmore illustration board. This board has a slight texture, an excellent surface for the technical pen. The surface is more pronounced than a plate-finish board or mount board, and thus it creates drawn lines that are sometimes slightly broken, giving the drawing a softer look.

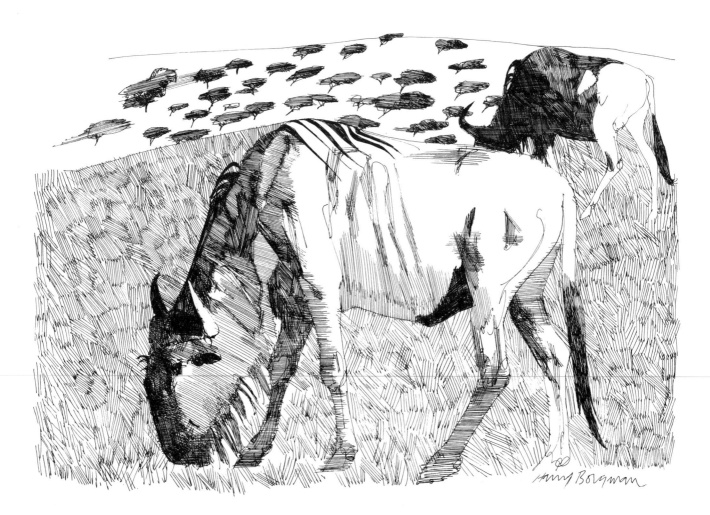

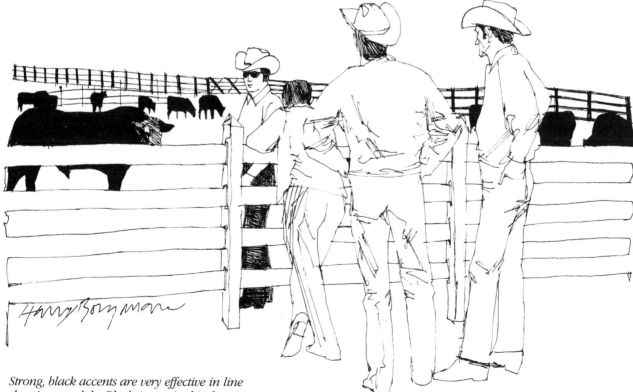

I frequently use acrylic illustration board for ink drawings, although this board is normally used for painting with acrylics and has a very fine clothlike texture. Its surface creates a soft, interesting line; and because of the slight roughness, there's a tendency to draw more carefully so the pen won't catch. This lends a totally different quality to a drawing as compared to one done on a very smooth surface.

Strong, black accents are very effective in line drawings, and the Black Angus in this drawing are a natural. To begin, I drew the outlines of the forms with the pen. Then I added a tone to the cowboy's hair and pants and accented the background fence by going over the lines, making them more pronounced. I put in the heavy, solid blacks in the cattle with a brush. If I'd wanted a texture in the cattle, I could have used a pen.

This drawing, which is composed of several smaller ones, is called a montage. It was done initially as an outline pen drawing to which the gray tones and solid blacks were added to clarify and separate the various elements. Again, the tones were carefully built up over the whole picture after the blacks were put in.

(Below) A mechanical object handled in a fairly loose manner. The drawing was done freehand with a loose crosshatched style. In this case, the pen was used with a very light pressure, causing the lines to be very fine and delicate.

(Above) Here are some examples of portraits done in the crosshatched style. Most of the drawing is done free-hand, with the exception of the shadow tones on the faces and on parts of the hats, both of which were done by ruling with the crowquill. I ruled the lines a little looser than usual to lessen their mechanical quality, although they're still fairly even in order to create the flat tone required.

This crosshatched drawing—more tonal than linear—was rendered in a finer, lighter technique than some of the other examples in this section. The ample amount of white helps the contrast of the picture. This drawing, and many others here, began as an outline to which the various tones were gradually added and built up until the illustration was finished.

Demonstration 11. *Crosshatching with a Pen*

The technique of crosshatching to build up tones with pen lines is an excellent one for a variety of subject matter. This technique can be handled both in a very free manner and in a tight mechanical way. The crosshatched style, not being a very spontaneous method of drawing, generally requires more preliminary work than other techniques. You should do a tightly rendered pencil drawing with the proper tones and values before attempting the final ink version. Solving most of the problems at the pencil stage will make the final ink rendering a much easier task.

This style has great value in the commercial art field, and much of my own advertising work incorporates the crosshatching technique. Crosshatched drawings reproduce very well under the adverse conditions of high-speed newspaper printing.

It is advisable to thoroughly research any drawing you plan to do. You can find photographs of what you may need in magazines and books , or you can take your own. The reference photos for this demonstration were taken with a Nikon FTn camera, using a Tri-X film. However, you don't need an expensive camera—a simple Kodak Pocket Instamatic will do nicely. Because of the short deadlines in the advertising world, I take many of my own reference photos with a Polaroid camera so that results can be evaluated immediately.

Step 1. *This reference photograph was taken at a nearby Air Force base where this World War I Spad was undergoing restoration for the museum. A variety of views as well as a few close-up details were photographed. I picked a view from the contact prints and had an 8" × 10" (20.32 × 25.4 cm) blowup made from the negative. This particular negative produced a less-than-perfect print, since it is spotted, but reference pictures need not be perfect so long as you can see the details you need. I made my pencil drawing from it.*

Step 2. *I tightened up the pencil drawing and drew in the details from the photo and other reference materials—I even added the squadron markings. Small details can always be added easily. I sharpened my pencil to a very long point. I kept the lead itself pointed by frequently using the sanding block. Then I finished a detail (left).*

Step 3. *Next, I made another tight pencil drawing—in tones this time—to establish the various gray and black areas in the illustration. After I taped a sheet of tracing paper over the pencil drawing on the illustration board, I rendered the tone drawing with an HB pencil (left). This was a very important step because I actually worked from this sketch when I inked the illustration.*

In effect, I tried to simulate the lines that would later be drawn in ink on the final rendering. Study this drawing carefully, and see how I established the directions of the lines as well as the crosshatched patterns (above). I could easily remove any errors with a kneaded eraser and draw the areas back in correctly. When you reach this stage, solve as many problems as you can—this drawing is really the key to the final rendering.

Step 4. *This is the completed outline in ink, drawn directly over the pencil drawing from Step 2—it's ready for the addition of tones and black areas. You can see that I did the inking very carefully—the lines are all clean and even. In many places, such as the wheels and wings, I established where the shadows and reflections would fall. All the careful planning and drawing at this and the previous stages ensured the success of the final illustration.*

Left, I used the technical pen with a ruler for some of the outline—I also used a triangle and French curves. Below left, I inked in the wheels with the help of an oval guide, a useful item for drawing mechanical objects. When you use all these tools, make sure that the previously inked lines are dry to prevent smearing.

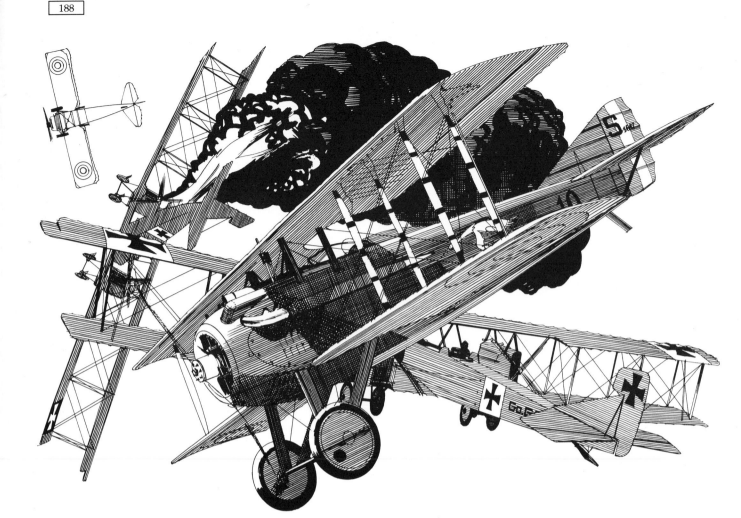

Step 5. *I started to add the tones, and at this stage the drawing was about half completed. Notice how I built up the tones gradually all over the whole picture rather than finishing one single object or section. This was very important—it would prevent me from overworking an area and rendering it too dark. I left the shadow area under the top wing unfinished to show how the tones were built up: first I added vertical lines over the horizontals, and then I drew lines at a 45°-angle to build up the dark tone.*

In the small photograph on the left, I tried to establish a medium gray area at the same time that I added the solid blacks to have something to work against. I started with the tones on the tail section, and then put in the black areas with a number 3 red sable brush. I could have put the blacks in with a pen, but it was much easier and faster to brush them in. In the center photo, I referred to my pencil tone drawing and to the other reference material. Right, I used the ruler to rest the crowquill on while I carefully drew in the lines to create the tones. This ruling technique with a pen may seem difficult, but with practice you can gain the control that's required.

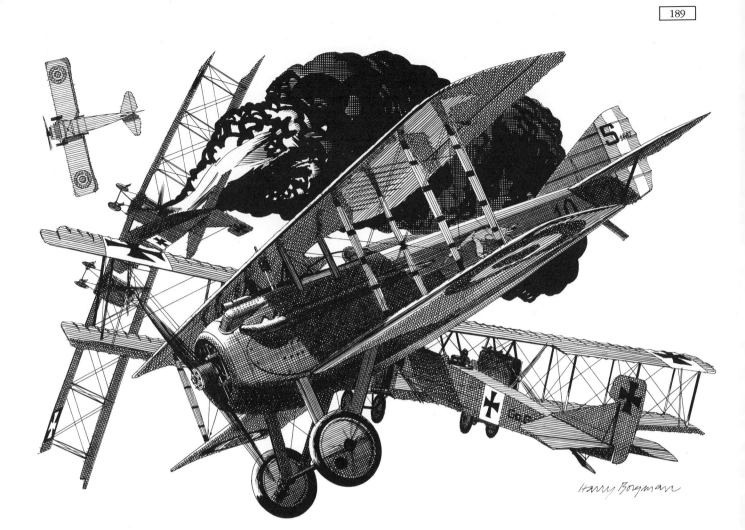

Harry Borgman

Step 6. *The finished ink drawing. Refer back to the tone pencil sketch in Step 3, and compare it with the final rendering. Notice how well all the various tones were defined. Because of the proper spacing of the lines, the tones appeared even and smooth. In a drawing of this type, there's always a danger of making the lines look too mechanical—a slight variation here and there actually helps to give a little life and interest.*

Left, I continued the gradual tone buildup until the drawing matched the toned pencil sketch. The numerous details and smaller areas were finished with a crowquill pen. Below left, I checked the drawing against reference material very carefully to see that squadron marking, wires, wing and tail ribs, and other details were added correctly.

15
EXPERIMENTING WITH
BRUSH LINE TECHNIQUES

To SHOW YOU SOME of the techniques that are possible with a brush, I've begun this chapter by showing you the same drawing in several different styles. The drawings are shown small here so that you can compare them—one is reproduced larger so that you

can study the technique I've used more carefully.

The brush is an excellent tool, which gives you a great deal of control when you draw. I feel it is more versatile than a pen. Learning to use the brush properly requires a great deal of practice and discipline.

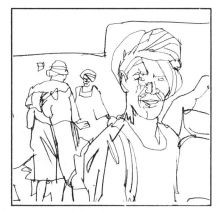
Basic pencil sketch

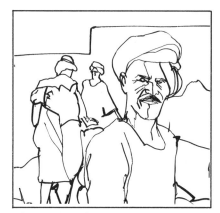
Thin outline drawing

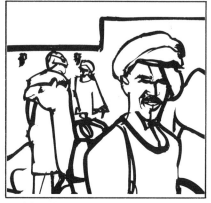
Bold outline drawing

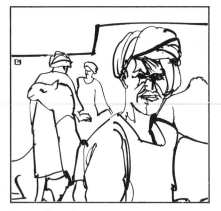
Loose drawing

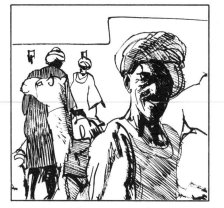
Drawing with textures and tones

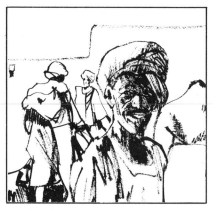
Drybrush drawing

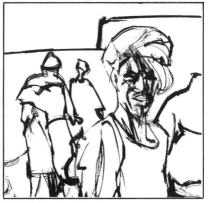

Bristle brush drawing

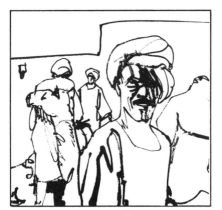

Drawing on blotter paper

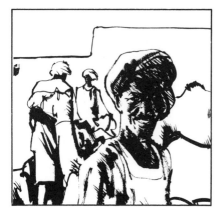

Drawing consisting mostly of shadows

Crosshatched drawing.

This final example, done on Crescent No. 100 cold-pressed illustration board, is done in the crosshatched technique. Starting with a basic outline drawing and adding the tones, I drew many of the lines that make up the tones with a Winsor & Newton number 3 brush and the ruling method. Some of the dark lines and black shadows are added last to help separate and clarify the elements of the picture.

Demonstration 12. *Drawing with a Bristle Brush*

Step 1. *Right, after doing a rough pencil drawing, I began the inking by outlining the dominant lamppost in the center of the composition. Far right, I added some blacks and drew in more details.*

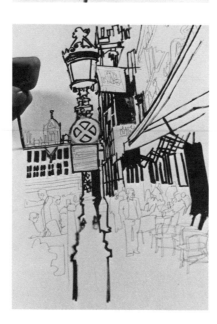

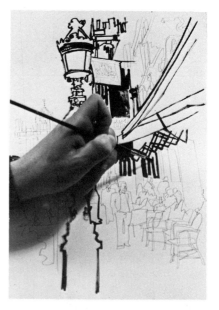

Step 2. *Right, I moved on to the buildings at the left—I always try to work over the whole drawing rather than finish any one area. Far right, I turned the illustration to facilitate working. By using the brush on its narrow side, I was able to draw a fairly thin line.*

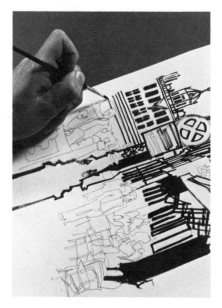

Step 3. *Right, I added the people and tables, drawing them very bold and simple in keeping with the rest of the picture. Far right, I put in the final black accents as the drawing neared completion. Large black areas added a nice design quality as well as a lot of punch to this drawing.*

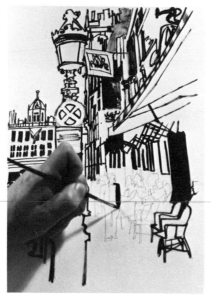

Step 4. *Although I made this finished drawing very carefully, it has a very sketchy, impressionistic quality. It's really impossible to put in much detail with a bristle brush, but I think leaving something to the viewer's imagination adds to the charm of the drawing. I look at a drawing like this as a design problem—and as an abstract composition of bold shapes and lines.*

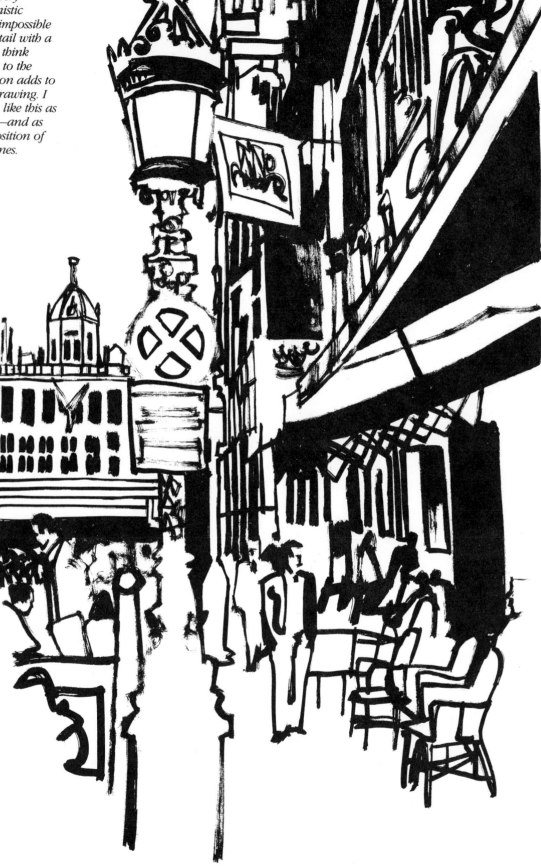

Crosshatching with a brush is really quite simple when you learn how to handle this tool. The brush is more versatile than a pen, and I personally feel that you can achieve more control using it. Learn to master the brush exercises in chapter 12, and you'll be on your way to doing crosshatched brush drawings.

Step 1. *First, I drew small pencil sketches to determine the composition. You could, of course, make hundreds of these sketches, but a few are all that's necessary. I generally do two or three and pick out the one that solves the particular problem best.*

Step 2. *I took these reference pictures with a Nikon F 35mm camera. The gun is a new Spanish reproduction from a local gun shop, and the other items are things I found around the house, including my son's pet chameleon. By gathering and shooting the best reference materials possible, I simplified many of the problems involved in doing a drawing of this type. Proper reference makes all the difference in the world to the outcome of the finished illustration.*

Step 3. *(Below) I projected the photographs with a Beseler projector directly onto Schoeller medium-surfaced illustration board and made an accurate pencil drawing. Since my reference pictures were quite good, I was able to eliminate the next step, which would have been to make a tight pencil drawing to establish the gray tones in the picture. The fact that this illustration has no background also simplified the rendering.*

Step 4. *I started the inking as a basic outline drawing with a Winsor & Newton number 1 red sable brush. Left, I ruled in the straight and slightly curved lines with a brush. Center, I drew many of the smaller details freehand, using the reference photos as a guide. Right, to help me judge how dark the gray tones should be drawn, I added the black tones.*

Step 5. *Left, I continued inking, building up for a few of the gray tones by brush ruling. Right, I darkened the leather on the telescope by crosshatching vertical lines over the horizontal ones. At the same time, I added the texture of the leather.*

Step 6. *Left, I rendered the wood on the gun and added the shadow area by crosshatching. Center, I brushed in the small nicks in the wood texture. Right, I finished off the last details and shadows.*

Step 7. *The different textures on the wood, metal, and leather added a great deal of interest to the crosshatched rendering. You can see that the finished illustration isn't just a duplication in ink of the reference photographs. Rather, the drawing is a simplified version of the photos, consisting of three gray tones and solid black.*

16

COMBINING PEN AND BRUSH

USING DIFFERENT techniques in the same illustration can add a great deal of interest to a drawing. Each technique has a unique quality to add to a particular piece of art. Thin lines or a linear texture with a pen, very bold lines rendered wet or dry with a brush, and smooth-flowing tones created with washes can be combined effectively. You should experiment with a variety of these techniques until you find the style that suits you best. I will cover many of the basic techniques in this chapter, but remember that the possibilities of combinations are endless. Use your imagination and explore some of them.

I did this drawing for a travel brochure on Mexico. I wanted to create the feeling that I had worked on the drawing on location—it would have been nice to actually draw it on the spot, but this is not always practical. Tight deadlines and advertising budgets rarely include a trip for the artist. Luckily, I had plenty of reference pictures from vacations in Acapulco years before. I did the illustration with a technical pen, and I planned the black areas carefully before I rendered them with a brush.

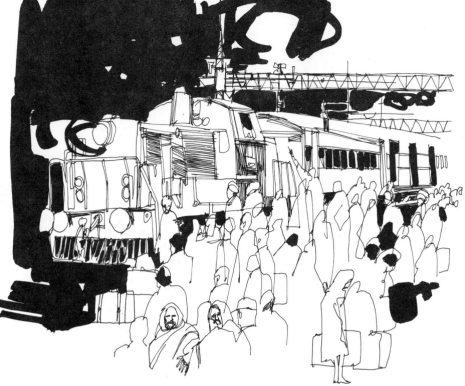

While vacationing in Egypt, my wife and I were caught in the October War of 1973. When we returned, the Detroit Free Press wanted to do a story on our experiences. Since I had not been allowed to take photographs during the war, the editors suggested that I illustrate the story with sketches. I did these drawings from memory a few weeks after our return. This sketch is a scene at the train station in Luxor. The very sketchy, loose line and brushwork convey the feeling of an on-the-spot drawing effectively.

(Below) This scene of our going through customs at Soloum, Egypt, was one of complete mayhem, with hundreds of trucks and cars piled high with boxes and luggage that the inspectors methodically searched. Notice that the slight amount of tone used in these Egyptian drawings really helps to establish planes and defines the various objects. I tried to keep everything very simple, and I used the circular shapes in the upper-right area to indicate spotlights.

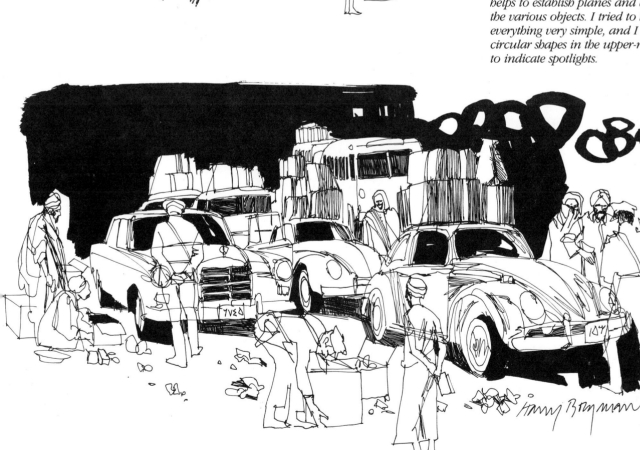

(Above) I had the good fortune of being sent to Japan on an exciting assignment for the Premier corporation. This sketch and the one of unloading crates on the next page were part of a series done to illustrate the shipping of cattle by air to Japan. I executed the drawings with a technical pen and brush on a linen-surfaced Crescent acrylic board using photographs taken during the trip for reference. Here we're approaching Mount Fujiyama.

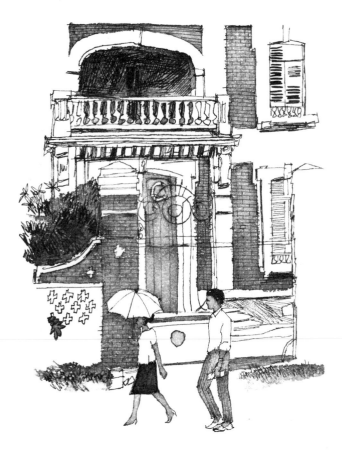

I did this drawing with the Hunt 513 pen and water-soluble ink on Arches rough watercolor paper. The tones were produced by washing clear water over the pen lines, dissolving some of the ink—the lines don't dissolve completely and show through the wash nicely. This is a particularly good technique for quick outdoor sketching, when you may not want to carry along a mixing tray.

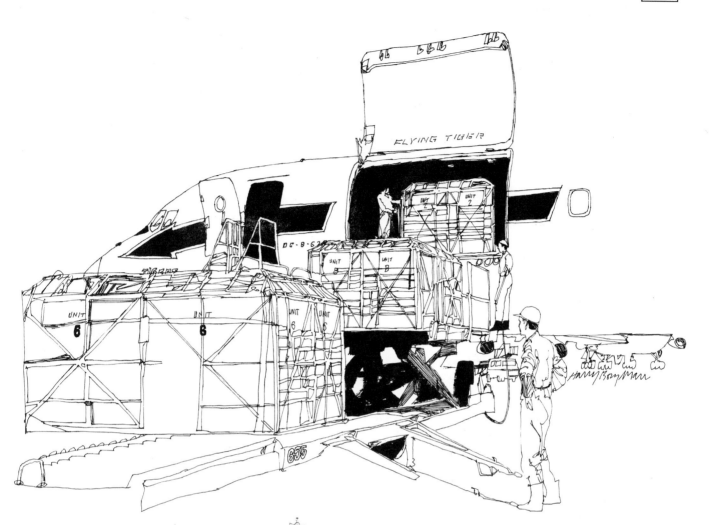

(Above) Spotting the blacks correctly helps to emphasize the crates that are being unloaded. The unloading was a very fast operation and would have been quite difficult to sketch on the spot. I hadn't slept for many hours and had enough trouble taking the reference pictures!

Using diluted ink with the pen as well as the brush is another interesting technique, which I've illustrated here. I diluted waterproof ink with water and drew a gray ink line—rather than a black one—with a Hunt 513 EF Globe pen. Then I put in the washes with diluted water-soluble ink—since the lines were waterproof, they didn't dissolve. In some areas, such as the church doorway and the schoolbag, I drew the pen lines in after the washes dried, which resulted in a darker line because of the transparency of the ink.

Step 1. *Right, after tracing my finished pencil drawing on the illustration board, I put in the bold accents in ink with a fairly well-loaded brush. The shapes and strokes helped convey the impression of foliage. Far right, I added the hair and sweater loosely and gave a pattern to the fabric on the chair.*

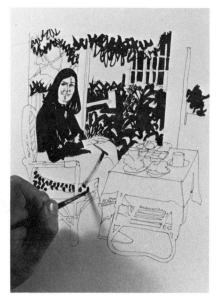

Step 2. *Right, I drew a very light tone on the shadow side of the face with the pen. Far right, I added tones to the background and the stockings. The drawing was starting to take shape and the elements were separating nicely.*

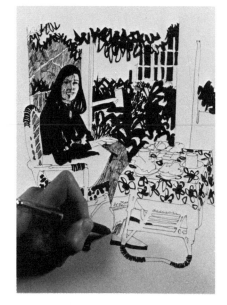

Step 3. *Right, turning the board for convenience, I crosshatched another set of lines over the stockings to darken the value of the tones. Far right, a light gray shadow tone in the cups and saucers finished off the table area and a final darkening of the background by crosshatching completed the drawing.*

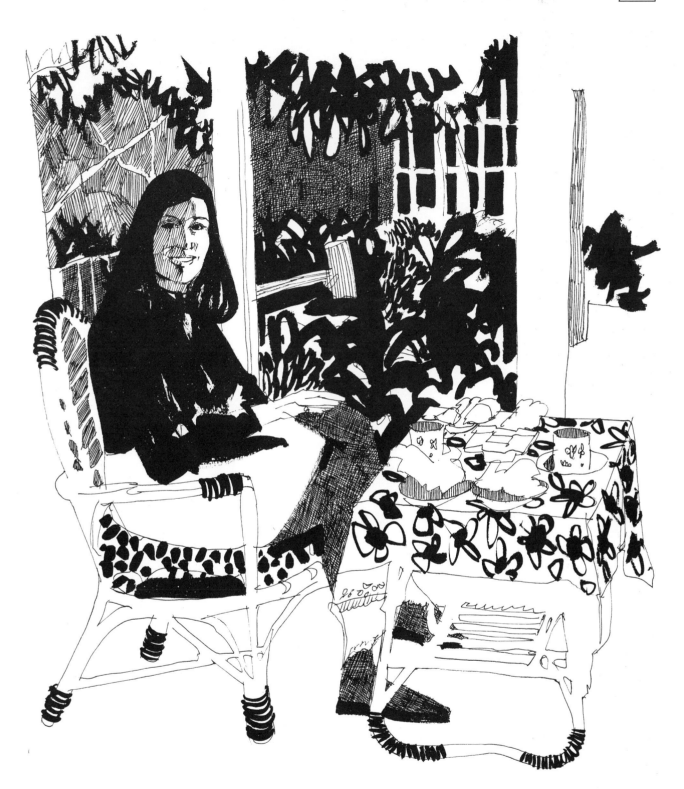

Step 4. *The overall feeling of this finished drawing was quite free—even the crosshatching was rendered in a loose manner. In spite of the casual style, though, the drawing was very accurate—the important features such as the nose, eyes, and mouth were in the right places. If part of this drawing, such as the crosshatching, had been handled too mechanically, it would have looked very much out of place.*

Demonstration 15. *Drawing with Pen and Brush*

Step 1. *Pen and brush are an excellent working combination. The outlines, tones, and textures can be drawn with the pen, and the heavier lines and solid blacks can be done using a brush. To begin this drawing, I first did a basic pencil underdrawing on common drawing paper with an HB grade graphite pencil. I drew in the largest flower, starting with the pistil, the central area, and then the petals. Some of the ribbing on the petals was indicated as well as the smaller petals in the pistil area. The flowers in the background were drawn last. Since this pencil underdrawing would be used as a guide, I put in as much visual information as possible.*

Step 2. *The important thing to remember about a pencil underdrawing is that although it can be very roughly done, it should be accurate with regard to shapes and proportions. To begin the ink rendering, I used a crowquill pen with India ink, carefully outlining all the elements in the picture, using the pencil underdrawing as a guide. The crowquill is a good choice of pen, since it has the capability of producing a wide range of lines and is especially suited for fine line work. The brush would be used to draw in the heavier lines and black accents. When inking the detail in the center of the flower, I used pen strokes to create the leafy texture.*

Step 3. *After the ink dried thoroughly, I erased the pencil underdrawing with a kneaded rubber eraser. It is best to remove the underdrawing when it is no longer needed because the graphite smudges quite easily. With a number 4 red sable brush I drew the shadow detail in the central area of the flowers, using short strokes made with the flat edge of the brush. Notice that I applied the brush to carefully indicate accents on the ribbed parts of the petals, using less ink to create a drybrush effect. Adding the black accents at this stage was important because it helped me judge the values of the gray tones, which were to be drawn next.*

Step 4. *Before rendering the gray tones I decided to block in the background, using a number 4 brush. Overlapping strokes were used to create a texture with the white paper showing through. This texture in the background helped to convey the impression of details in the shadow areas. While inking in the background, I was careful not to brush over the petal shapes; the edges were inked first, then the background was filled in. At this stage the drawing appeared quite contrasty, but this effect was to be minimized as the gray tones were added. Since this subject was quite complicated, it demanded a great deal of planning concerning where tones should be drawn.*

Step 5. *Adding gray tones was a very critical stage of the rendering. I began by adding the light gray tones to the petals, using quickly drawn pen strokes. The lines were drawn parallel, but lengthwise on the petals. Certain areas on the petals were left white, creating a sunlit effect. Next, a gray tone was added to the pistil area, using vertically drawn lines. The white texture in the black background was toned down by drawing lines over the whole area. Notice that instead of finishing any single part of the drawing I worked over the whole picture, gradually building up the gray tones so they fit in with the dominant background.*

Step 6. *The medium gray tones were now carefully drawn with the crowquill pen. More strokes were also drawn on some of the petals to darken them slightly. Then the shadow areas were indicated. Some of the shadows were rendered using crosshatch strokes, but I was careful not to draw the tones too dark since they would merge into the background. The shadow side of the pistil areas on the flowers were also built up using vertically drawn pen strokes. Since the background texture still seemed too strong, more pen strokes were drawn over this area, toning it down slightly. Comparing the previous stage with this drawing dramatically shows the change in the picture through the addition of a few tones.*

Step 7. *If you study the flower petals, you can see subtle variations in the gray tones. This was not easy to accomplish and required great care. It was a matter of planning and then building up the various gradations slowly. I added darks to strengthen the ribbing on the flower petals, using a number 7 brush. A few more shadows were added throughout the drawing, working carefully with the brush so as not to render these accents too strong. On the finished drawing, it should be apparent that each tool was used to advantage. The pen was used for drawing the outlines and the gray tones, and the brush was used to draw the heavier lines as well as the solid black areas. When you examine the various stages the drawing went through, it should be obvious that planning was very important and that tones had to be built up gradually, working against the darkest areas. In this drawing, it was essential to put in the dark background first so that the gray values could be determined easier. This is a commonly used pen and brush technique and works well for drawing any type of subject. It is especially suited for those subjects that are very contrasty and include lots of black. Almost any paper can be used for the technique, but the rougher surfaces require more care when working because the pen can catch on the texture.*

17

USING UNUSUAL PAPERS, BOARDS, AND A VARIETY OF PENCILS, MARKING PENS, AND CRAYONS

THERE ARE MANY unusual papers and boards that you can use for ink drawings. Mechanical tones and printed texture sheets that can be transferred to artwork are also available. In this chapter I discuss and use many of these unique boards and unusual tools, including a variety of pencils, marking pens, and crayons that you can combine with pen and brush drawings. Experiment with the following techniques to familiarize yourself with the boards, papers, and other items at your disposal.

Simulating a woodcut or engraving with scratchboard. I planned the drawing very carefully in pencil on tracing paper and then transferred it to the scratchboard using a graphite tracing sheet. I did the rendering with a brush and waterproof ink. I cleaned some of the lines up and added a few white lines to give the proper effect. Next, I drew some black lines in the ground area, scratching through them to add to the woodcut feeling.

Here's a very small, spot drawing from an Ethyl Corporation ad series. The drawing is almost solid black with a few white lines scratched in to indicate the masts, sails, and other details of the ship. I then outlined the whites in black with a brush, giving the drawing a distinct woodcut feeling. The white lines in the waves followed the form to add to the effect of motion.

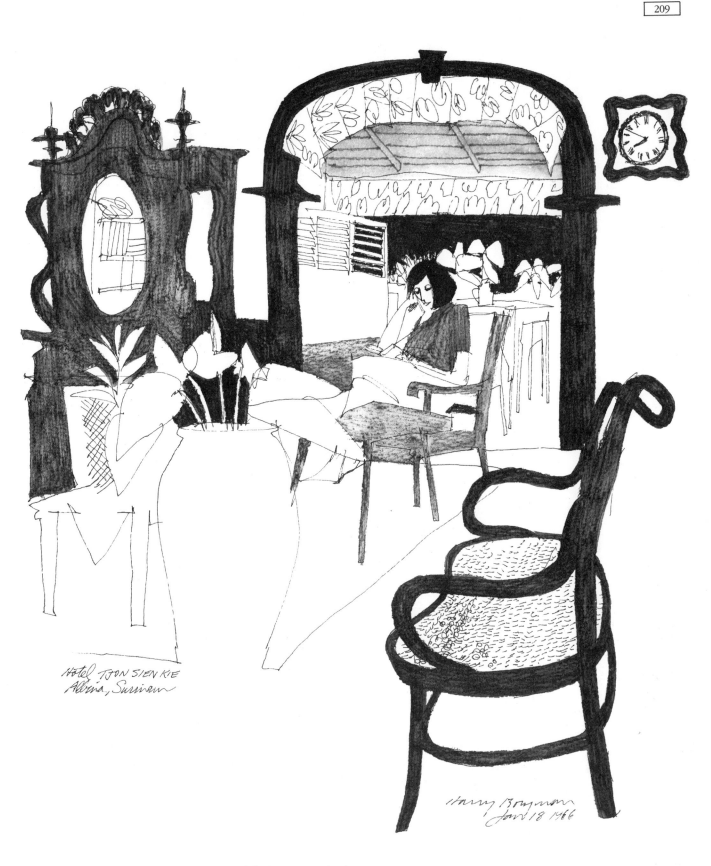

Hotel TJON SIEN KIE
Albina, Surinam

Harry Borgman
Jan 18 1966

This sketch is one of a series done while I was vacationing in Surinam. The technique is a very simple, effective method to use when doing on-the-spot drawings. I used a technical pen and Pentel on watercolor paper, and I dampened the Pentel areas with a wash of clear water to create gray tones.

Step 1. *With a fine-line marker pen, I drew the basic outline sketch of the scene on rough watercolor paper. Although the sketch appeared loosely done, I nevertheless made an effort to create an interesting composition through the positioning of the camels and the background buildings.*

Step 2. *Using the fine-line marker pen, I drew in the shadow areas on the camels. The strokes used here were quickly drawn, which created a lighter gray line because the marker pen touched only the raised parts of the paper surface. Notice that I frequently changed the direction of the strokes in the shadows to create interesting texture.*

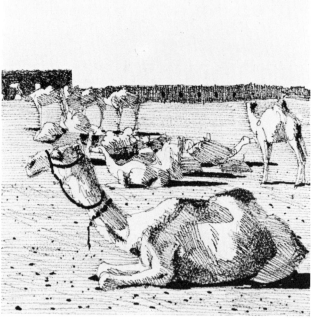

Step 3. *I filled in the background with horizontally drawn strokes, then random strokes over this tone for a texture. The buildings in the background were darkened by drawing lines over one another to create a crosshatch effect. The tone appeared dark because the lines were drawn closely together.*

Step 4. *I added shadows under the camels, then spotted in shadows of pebbles and stones on the ground. Darker tones were drawn on the foreground camel and the harness, and reins were indicated in solid black. Dark accents were also spotted on the camels in the background.*

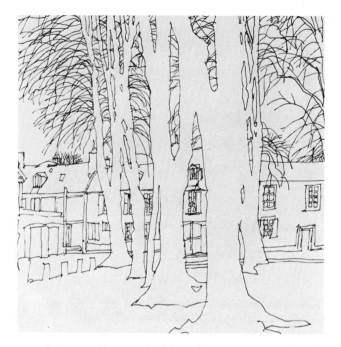

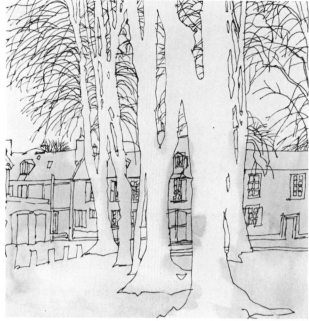

Step 1. *An excellent method for adding tones to India ink drawings is to use water-soluble ink washes. This medium works quite well on most paper surfaces. I started this drawing by sketching with a technical pen directly on common drawing paper. I first drew the trees, then added the background buildings and the branches.*

Step 2. *When I was certain the ink had dried completely, I added a wash of clear water to the picture area behind the trees with a wide, soft brush. Then I diluted a few drops of water-soluble ink in a ceramic mixing tray to mix a tone, which was then washed over the dampened area with a number 6 red sable brush.*

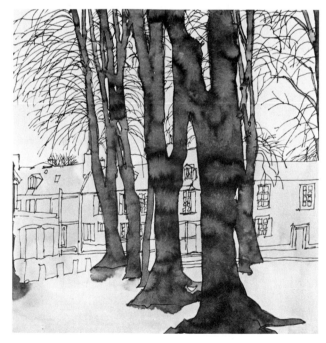

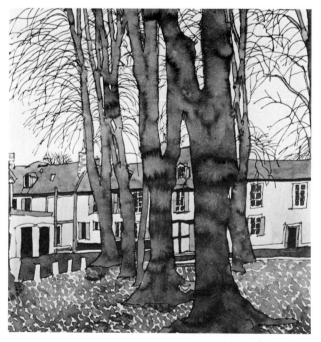

Step 3. *I mixed the darker tone using less water to dilute the ink, then washed this tone over the tree trunks with a smaller, number 4 brush. The variation in the tone occurred because the paper buckled from being wet and the washes became concentrated in the valleys of the paper. This unevenness was a happy accident that resulted in an interesting tone.*

Step 4. *I added tones to the roofs and shutters on the houses. Then, with a number 4 brush, I drew the grass area in the foreground, using a pattern of dabbled strokes. With pure black water-soluble ink I painted in the dark door and window areas. This was a very simple but excellent technique for sketching indoors.*

(Above) A drawing done for
newspaper reproduction to illustrate a
story on Onassis. I used a Pentel pen
for all the line work and put the large
black masses in with a brush and
waterproof ink. Then I washed clear
water over some of the areas to create
a gray tone—the pen lines delineating
the foreground figure were washed
away at this time, adding greatly to
the feeling of movement. This wasn't
planned—it was just one of those
happy accidents. The effect was just
what the drawing needed.

Coquille board, which is available in
different surface textures, has a special
surface that is excellent for use with a
litho crayon. This particular surface
has a dot texture not unlike the
texture found in a half-tone
engraving used in newspaper
reproduction. You can easily draw on
this surface with a pen or brush, and
then add the gray tones with a litho
crayon or a China marking pencil.

I did this newspaper ad on canvas board. The advertising manager of the Premier Corporation, James Donahue, wanted this ad done in an art technique that would stand out in a trade publication, where most of the ads were photographic. This illustration works very well even though it's done very loosely—the black mass behind the rider is suggestive of a herd in spite of the lack of details. This drawing started as a line drawing in waterproof ink. Then I added some acrylic washes and even did some of the drawing with these tones. To create the mottled effect in the background, I floated clear water over the washes while they were wet.

This drawing shows the variety of materials and textures that you can make in the scratchboard technique. This illustration was composed primarily of black with a minimum of white areas and lines. I put in the blacks very carefully with a brush and then allowed them to dry thoroughly. Then I scratched the tones on the front of the bowl, the rice, and the reflections on the bottle in freehand with the scratchboard tool. I created the textures on the inside of the bowl, parts of the bottle, and the chopsticks with the aid of French curves and a triangle. The lettering and trademark were my final touches.

An illustration done for American Motors, rendered on canvas board. It's difficult to transfer drawings to canvas board by tracing with a graphite sheet, so I projected the photographs of the vehicles directly onto the board and drew with an Eberhard Faber Markette pen. Then I put the washes in with acrylic paint.

Scratchboard is another unusual surface for ink drawings—the board has a special coating you can cover with ink and then scratch through. As you scratch back into the white, you get both tones and whites. The effect is very much like a woodcut or engraving. A good deal of careful planning is necessary to do a successful scratchboard drawing because the surface is easily damaged from overworking. Therefore, to begin you should do a well-planned drawing in pencil on tracing paper and then transfer it onto the scratchboard by projecting the design or by using a graphite sheet. Put the solid blacks and linework in with a brush and allow them to dry thoroughly. Add the whites by scraping the board surface with an X-acto knife or a scratchboard tool. You can achieve very crisp, clean effects using this technique.

In these particular drawings, I did all the lines with a ruling pen and waterproof ink. I put the solid blacks, windows, trees, and mountains in with a brush. Then I cleaned up the drawing and added textures to the grass and windows with a scratchboard tool. Please note that you must let the ink dry completely before you scratch into it—you can't work the board properly if it's still wet or even damp. Also, notice how well the drawing reduces.

I made these drawings for a story in a magazine, Ward's Quarterly. *They're handled in a very decorative, almost cartoonlike manner. I used a brush for all the linework and then cleaned up the lines with a scratchboard tool. I cut some of the textures into solid black using a crosshatch technique, as on the France illustration.*

Using scratchboard for rendering mechanical objects. I did this example—a proposed style for the newspaper ad automotive art—as a sample for McCann-Erikson Inc., the advertising agency for the Opel account. I began the drawing by tracing a photostat of the car onto the scratchboard, and then very carefully inking the outline with a technical pen. Then I put in the large black areas with a brush. I created the tone on the side of the car by cutting white lines into the black (after it dried) by ruling the scratchboard tool with a triangle. If you make a mistake when you do it, you can repair it by re-inking the area and scratching in a new tone. I did the car interior in a more freehand manner to capture the feeling of the leatherlike material on the seats—I used a brush almost entirely, and I cut many of the tones in with the scratchboard tool. The smaller reproductions beneath the larger ones show how well these drawings held up under reduction. The key is to keep the lines far enough apart on the original so they don't fuse together.

Step 1. *A unique drawing surface is scratchboard, known as scraper board in the United Kingdom. This surface is coated with a pigment or clay that takes ink very well but does not allow the ink to penetrate too deeply. This coating also enables lines and tones to be carved into the surface with a special knife, creating effects similar to that of a woodcut or wood engraving. To begin this drawing, I first traced a previously drawn pencil sketch onto a piece of scratchboard. Then, using a number 4 red sable brush with India ink, I rendered all the areas on the drawing that would eventually appear as tones. This was done in solid black, except for the light tone on the jar at the left.*

Step 2. *I want to emphasize that more care and planning are required to do a scratchboard drawing properly than other types of ink drawings. As you work, you must allow the ink to dry thoroughly before using the scraper tool, or the surface will not respond properly. To scratch the tones, I used a special cutting tool that fits into a standard pen holder like a pen point. I began to add white lines on the black tones, drawing them parallel to create a uniform tone. The value of the tone is determined by how thick the scratched lines are and how closely they are spaced. I used the edge of a plastic triangle to scrape the lines in straight. I added white lines to the bottom edges of the jars for greater definition.*

Step 3. *I added a lighter tone of gray on the lower section of the jars by scratching the lines more closely together. In certain areas, I scratched vertical lines over the horizontal ones. The effect achieved was one of a reversed crosshatch, white lines on a black background. The lightest tone on the left-hand jar was lightened even more by using this method. It was quite difficult to determine at this stage whether the tones were correct. However, the tones at the bottom edge of the jars next to the black shadow looked very good. In order to visualize the tones better, the existing white areas had to be filled in with black.*

Step 4. *I rendered the black areas using a number 4 red sable brush. The interiors of the jars were inked first, then the interesting glazed pattern was added on the upper portion. Since I had rendered the black areas, I could see that the gray values worked quite well. I added a few subtle touches, then scratched more lines for the interior highlight areas. The shadows from the jars were softened a bit by scratching lines along the outer edges. This interesting technique works best for still life subjects or scenes. It is not really suitable for portraits or figure studies, but it is excellent for drawing animals that have fur or a heavily textured skin.*

Demonstration 19. _Using Scratchboard for Decorative Drawing_

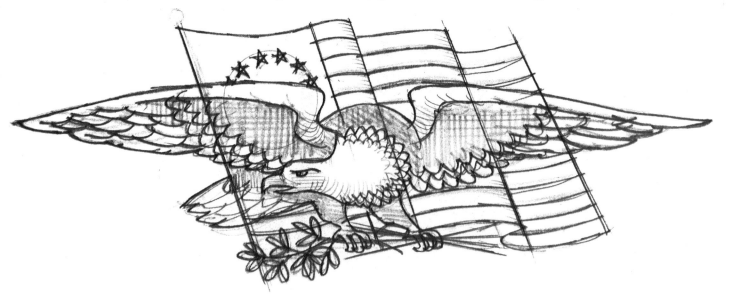

Step 1. _After drawing my sketch with marking pen, I did a tight pencil sketch on tracing paper over the marker drawing, above. Left, I taped the pencil drawing to the scratchboard and traced it using a graphite tracing sheet. Below left, I began inking with a number 1 red sable brush—the inking was rather crude to simulate a woodcut._

Step 2. *I scraped some of the tones on the upper parts of the wings and the eagle's head with the scratchboard tool and then inked the flag with the brush, left. You really don't have to be as careful when doing this type of drawing as when you're doing a realistic one, since any roughness helps convey the feeling of a woodcut. Below left, I scraped the tones of the flag in with the scratchboard tool. Above, the final drawing—it's rather crude in actual size but holds up well in the smaller reproduction, below.*

Demonstration 20. *Drawing on Toned Paper*

Step 1. *A very effective technique involves the use of black-and-white ink lines on toned paper. This method can be used to draw many kinds of subjects, but it is especially suitable for drawing detailed landscapes. On a sheet of medium gray charcoal paper, I sketched the scene with a 2B grade graphite pencil. I did this quite simply, indicating only bold, outline shapes, using a few details on the cows in the foreground. Notice that the areas that will be white have been drawn with a white wax pencil. I used the soft 2B grade graphite pencil for the basic drawing because it would erase easily later.*

Step 2. *Using a pen, the type with an ink reservoir, I started to render the medium gray tones in the scene. This was done using a linear sketch technique, which simulated the foliage texture. Next I drew in the group of buildings quite carefully, then added trunks to some of the trees. The grass texture was added to the foreground by drawing in short pen strokes to achieve the necessary texture. Shadows were drawn under the cows and some of the trees.*

Step 3. *White ink can be used for the white lines on this type of drawing, but I mixed a little white gouache paint to the consistency of ink and drew in the light areas of the scene. The white on the buildings and on the background hill was drawn using diluted white paint in the pen. In the middle ground I drew in the white tree trunks and some of the lighter ground areas. In the foreground, I indicated the fence posts and filled in the cows, leaving some of the paper showing through for the shadows. I created a grassy texture in the foreground.*

Step 4. *Because this paper has a very soft surface, which could easily be damaged by the pen point, I used a number 4 red sable brush when adding solid black areas. I darkened the shadow areas on the buildings and the foliage in the background with the brush. Shadows were added to the middle ground trees and also on the cows. A few more textural lines were drawn in the foreground grass area with the pen, completing the sketch. This was a simply done but effective presentation of the scene.*

Step 1. *An excellent method for adding color to India ink drawings is to use washes of color inks. Similar to watercolor but much brighter, colored inks result in brilliant, fresh renderings. They are quite manageable to use because the washes can be easily controlled. I began by doing a drawing with an HB graphite pencil on a medium-surfaced illustration board. I completed the drawing, clearly defining all the elements. I prefer using mounted papers when working with washes so that there is no chance of the surface wrinkling when it is dampened with water. The medium and rough surfaces are much better for this medium; the smooth surfaces do not take washes well.*

Step 2. *When you use washes over ink drawings, make sure you use waterproof India ink for your basic pen drawing. Other types of ink will dissolve when washes are applied over them. I used a regular drawing pen for the ink rendering, starting with the outline, the foliage, trees, foreground rocks, and landscape areas of background. Various kinds of lines were used to indicate different objects: looplike lines for the bushes and other foliage, smooth lines for the landscape areas and rocks. With a number 4 brush, I drew in the textures and shadows in the bushes and rocks. Notice that these strokes have a different feeling from those done with the pen.*

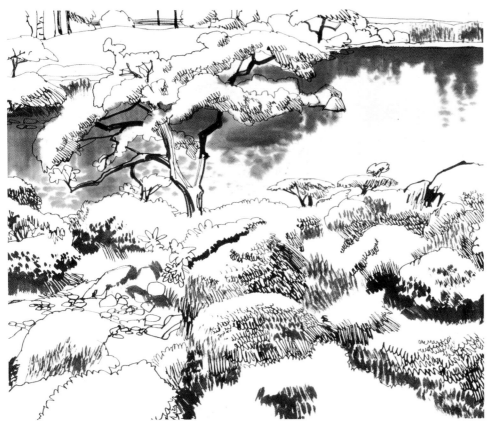

Step 3. *Using a soft, wide brush, clear water was washed over the lagoon area, then a very pale blue tone was painted over the dampened surface. Prewetting the paper ensures that the color will spread evenly without forming any hard edges. I mixed a tone of olive green, then painted it on the still-damp wash tone, blending slightly to create the effect of a reflection. Keep in mind that colors dry slightly lighter than they appear when wet. This is something to consider when you mix colors.*

Step 4. *A light yellow color was washed over the background at the top of the scene, then a mixture of lemon yellow and grass green was painted over the trees. A few olive shadow tones were added over these washes while they were still damp so that the colors would spread, creating a softer effect. You can control the spreading of washes in two ways: the dampness of the paper (the most important factor) and the amount of ink on the brush. If the paper surface is quite wet, the washes tend to spread more, whereas on a slightly dampened surface washes can be relatively contained. A brush fully loaded with ink will cause the wash to spread more; less liquid will not spread as much.*

Step 5. *On the lower portion of the picture, I painted a brighter mixture of cadmium yellow and grass green, warmed slightly by a small amount of persimmon red. The softness of the edges of the washes was due to the fact that they were painted over the dampened paper surface at just the right moment. The brilliance of the colored inks became very apparent here—even the darker green washes were quite lively and intense.*

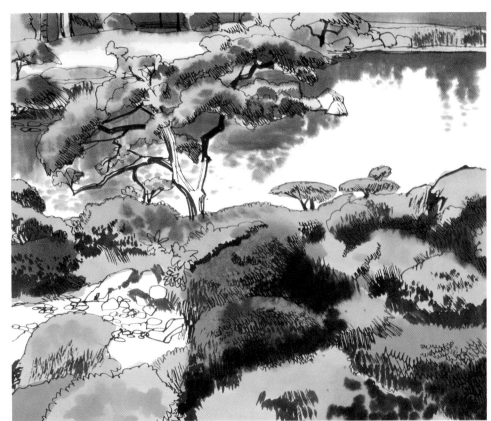

Step 6. *The gray stones in the lagoon near the foreground were painted with a mixture of water-soluble black ink and blue. While this area was still damp, I added the darker tone to indicate the shadow areas, this same color being used to paint in the trunk of the larger tree. I mixed a dark green and painted in the background shadow and some of the bushes. This darker tone helped to clarify these areas. Notice that the darker green wash had crisp edges. I painted it over an area that was completely dry so that the color could not blend into the surrounding area.*

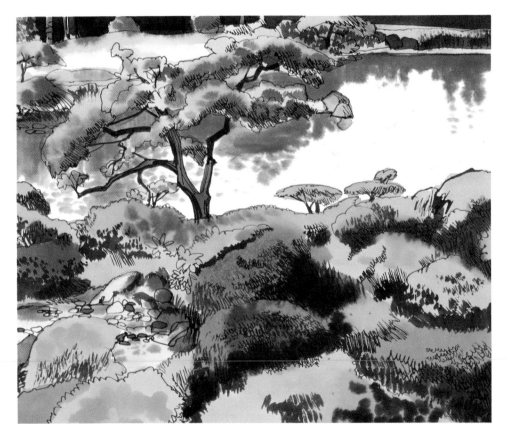

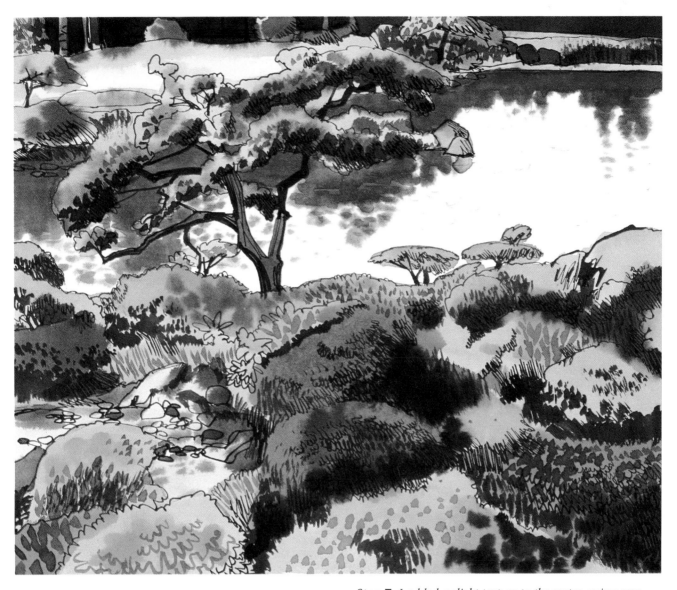

Step 7. *I added a slight texture to the water, using very finely drawn brush lines. The color of the reflections in the lagoon was too brown—I corrected it by washing a tone of dark green over them. The resulting tone was too similar to that in the foliage of the large tree. I added a dark shadow tone to the tree foliage to correct this, which enabled it to stand out better from the background. When you change a color or tone on a painting, it invariably means changing adjacent tones or colors also. More shadow tones and textures were added throughout the foliage, using small brushstrokes painted with a dark green color. Next, I painted in the orange flowers to add a few brighter touches to the scene. I painted all the foliage details and textures using a number 7 watercolor brush. Colored inks are more brilliant than other color mediums, but they do have a serious flaw. They are not permanent and can fade. For this reason, inks are used more for commercial work and illustration, where fading is not an important factor. However, inks are interesting to work with, and you can achieve unique effects with them.*

Step 1. *Colored inks are a very fresh medium, quite similar to watercolors, with the exception that ink colors are generally brighter and more vibrant. When you use them, it is best to work on medium or rough surfaces. The mounted papers are preferable because they are not subject to wrinkling when washes are applied. I began by drawing a simple diagram of the scene using an HB graphite pencil. After drawing in the lines indicating the foreground hills, I added various planes of the landscape and the background mountains. The lines dividing up the scene are the basis for the final pencil underdrawing.*

Step 2. *I developed the pencil drawing further, defining the various planes in the picture, then adding many of the important details. The foliage areas were drawn throughout the scene, as were the rocks and boulders. I also indicated the shadow areas on the mountains in the background. These details, although roughly drawn, were sufficient to guide me when I painted in the colors. They enabled me to concentrate on the tones and effects I wanted to achieve in the rendering. You can also* this type of underdrawing *with a brush, using a light, neutral wash tone for drawing the lines.*

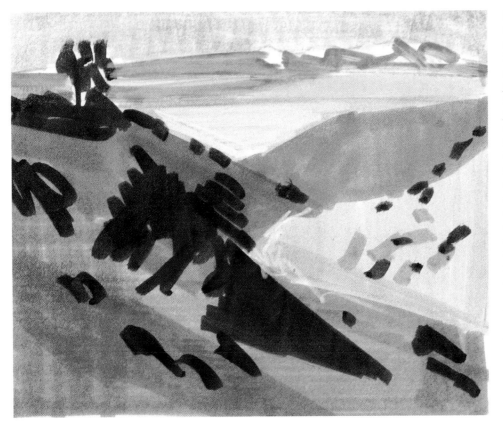

Step 3. *Before proceeding with the color rendering, I decided to do a color sketch. This important step will be useful when doing the painting. Any preliminary work, such as an accurate pencil underdrawing or a color sketch, will ensure a more successful result. The simplest, fastest method for doing preliminary color sketches is to use markers on layout paper. Notice that on this preliminary color sketch I used very simple, bold strokes to indicate the various tones of color in the scene. No matter how simply or roughly done, sketches can prove invaluable. You can easily do two or three, then compare them before making a choice.*

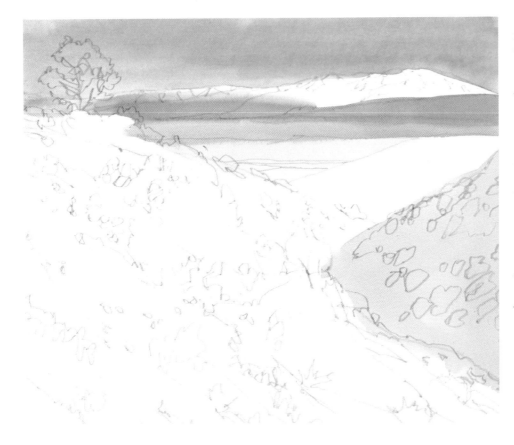

Step 4. *To start the color rendering, I wet the sky area of the paper surface using a wide, flat brush and clear water. While the board surface was still wet, I washed in a turquoise color with a number 7 red sable watercolor brush. Painting over previously dampened areas ensures a fairly even, uniform tone of color. Next, I painted the ground areas, using tones of yellow and light brown. A mauve color was then painted over the mountain in the background. Notice that some of this tone has a hard edge. The soft, blended portion occurred where the wash was painted over a damp part of the paper.*

Step 5. *I mixed a tone of water-soluble ink—black, brown, and a slight amount of yellow, then painted this color over the shadow area on the hill at the left. A darker tone, which I created by adding more black to the previous mixture, was painted over this, after allowing the first wash to dry slightly so the tones did not blend together. The side of the hill at the right was painted using a brown tone and the mountain in the background was painted blue, with some of the white paper used as areas covered with snow. I added a neutral gray tone over the central background area. I used a medium-toned wash mixture of brown and black to indicate the bushes on the sunlit hill in the foreground.*

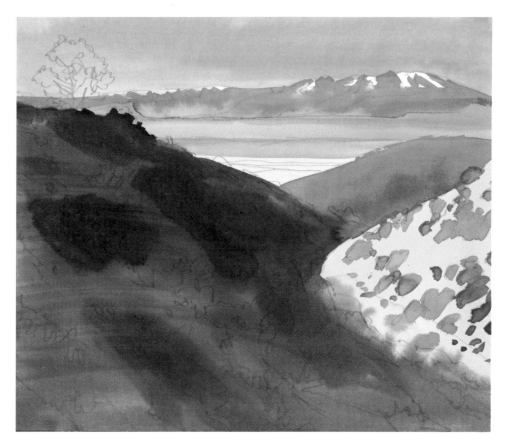

Step 6. *I mixed a dark shadow tone from black and a slight amount of brown. I painted this tone over the hill on the left and used dark blobs and brushstrokes of the same color to indicate the details in the shadows while the wash was still damp. I also rendered the tree at the top of the hill and painted in the shadows of the bushes on the sunlit hill. While the wash on the foreground hill was still damp, I painted in various details such as brushes, rocks, and numerous ground textures. With the same dark brown tone, I painted the shadow area on the background mountain and on the bright patch of ground near the center of the picture.*

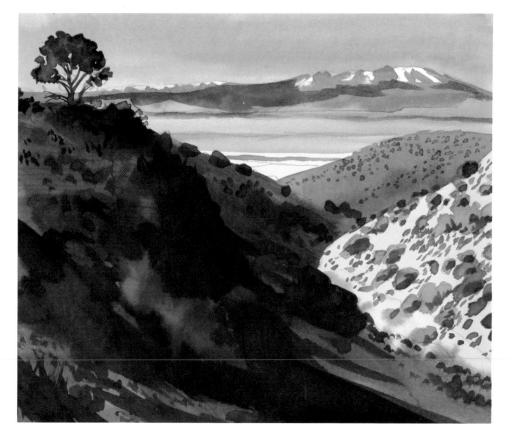

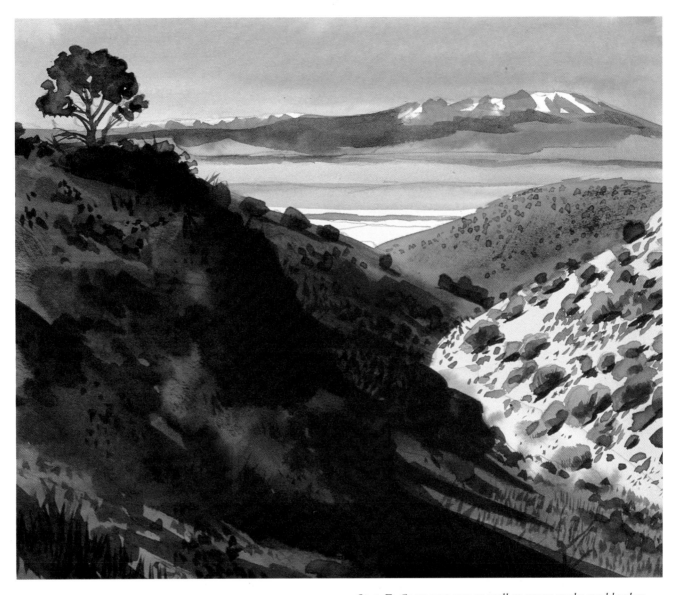

Step 7. *Grass textures as well as more rocks and bushes were painted into the shadow areas. In the foreground on the right, I used small brushstrokes to indicate more grass. The shadows under the bushes on the sunlit hill were darkened with a wash mixture of brown and black and smaller shadows and dots were indicated throughout the area to simulate the ground texture, finishing the rendering. Although the finished painting was not exactly like the preliminary color sketch, it had been based on it and is quite similar. As I worked, I livened up the painting by using more intense colors than were indicated on the marker sketch. The shadow areas in the painting were also much stronger. The color sketch served to give me a direction, a point of departure from which I was able to develop the finished rendering. This fresh, colorful technique is suitable for painting just about any subject. I should mention that when you paint in washes, it is best to work on a flat, level surface so that the washes don't run down the paper. One reason this painting has a fresh look is that it was done simply. I did not overwork it, which could have resulted in muddy colors. Drying washes can be facilitated by using an electric hair dryer. Washes can be partially dried, then painted over for special effects.*

Step 1. *Markers work well on just about any surface, although very different effects can occur depending on how the particular surface absorbs the medium. An excellent surface for markers is the smooth surface, although it reacts quite differently to markers than other papers do. For this demonstration, I used a different kind of smooth surface—scratchboard. It responds to markers the way smooth bristol boards do, but it has other interesting qualities. The main advantage scratchboard has over other boards is that its surface can be scraped with a special tool to achieve special effects. This allows the artist to make simple corrections. I used a fine-tipped marker pen for the basic drawing.*

Step 2. *The marker used for the drawing had a fine tip with water-soluble ink, which was perfect for doing the basic drawing because the drawn lines would not dissolve when permanent markers were used over them. After the shadow tones on the women were sketched in, I began to add color by using a yellow marker on the dress of the woman at the right. To paint in the colors, I used permanent markers with multifaceted wedge-shaped nibs. Many different kinds of lines, as well as ⸳rge areas of color, can be ⸳⸳dered with this versatile ⸳⸳. I should mention that ⸳ ⸳en you work with markers, remember to recap them tightly after use to prevent the ink from drying.*

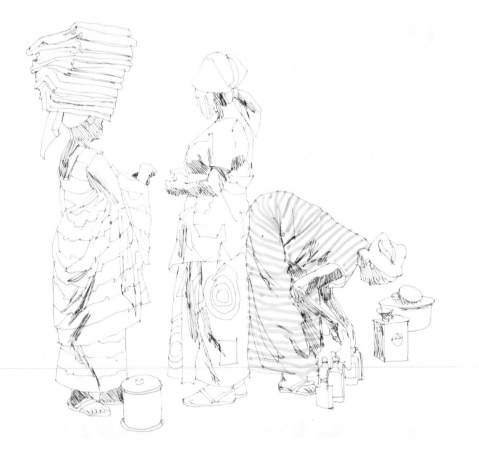

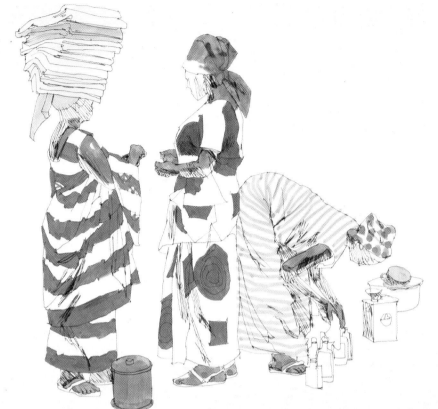

Step 3. *I added more bright color patterns on the other women's dresses, using red magenta markers. An aqua color was drawn on the cup in the tub on the ground. Then I added light blue and pink tones over the folded sheets on the woman's head and a bright yellow to her headband. On the center woman's headband I used sepia and blue. Where the colors overlap, they combine to create a shadow tone. I began to add the sepia color to the flesh areas and used it to color the can in the foreground as well.*

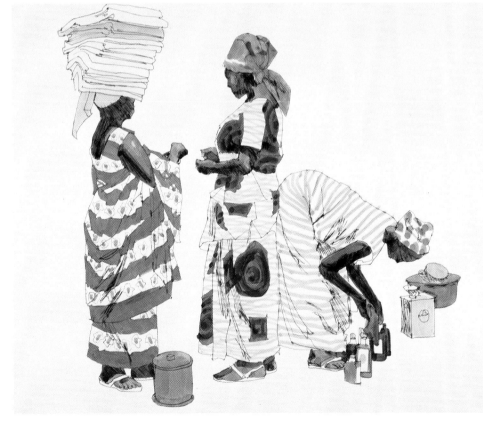

Step 4. *When I finished putting in the flesh tones, I used a darker brown for the shadow tones on the skin. I added color to the bottles as well as to the tub and the can on the right side. I accented the pattern on the dress of the woman in the center by adding a brown color over the magenta. Then I drew a small pattern on the dress with the red stripes. With the fine-line marker pen, I drew outlines around the pattern.*

Step 5. *To draw the shadow tones on the dresses, I used a number 6 warm gray marker, adding these tones very carefully. The fact that the marker ink is transparent made it quite easy to indicate shadow tones over color areas that show through the tone. Shadow tones were also added to the cans and tub on the ground. I used the gray marker to draw in the shadow tones on the folded sheets on the woman's head at the left, then drew in the shadow tone on her bandana. Next, I added the pattern on the center woman's bandana, using a dark brown.*

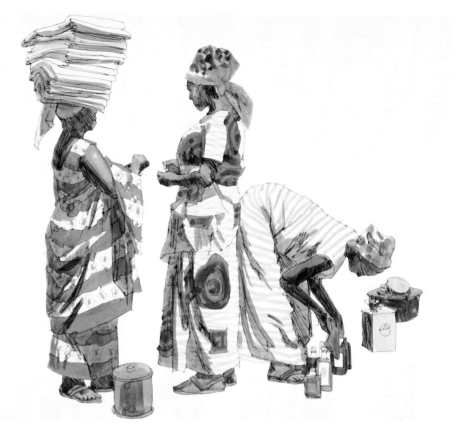

Step 6. *I drew darker grays on the folds of the women's dresses with a number 8 warm gray marker. The shadows on the flesh areas of the figures were darkened with the same tone. You must exercise great care when drawing in the finer details—they are best executed by drawing with the corner edge marker nib. Highlights were added to the flesh tones by dissolving some of the color with a light gray marker. I used the same method to create the light lines on the pattern of the center woman's dress. On a hard smooth surface, light-colored markers can be used to dissolve darker tones.*

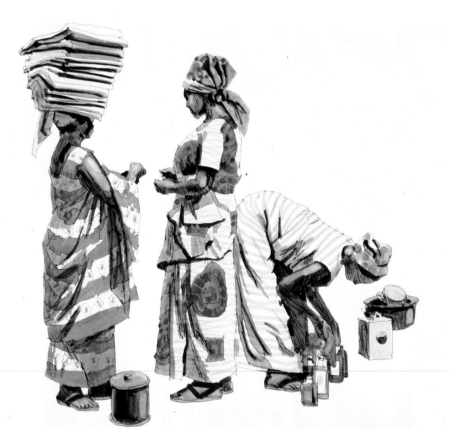

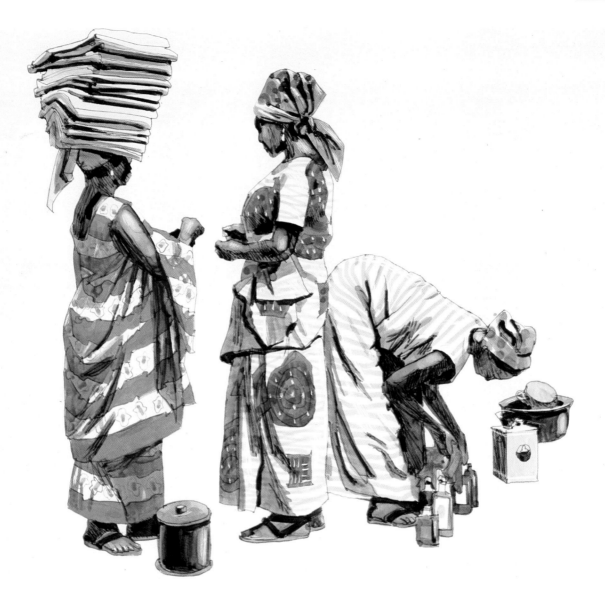

Step 7. *Since the drawing was done on scratchboard, more details could be added by using the scraping tool. Also, the edges of the drawing could be cleaned up by scraping away the imperfections. The special tool for this fits into a pen holder and is used the way a pen is to etch lines into the color tones. You can also remove large areas of tone with this tool, but it is best to use it sparingly, limiting the scraping to the addition of a few white accents or to clean up the edges of the drawing. Using the scraping tool, I added white dots on the pattern of the center woman's dress. I worked carefully because errors are difficult to repair. Tiny lines were scraped over some of the highlighted areas on the skin to brighten them still more. Then the edges were cleaned up by scraping around most of the drawing with the tool. This interesting technique also be done using inks or other painting mediums instead of markers. Scratchboard offers great possibilities for experimentation also, since other kinds of tools and even sandpaper can be used to create textures or to remove areas of color. By working on a white background, I've kept this demonstration subject fairly simple. Beginners should first work against a white background. You can attempt more difficult drawings later.*

Step 1. _You can use markers to do sketches or paintings with effects that resemble watercolors, especially if you work on paper with a rough texture. Markers are fast, convenient tools to use for painting, but the results can vary greatly, depending on the type of paper. On smooth surfaces the results are quite different from those you can achieve on rougher papers. On smooth papers, lines and tones are smooth and flat; on a rough surface, lines would be broken and tones textured. For this demonstration, I used markers on medium-surfaced illustration board. I began by doing the basic drawing with a number 3 gray marker; it is best to do the initial drawing with a neutral color._

Step 2. _I rendered the pale blue on the sky area, then used this same color on the water. Both tones were applied with quickly drawn strokes. Because the marker ink dries quite rapidly, working quickly when rendering larger areas of color ensures a flat, uniform tone. Something to remember when working on an absorbent surface such as this, is that tones appear darker than they would on harder, smooth paper surfaces. On less absorbent papers, not as much ink soaks into the surface and the colors appear lighter. Only by working on various papers will you understand how markers react to each surface._

Step 3. *I painted flesh color on the buildings, again working very quickly so that the tone would dry evenly. (As I have mentioned, there is the possibility of hard edges forming between the drawn strokes if they are drawn too slowly, causing an unsightly linear pattern throughout the tone.) Next, I added a very light gray tone to the adjacent building, using a number 2 gray marker.*

Step 4. *I used a darker number 5 gray marker over the domes and roofs of the buildings. Some of the building details were drawn with the same marker. I painted a pale sepia color on the building with bold strokes, using the widest facet of the marker nib. I used the same color for the lighter tones on the gondola. These tones appeared too strong at this stage but would be subdued and fit in better when I added the darker tones to the sketch.*

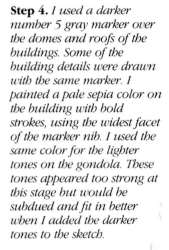

Step 5. *To create the pattern of the waves on the water surfaces, I used a pale olive color over the blue. Boldly drawn strokes were used to indicate the reflections on the waves in the foreground and the shadow under the gondola. On the left in the background, I blocked in the shapes of trees with the dark green color. I used a number 2 gray marker and a flesh tone over the water area in the background to simulate the reflections. When I later added the accents to the buildings, the reflections on the water would be darkened further.*

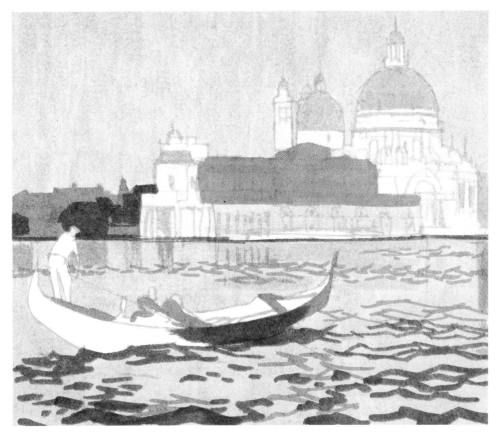

Step 6. *The scene had taken on the characteristics of a watercolor painting. Both markers and watercolors are ideal for doing sketches like this. To add the darkest tones, I used a number 9 gray marker to draw in the rest of the gondola and the people. I did this by carefully drawing with the sharp point on the edge of the marker nib so the details would be easier to indicate. With the lighter number 6 and 3 grays, I began to draw in the details and shadows on the buildings.*

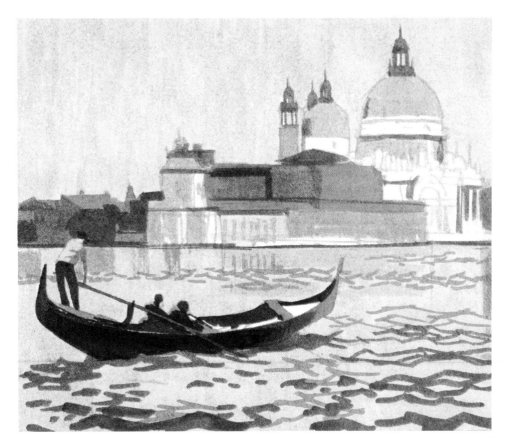

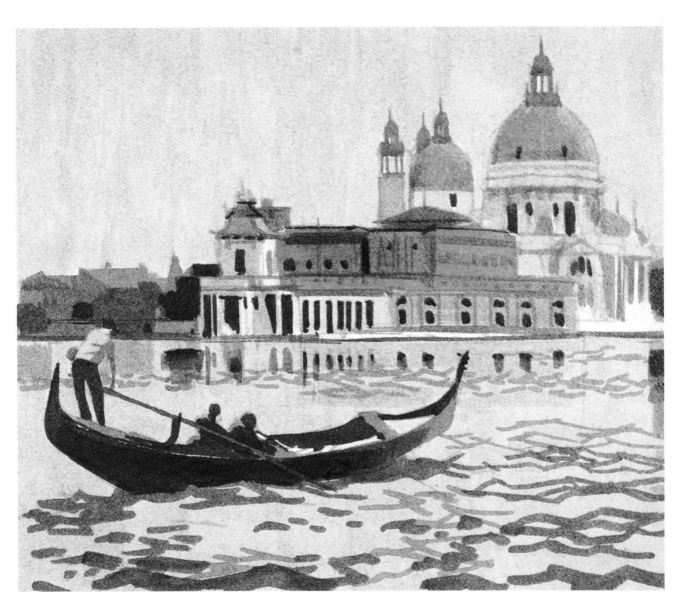

Step 7. *I drew the windows of the buildings with a number 9 gray marker. The reflections on the water were darkened with the same marker. Some of the dark areas in the reflections were softened by using a lighter gray marker to blend the edges. I added darker tones to the front of the buildings to indicate shadows, using a number 6 gray marker. The near-black accents were added with the number 9 gray. I applied a blue color to the domes on the buildings and softened the edges of these tones with a number 1 gray marker, helping to create form. The sketch was finished, using only a few colors and simple marker strokes. The sketch resembles a watercolor because it was done quite rapidly, using boldly rendered strokes without much detail. Like watercolors, markers should not be overworked but should be handled in a very direct manner. Markers are ideal for doing simplified sketches; it is difficult to render fine details or thin lines with the wedge-shaped nib. When you begin to use markers, start out by first doing sketches with black and gray markers. As you gain confidence and experience, you can advance to more complex subjects, doing them in color. Your first efforts should be done on a good-quality layout paper; then try other surfaces.*

18
CORRECTING INK DRAWINGS

YOU CAN ALWAYS correct ink drawings by painting out unwanted areas with white paint, and then inking over the paint when it's dry. However, this isn't the most satisfactory way to change an ink drawing because the pen doesn't handle very well over paint, especially if the paint is thick. The result usually looks very messy. The best way to remove unwanted areas and lines is to use an ink eraser. Most good-quality illustration boards hold up well when you use a fiberglass eraser. The surface remains undamaged and new lines can easily be drawn back in. An even faster, more efficient method is to use an electric eraser, with which you actually grind away a portion of the illustration board surface. Erasing machines use eraser plugs that are available in various grades to meet every erasing problem. I usually use the gray eraser plug for removing ink lines and solid black areas of ink, and the pink eraser plug—which is less abrasive—for taking out more delicate lines and for removing washes without damaging the board surface so you can apply a new wash without any problems. The electric eraser is equipped with an automatic switch that starts the motor when it's tilted downward for use. It's probably the handiest tool I own. It has saved many an illustration from the wastebasket.

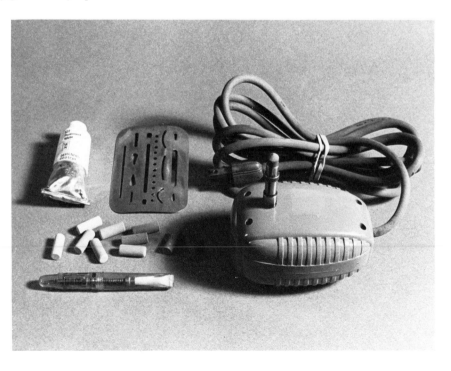

White paint—like the Winsor & Newton gouache permanent white in the tube at upper left—can be used to correct minor errors and to take out unwanted lines, but it's usually difficult to draw over the paint with the pen. To the right of the paint is an erasing shield, which can be very helpful when taking out small areas or when protecting adjacent areas from damage if you're using a fiberglass or electric eraser. The electric eraser, far right, is the best method to use for correcting ink drawings. Eraser plugs, lying in front of the paint and shield, are available in various grades and can be purchased singly or by the box. Underneath the plugs is a fiberglass eraser—it can be used on most high-quality illustration boards.

Try to put some life into the mechanical subjects you draw. Here I used a cat playing with the crank handle to bring a little action to an otherwise static picture. The brushstrokes in the headlights and fenders also helped loosen up the mechanical rendering of this old Chevrolet.

This is a very professional method for correcting ink drawings. It gives a much better result than if white paint is used to correct mistakes.

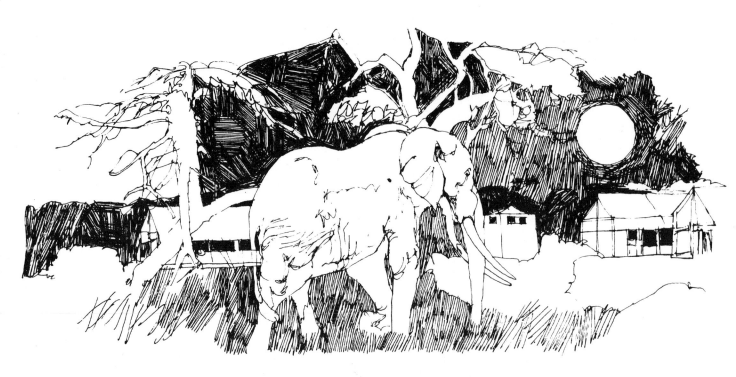

Step 1. *Here is the drawing before it was corrected—I wanted to replace the tent on the extreme right with some foliage.*

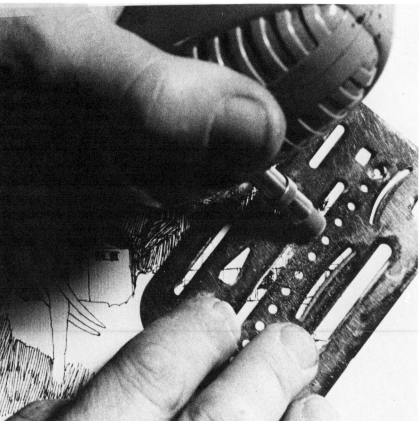

Step 2. *I used an erasing shield to remove the unwanted lines so that the adjacent lines wouldn't be damaged. Sometimes I go over an area two or three times before all the lines are erased and the area is clean. When you do this, take care not to grind through the board surface to the backing.*

Step 3. *I drew over the area again easily because the surface wasn't damaged.*

Step 4. *The corrected drawing looked perfect—there was little evidence that it had been reworked.*

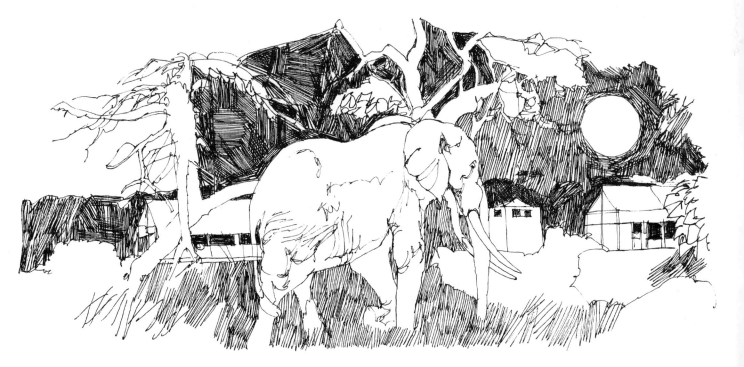

Demonstration 26. *Using the Electric Eraser*

The only way to correct a wash drawing is by using the electric eraser. You can't do it by using white paint because the paint will dissolve when you attempt to put a wash over it. And a fiberglass eraser cuts into the surface slightly, causing the new wash to go on unevenly. Please note that a wash drawing can best be corrected when it has been done on a high-quality illustration board, such as the Strathmore board used here.

Step 1. *I used the electric eraser with a pink plug to remove the wash on the man's pants. I erased the area several times until it was clean.*

Step 2. *The erasing shield minimized damage to the adjoining areas.*

Step 3. *I used a drafting brush to wipe away the eraser particles—it's very important to have a clean board surface when you apply the new washes.*

Step 4. *I drew the outline back in.*

Step 5. *The new washes went on quite evenly because the board surface wasn't damaged by the erasing.*

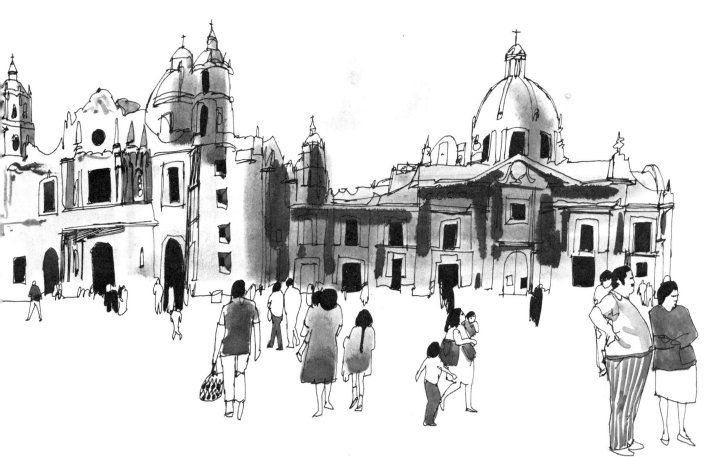

Step 6. *Here is the finished drawing after corrections.*

Demonstration 27. _Correcting a Scratchboard Drawing_

Scratchboard has a unique surface that allows you to scrape away unwanted areas. If you do this carefully and don't scrape too deep, you can easily re-ink the area and even cut in a texture or tone. If you scrape off too much of the board surface, you damage the board—and it's doubtful that you'll be able to save the drawing.

Step 1. _This illustration was nearing completion, but I didn't think the buildings and the sky in the Hong Kong scene were working properly. The buildings looked too crude, and the lines in the sky were too fine for good reduction. Since this illustration was to be used in a variety of sizes for newspaper reproduction, it had to be rendered bold enough for good reduction._

Step 2. _I taped a sheet of tracing paper over the illustration and made a quick tracing of the area to be corrected. When I scraped out the unwanted area, I would naturally lose my drawing. By making this tissue, I was able to trace the drawing back in after scraping the area clean._

Step 3. *I removed the tracing paper and scraped the section of the drawing to be corrected carefully with a scratchboard tool. When you do this, be very cautious and don't scrape too deep—make sure the surface remains workable.*

Step 4. *After the area was scraped clean, I retraced my drawing with a graphite tracing sheet and a stylus.*

Step 5. *It wasn't necessary to scrape the ink from the island, since the drawing in this area was basically done by scraping white lines into the black background. I just brushed ink over this whole section. Then I waited until the ink was thoroughly dry, since clean lines can't be cut into wet or even damp ink.*

Step 6. *I cleaned up the edge of the aircraft by cutting with a scratchboard tool—I guided the tool with a curve and triangle.*

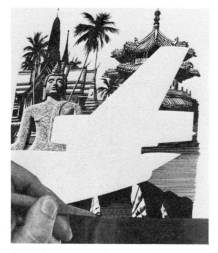

Step 7. *I scraped horizontal lines into the land area using a T-square as a guide. Then I ruled a gray tone into the sky and allowed it to dry. Gradually I built up the tones in the houses and buildings, putting in the black shadows and windows with a brush.*

Step 8. *After scraping clouds into the sky, I again decided to change the whole character of this section. I felt that an overall texture made up of small brushstrokes would work better.*

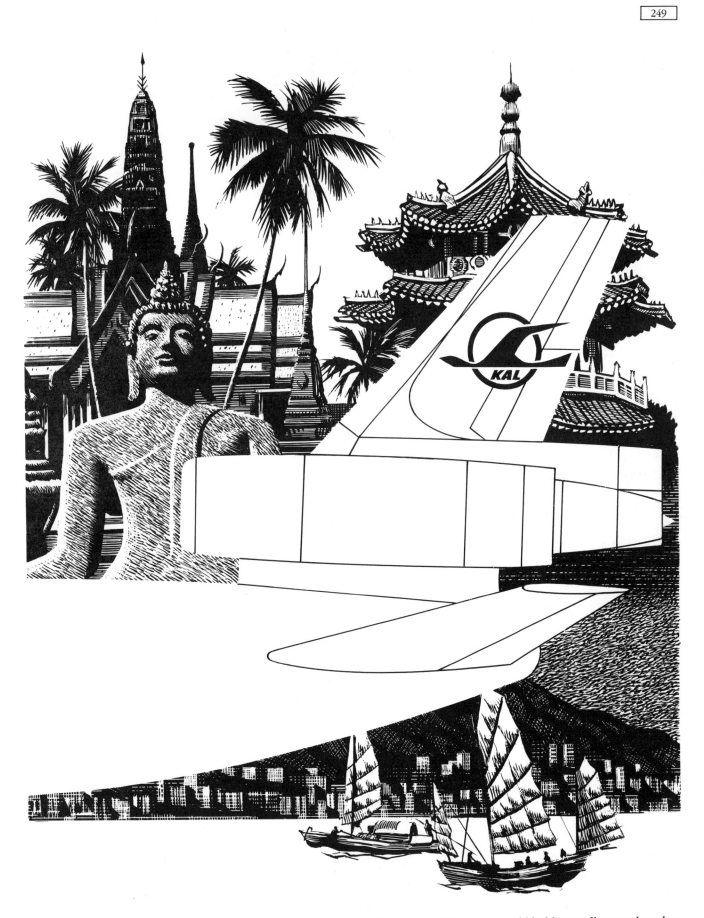

Step 9. *Here's the final art—all the lines would hold up well even when they were reduced to the size of a newspaper ad. Reduction is often an important consideration when doing advertising artwork.*

19
TECHNICAL TIPS

I<small>N THIS CHAPTER</small> I'll discuss a variety of subjects—cleaning your tools, reference sources, camera equipment, and making a graphite tracing sheet.

CLEANING YOUR TOOLS
Keep a rag handy for wiping your pen points clean after you use them—an ink-encrusted pen won't function properly. You can clean points for technical pens with a pen-cleaning fluid that dissolves dried ink. This solvent will also remove hard, dry ink on brushes. Be sure to clean your brushes after each use also.

REFERENCE AND RESEARCH SOURCES
Many artists have a reference file of clippings they've taken and of magazine picture clippings covering various subjects that they might need at a later date. This is a good idea for you. A fairly complete file, however, can take up a bit of room and requires a certain amount of time to keep up to date. My solution is a combination of a very small reference file and a good selection of magazines and books

stacked on steel shelves in the basement. I picked most of them up at used-book stores. *National Geographic, Sports Illustrated, Ladies' Home Journal, McCall's,* and old *Life* magazines are all very good sources for finding reference material.

I also photograph subjects I may need at a later date for illustration backgrounds. Photographs taken at the airport, rodeos, air shows, and parades can be invaluable if an assignment comes up that requires this type of material. I make contact prints of these negatives and file them away. When traveling, I shoot a great many 35-mm color slides and have found them to be an excellent source of reference material, especially for backgrounds.

Certain subjects, such as automobiles, ships, and aircraft, are well covered photographically in many books available in your public library. Some libraries have extensive picture collections that are very helpful for the artist. Since I'm very interested in aviation, I have a very large collection of aircraft magazines and books and can locate almost any aviation subject needed. If you need photos of people, you can shoot pictures of friends or members of your

Brushes should always be rinsed well after use with ink or paint, and they should occasionally be washed in water with mild soap. To wash a brush in soap and cold water, rub the brush in soap and clean the brush in the palm of your hand until all the dried ink particles are removed. When you are finished, rinse the brush thoroughly in water. If you leave ink or paint to dry in a brush, the brush may be permanently damaged.

family. Occasionally I'll set the camera on the self-timer and shoot pictures of myself in the poses required. You can also hire professional models through model agencies—the agencies have composite books from which various types of models can be picked.

There are firms that specialize in stock photographs, and they have thousands of photographs available on countless subjects. And frequently, used book and magazine stores carry old Hollywood movie promotion photographs taken from the films. You can find great shots of cowboys, battle scenes, old ships, and other oddities in these promotion pictures. Another source of reference for certain subjects is the hobby shop. Hobby shops carry many finely detailed plastic model kits of aircraft, tanks, automobiles, ships, submarines, and guns. After you assemble these models, you can photograph them at any angle. All this may sound like a lot of effort, but finding the proper reference is really worth whatever work is necessary. You can't simply guess or try to remember what a certain subject looks like—you must know.

I have to photograph much of the reference material I need specifically for particular assignments. Many times it's much easier to shoot the reference photos than to look through hundreds of magazines for a certain subject. And if you're a working illustrator, your clients may be able to furnish good reference photographs of their products.

CAMERA EQUIPMENT

For a great deal of my picture taking, I use the Polaroid 180 camera. This is an excellent camera, and I was fortunate to find a used one in very good condition. This model is without the automatic electronic exposure control found on many instant picture cameras—I prefer to alter the exposure if necessary. The great advantage of the Polaroid cameras, of course, is that you get instant results.

For most of my general photography, however, I prefer my Nikon FTn, an excellent, very rugged camera. This camera has operated flawlessly in jungles and deserts and under other extreme climate conditions. I prefer the 35-mm format because it offers a great range in the selection of available films—you can get 35-mm color slides as well as both 20 and 36 exposure rolls. Also, you can view directly

through the picture-taking lens and see exactly what you'll get. The Nikon FTn incorporates a through-the-lens meter/finder and has shutter speeds from one full second to 1/1000 of a second. I've enjoyed excellent performance from this camera and consider it to be one of the finest on the market. My lenses consist of a 55-mm f/1.2, which is an extremely fast lens—very good for taking pictures under poor light conditions; a 24-mm wide-angle; and a 135-mm telephoto lens. I find the 24-mm wide-angle lens perfect for most subjects, such as people, buildings, marketplaces, and panoramic shots. The telephoto, a moderate 135-mm, is sufficient for most long shots, perfect for shooting pictures of wild game on an African safari. I use my 2x lens extender with the telephoto when I want to convert it into a more powerful lens. The extender converts the 135-mm lens into a 270-mm with excellent results.

When I don't want to carry around a heavy load of camera equipment all day, I take my lightweight Rollei 35. This is a compact, full-frame 35-mm camera that is a precision piece of equipment, capable of taking excellent pictures. Its lens is a relatively slow f/3.5 and is not interchangeable. However, it is sufficient for average outdoor lighting conditions. The Rollei has a built-in light meter and shutter speeds of 1/2 second to 1/500 of a second. This is the smallest full-frame 35-mm camera made.

Another very interesting camera is the miniature Swiss-made Tessina, which measures 2⅝″ × 2″ × 1″ (7.69 × 5.1 × 2.54 cm). It uses 35-mm film in special cartridges with up to 24 exposures. The negative size is 14 × 21mm rather than the standard 35-mm negative size of 24 × 36mm. The Tessina has a 25-mm f/2.8 lens and shutter speeds from 1/2 second to 1/500 of a second. The spring motor-driven film transport also cocks the shutter, enabling you to take pictures very rapidly—you can make excellent blow-ups from this camera's sharp negatives.

The Robot Royal incorporates a rapid-wind spring motor that permits taking pictures in rapid sequence. You can shoot up to five to six photos per second and take twenty exposures without rewinding. It's a great camera for taking pictures at auto races or sports events.

There's a great variety of camera equipment on the market—the cameras I mention here are just a few of the ones I've used over a period of years.

Demonstration 28. *Making a Graphite Tracing Sheet*

The most widely used method for transferring sketches and drawings to illustration board is to use a graphite tracing sheet, which is similar to the carbon paper used in typing. To use the graphite tracing sheet, tape your drawing (done on tracing or layout paper) to the illustration board, slip the graphite sheet in between, graphite side down, and trace the drawing onto the illustration board with a stylus or a hard pencil.

Step 1. *Cover the surface of good-quality tracing paper, 14″ × 17″ (35.56 × 43.18 cm), or larger if you prefer, completely with graphite by rubbing the sheet with a 4B or 6B graphite stick.*

Step 2. *Dampen a wad of cotton with Bestine, a solvent used for thinning rubber cement. Be careful not to saturate the cotton since the solvent may wash the graphite away and you would have to recoat the paper.*

Step 3. *Rub the dampened cotton over the graphite, dissolving it into a smooth and even black tone. You may have to go over the whole area two or three times to achieve an even tone.*

Step 4. *Once the surface has an even black tone, rub over the whole sheet with a fresh piece of clean, dry cotton. This will remove any excess graphite and produce a harder surface that minimizes smudging.*

Step 5. *Place the completed graphite tracing sheet facedown between your drawing and the illustration board surface, and trace the drawing with a stylus or a hard pencil, such as a 4H. When properly prepared, the graphite sheet will produce clean black lines. While tracing your drawing, be sure to lift the sheet occasionally to check if you've missed any lines. After the tracing is completed, you can redraw or correct any errors before starting the inking.*

You can use this same method to trace photostats of photographs onto illustration board. Just coat the back of the photostat with graphite and go through the same process until you have a uniform, solid black tone. Tape the photostat to the illustration board and trace it with a stylus.

CONCLUSION

FIRST, BE SURE to study all the technique examples and step-by-step demonstrations. Go over these examples carefully until you understand how they were done. The step-by-step demonstrations are especially important because you can study the drawings at their various stages. At first, the diverse number of technique examples may seem confusing, but as you study them, you will begin to understand how they were done. Even the differences in styles will become more apparent as you develop your drawing skills.

When you begin working with the techniques, don't work on several at a time. Stick to one technique until you feel you have mastered it. Then go to another one. Also, practice all the exercises as I have suggested, for they will provide background for later techniques. They will also familiarize you with the various drawing tools and paper surfaces.

When you attempt any of the techniques, be sure to begin with simple subject matter. And keep your drawings small until your skills are developed. This way you won't become discouraged, and you will progress rapidly. After you feel at ease with simpler techniques, progress to more complicated ones.

I cannot stress enough the importance of practicing often. If you were learning to play the piano, you would practice a great deal. The same holds true for drawing or painting. Also, it is advisable for you to enroll in a basic drawing or life drawing class. Many schools offer such classes in the evenings or on Saturdays. Working with a competent art instructor will be very helpful. Meeting other art students is also important, for it will give you the opportunity to see others work and to discuss art with people who share your interest. Try to expose yourself to as much art as possible. Go to galleries and museums, where you can study drawings and paintings. Such trips can be quite stimulating and inspiring.

There are also many books and magazines on art, which can be found in your local library. You might even want to purchase a few good books for handy reference material. Everything you see and read about art will help you develop as an artist.

Remember what I said about discipline—it is an extremely important part of being an artist. You must be *self-motivated*.

Drawing—especially learning how to draw—may seem at first appearances to be quite a chore. But if you look at it as a wonderful learning process, a very new world may open up for you. If you are determined and work hard, you may be pleased to see much progress in a relatively short period of time. For this reason, it is a good idea to keep all your drawings and sketches so that you can compare your earlier work with later endeavors. You will have an actual record of how far you've progressed over a period of time.

Drawing is a pleasure, which you will discover as you progress and develop an ease of accomplishment. At the beginning, it can be tough, but when some of the mystery is taken out of drawing through your own experience and developing expertise, drawing will increasingly seem a pleasure and a challenge you look forward to.

INDEX

Acrylics, 125–27
Along Kandy Lake, 97

Balinese Children, 88
Banana Girl, Besakih Market,
Bali, 98
Besakih, Bali, 99
Blended-tone technique, 57, 71
Boulevard St. Germain, Paris, 53
Bristol board, 16, 107. *See also*
Paper
Brushes, 130, 142, 148, 149,
156–57, 251
and pen, 198–207
Brush line techniques, 190–97

Camera equipment, 251
Charcoal pencil, 12, 70–74,
78–79
China marking pencils, 15
Church at Vezelay, 84, 85
Cleaning tools, 250
Color, using, 96–127
Colt, The, 109
Conté crayon, 15
Contour-line technique, 56
Crosshatching, 41, 161, 171, 183,
184–89, 191, 194–97
See also Hatching
Crowquill pens, 178, 182–83

Decorative line, 64, 66–67

Decorative line-tone, 85
Decorative tone, 76–77, 84, 86,
89, 99
Denpasar Market, 67
Dissolved-tone technique, 57, 88,
92–93, 97, 101, 102
Drafting tools, 138
Drawings
correcting, 240–49
preserving, 130–31
simplifying, 162
See also Techniques
Drawing surfaces, 23. *See also*
Materials; Paper
Drawing table, 23
Dyes, 119–21

Erasers, 16, 175, 240, 244–45
Eraser shields, 242–43

Fixatives, 16, 130–31

Gouache, 122–24
Graphite pencil, 12, 52–69
Graphite sticks, 15
Graphite tracing sheet, 252–53
Gray value, 163

Hatching technique, 88, 91, 160,
161, 170–75
See also Crosshatching

Impressionistic line and tone,
103
Inks, 119–21, 135, 138, 211,
224–31

Kandy, Sri Lanka, 87
Kongoni, 100

Layout paper, 16
Life, drawing from, 131
Lighting, 23
Line
and color, 110–13
pen-point, 136–37
and shape, 144
techniques, 178–89
and texture, 145
types of, 145–48
Line and tone technique, 56, 143
Line-tone technique, 56, 68–69,
85
Loose-line technique, 56, 82
Lucky de la Petite Sologne, 121

Markers, 138, 149, 158–59, 210,
232–39
Materials
acrylics, 125–27
brushes, 130, 142, 148, 149,
156–57, 198–207, 251
cameras, 251
cleaning, 250

drafting, 138
drawing surfaces, 23
dyes, 119–21
erasers, 16, 175, 240, 244–45
eraser shields, 242–43
fixatives, 16, 130–31
gouache, 122–24
inks, 119–21, 135, 138, 211, 224–31
lighting, 23
markers, 138, 149, 158–59, 210, 232–39
masking tape, 15
oil crayons, 122–24
pastels, 15
pens, 134–38, 142, 149, 150–55, 178, 180–81
sandpaper block, 15, 16, 128
sketching, 134
stumps, 23
X-acto knife, 16, 128
See also Paper; Pencils, Technical tips
Michigan Farm, 60
Misty, 82
Montmartre, 102
Mont St. Michel, 79, 106

Nevada Dawn, 127

Oil crayons, 122–24

Paper
 bristol, 16, 60, 107
 charcoal, 16, 23
 common, 139
 comparing types of, 17
 hot- and cold-pressed, 16
 for ink, 138, 175, 208, 222–23
 layout, 16
 newsprint, 16
 printing, 23
 rough, 141
 smooth, 140
 soluble, 114–17
 textured, 104–6
 toned, 222–23
 tracing, 16
 visualizing, 16
 watercolor, 16
Paris Bird Market, 103
Paris Mood, 101
Pastel pencils, 70, 75–77
pastels, 15
Pencils
 charcoal, 12, 70–74, 78–79

China marking, 15
color, 104–9, 119–21, 122–24, 125–27
graphite, 12, 52–69
pastel, 70, 75–77
sharpening, 15, 16, 128
water-soluble, 15, 114–17
wax-type, 12, 15, 80–87
Pens
 brushes and, 198–207
 crowquill, 178, 182–83
 marking, 138, 149, 158–59, 210, 232–39
 technical, 134, 138, 178, 180–81
 types of, 134–38
pen strokes. *See* Stroke techniques
Photographs, drawing from, 48, 49, 50, 51, 131, 163, 164, 165, 184–89, 195, 250–51
Place de l'Ama, 8
Place des Vosges, 76, 77
Pont Neuf, 81

Quai de Bourbon, 61

Realistic line, 82, 102
Realistic tone
 blended, 98
 dissolved, 97
 rendered, 61, 74, 89
 smudged, 60, 61, 75, 78–79
Reference sources, 250–51
Reflections, 83
Rendered-tone technique, 57, 61, 74, 81, 83
Rodeo at Hillside, Michigan, 64–65
Rooster, 75
Ruling lines, 147, 161

Sailboat, Lake St. Clair, 71
Sandpaper block, 15, 16, 128
Sandra, 118
Scratchboard, 208, 214, 217, 218–21, 232, 235, 246–49
Scribbling technique, 88, 90, 210
Shapes, 144
Sharpening pencils, 15, 16, 128
Sketch technique, 56, 168–69
Smudged-tone technique, 57, 58–59, 60, 66–67, 75, 76–77, 78–79
Soluble pencils, 15, 114–17
Street Market, Rue Mouffetard, 58–59

Stroke techniques
 broad, 25, 32–35
 ink, 142–59
 parallel, 25
 textural, 26
 thin, 25, 28–31
 varied, 25, 36–39, 161, 176–77
Stumps, 23
Subtractive technique, 88, 94–95
Sukri, 74, 124
Supplies. *See* Materials

Taboret, 23
Tavis, 62, 63
Technical pens, 134, 138, 178, 180–81
Technical tips, 128–31, 250–53
Techniques
 blended-tone, 57, 71
 brush, 190–97, 212
 comparing, 56–57, 88–95
 line, 178–89
 rendered-tone, 57, 61, 74, 81, 83
 scribbling, 88, 90, 210
 sketch, 56, 168–69
 smudged-tone, 57, 58–59, 60, 66–67, 75, 76–77, 78–79
 stroke, 142–59
 subtractive, 88, 94–95
 tonal, 160–77
Texture, 26, 164, 172
Tonal Study for a Pencil Drawing, 64
Tonal techniques, 160–77
Tone
 building, 40–47, 54–55, 72, 74, 75, 219
 simplifying, 48–51, 164–65
Tone technique, 56
Tools. *See* Materials

Value, 50, 51, 60, 161, 163–67
Visualizing paper, 16

Wash, 110–13, 160, 224–27, 229–31
Watercolor, 110–13
Watercolor papers, 16
Water-dissolved technique, 57, 86, 99
Wax pencil, 12, 15, 80–87
Wooded Area Near Le Mans, 27
Working Elephant, Sri Lanka, 69

X-acto knife, 16, 128